THE COMPLETE
35MM
SOURCEBOOK

THE COMPLETE 35MM

SOURCEBOOK

Michael Busselle

Consultant Editor Richard Platt

AMPHOTO
AN IMPRINT OF WATSON-GUPTILL PUBLICATIONS/NEW YORK

Edited and designed by the Artists
House division of Mitchell Beazley International Ltd
Artists House, 14—15 Manette Street, London W1V 5LB

Executive managers Kelly Flynn
Susan Egerton-Jones
Design Hans Verkroost
Editors John Farndon
Jonathan Hilton
Production Peter Phillips

First published in 1988 in the United States by Amphoto,
an imprint of Watson-Guptill Publications, a division of
Billboard Publications, Inc., 1515 Broadway, New York,
New York 10036

LIBRARY OF CONGRESS
Library of Congress Cataloging-in-Publication Data
Busselle, Michael.
 The complete 35mm sourcebook/Michael Busselle;
 consultant editor, Richard Platt.
 p. cm.
 Includes index.
 ISBN 0-8174-3703-7 (pbk.)
 1. 35 mm cameras. 2. Photography—Handbooks,
 manuals, etc.
 I. Platt, Richard. II. Title. III. Title: Complete
 thirty-five millimeter source book.
 TR262.B87 1988
 770'.28'22—dc19

The publishers have made every effort to ensure that all
instructions given in this book are accurate and safe, but
they cannot accept liability for any resulting injury, damage
or loss to either person or property whether direct or
consequential and howsoever arising. The author and
publishers will be grateful for any information which will
assist them in keeping future editions up to date.

Typeset by Bookworm Typesetting, Manchester
Color reproduction by la Cromolito s.n.c., Milan
Printed in Portugal by Printer Portuguesa Grafica Lda.

Front cover photographs: *Clockwise from top left:-* Kodak Ltd; MB;
Richard Platt; Richard Platt; MB; MB; The Science Museum;
MB; Nikon, UK; David Secombe; MB; MB.

Back cover photographs: *Clockwise from top left:-* Richard Platt;
Gert Koshofer; Michael Busselle; MB; MB; Minolta, UK; John
Miller; MB; MB; MB.

CONTENTS

THE WORLD OF 35MM PHOTOGRAPHY

THE 35MM FORMAT

35MM EQUIPMENT

THE 35MM CAMERA IN USE

COMPOSING WITH 35MM

THE SUBJECT

PROCESSING THE 35MM IMAGE

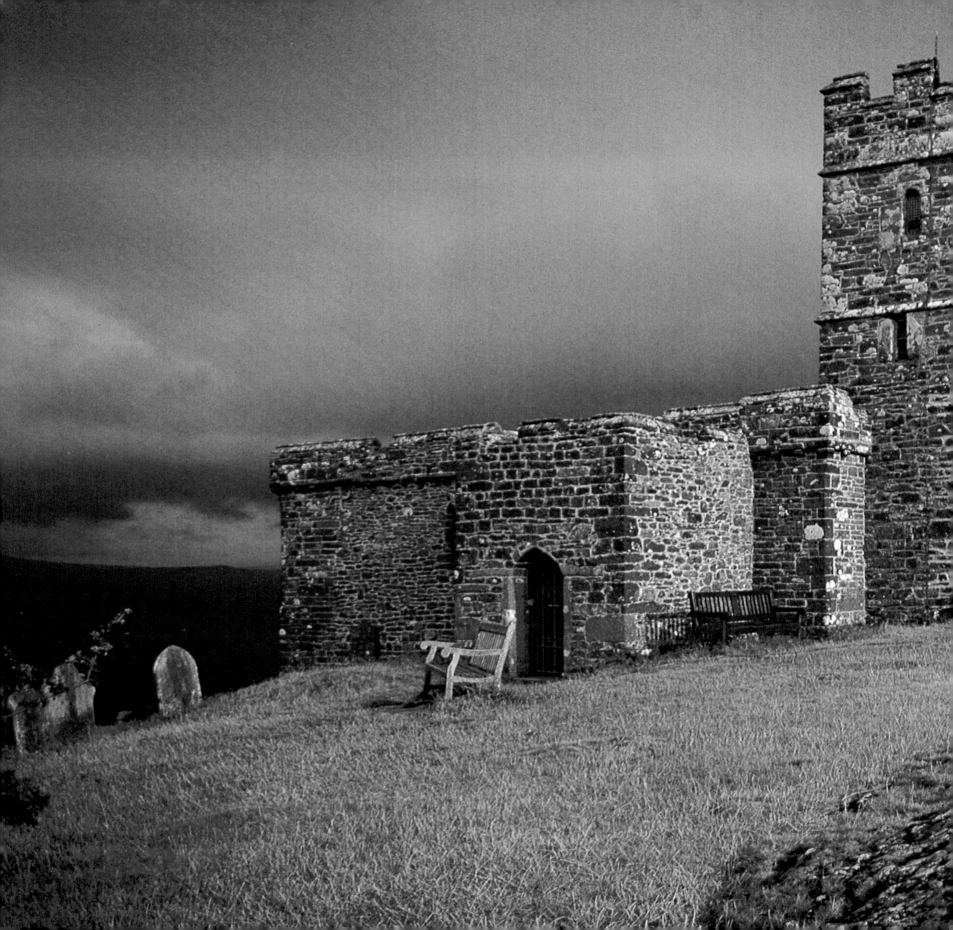

THE WORLD OF
35MM PHOTOGRAPHY

PEOPLE

The world of 35mm photography encompasses the full range of photographic endeavour: from the tiniest close-up to the infinity of space; from the candid snapshot to the carefully considered portrait.

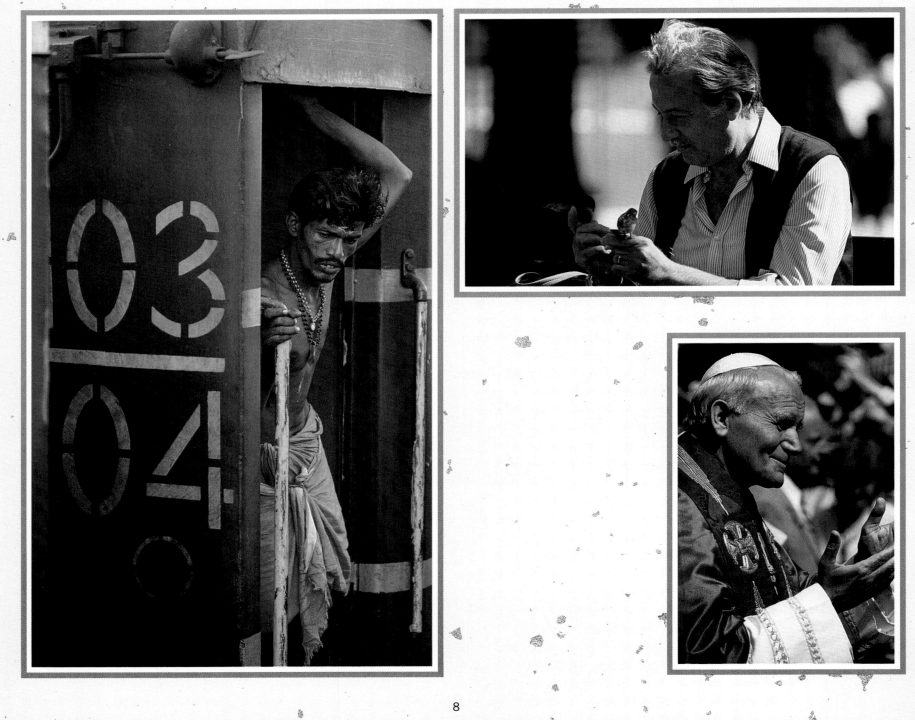

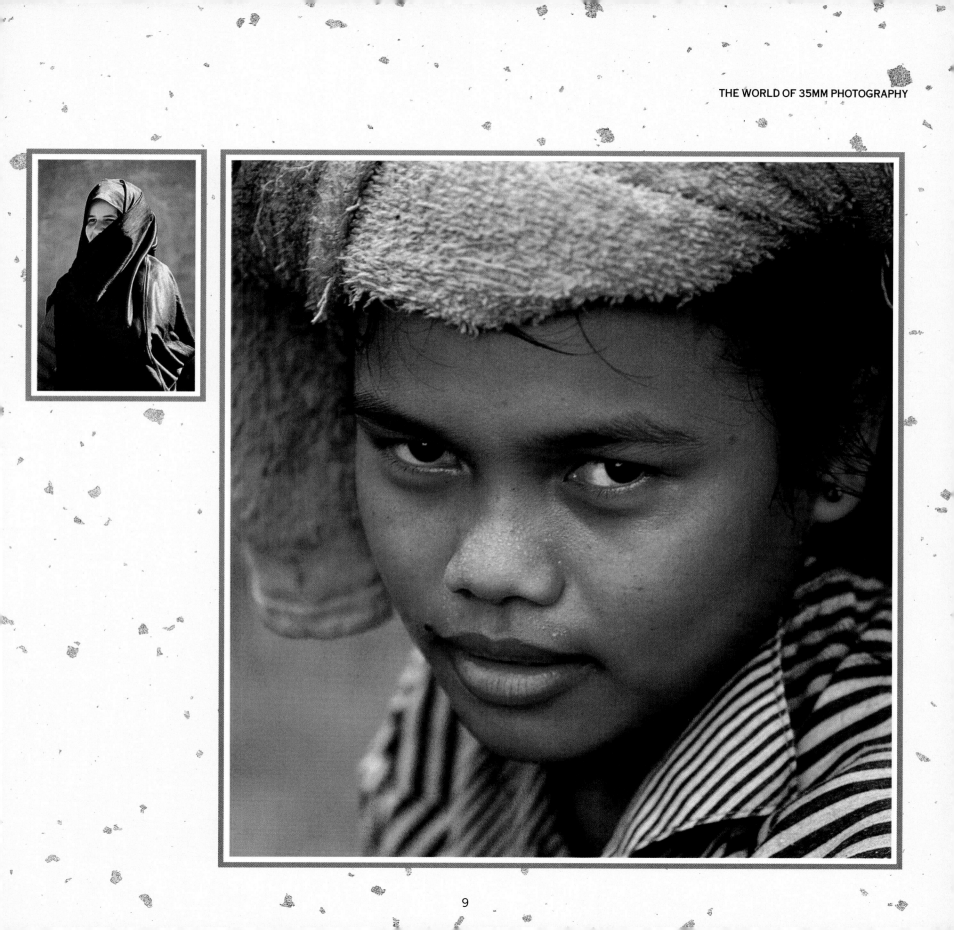

ACTION

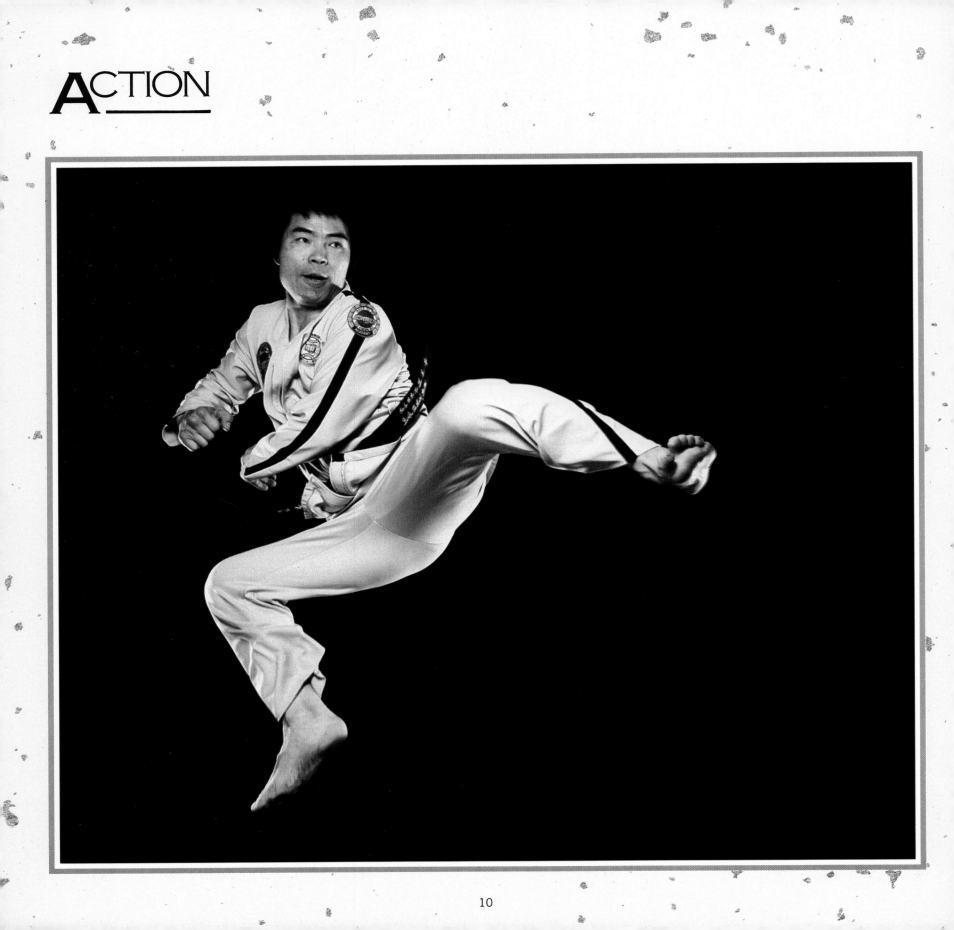

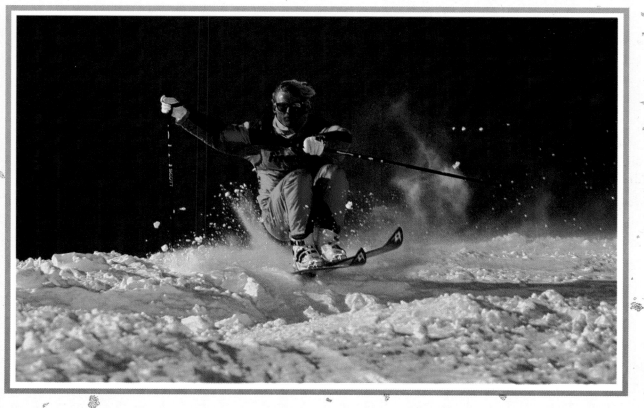

WILDLIFE

PLACES

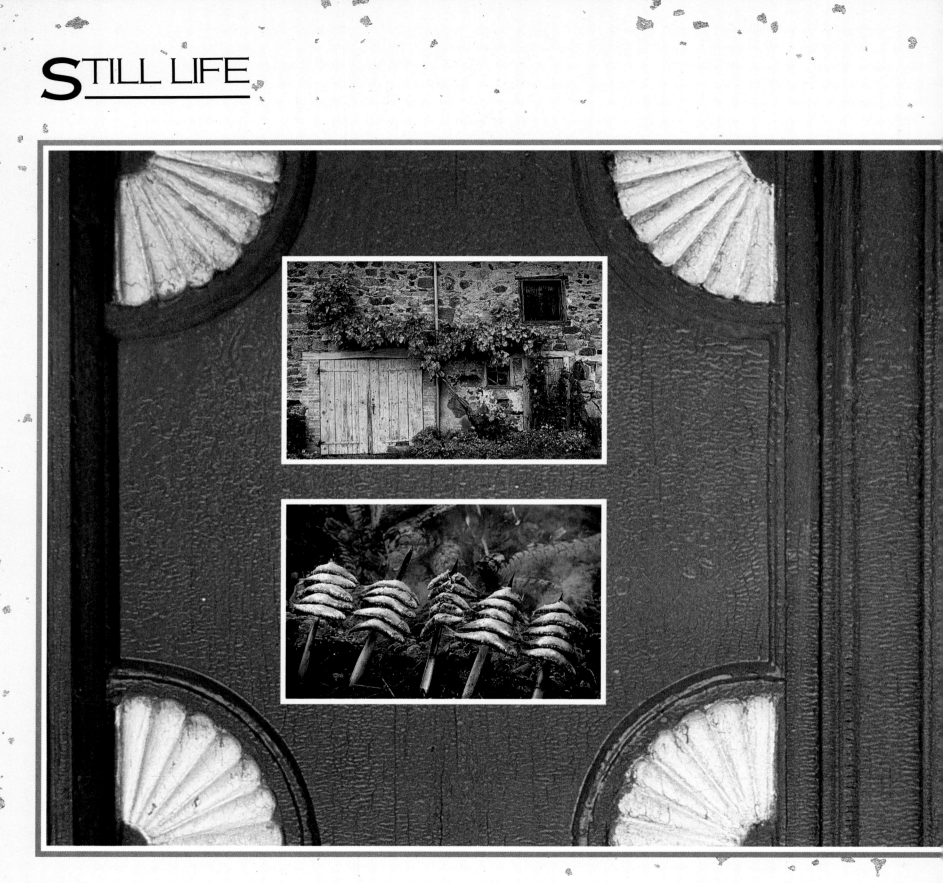

INNER AND OUTER SPACE

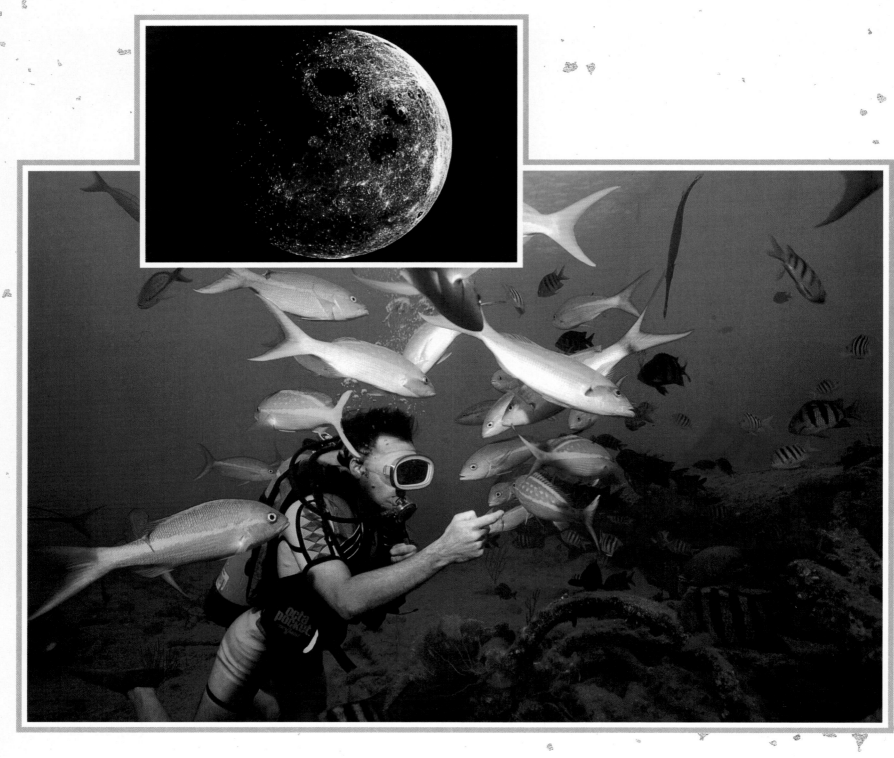

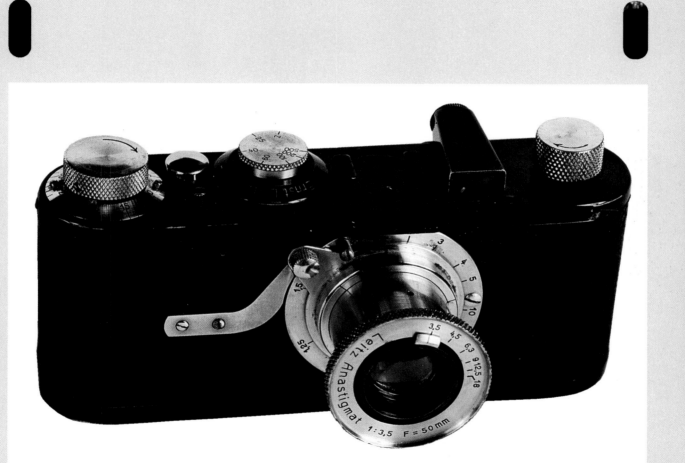

THE 35MM FORMAT

BEFORE THE 35MM CAMERA

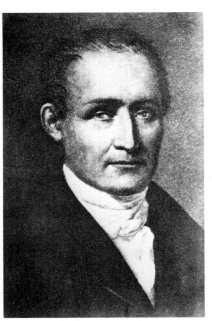

Nicéphore Niépce's first photograph (below) was made using a pewter plate coated with bitumen of Judea. To develop the image, he washed the plate with a mixture of gasoline and oil of lavender. The exposure, from a window of the family home, took eight hours; as a result, shadows appear on both sides of the yard.

Niépce (right) must be given the credit for the first photograph using a camera fitted with a lens, but the process he used was hardly a practical one. Photography as we know it began to evolve only when exposure times could be reduced from hours to minutes.

*I*n describing the development of 35mm photography, it is difficult to avoid using the word "evolution". Like animal species, some cameras and photographic processes thrived, while others became extinct. And today's "intelligent" single lens reflex cameras are perhaps the Camera sapiens of photography—a species refined by 150 years of natural selection.

It's easy to forget, though, that the 35mm format evolved nearly a century after the invention of photography. The various photographic technologies that made 35mm cameras possible appeared painfully slowly between 1827 and 1925.

For example, one of the characteristics that we associate with photography is the potential for making an infinite number of copies of the same original. Yet the first true photograph, made by Nicéphore Niépce in 1827, lacked this feature: it was a unique image—much like today's instant pictures—and to have made further copies, Niépce would have had to rephotograph the original picture.

The negative–positive process that makes possible multiple copies of photographs had to wait in the wings for twelve more years. In 1839, William Fox Talbot, an Englishman, used a tiny camera to make a negative image on writing paper soaked in light-sensitive silver salts. The negative recorded the brightest parts of the subject in dark tones, and the shadows as pale tones. Pressing this negative into contact with a second,

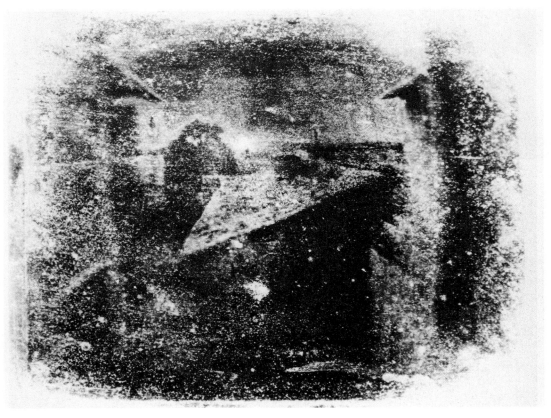

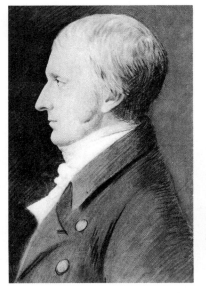

Thomas Wedgwood (left) noticed that light darkened silver compounds, and thus paved the way for the work of William Fox Talbot (right), who used tiny cameras (below) to make the first negatives.

similarly sensitive sheet, and shining light through the sandwich reversed the tones to create a positive print. Repeating the process made further copies.

Talbot wasn't the first to notice the action of light on silver salts; Thomas Wedgwood, the crockery heir, beat him to it by forty years. Nor was Talbot the first with a practical photographic process, either; a Frenchman took this prize just months earlier. But Talbot had the genius to bring together several elements to create the forerunner of the photographic process used in all today's 35mm cameras.

Many of the other elements that make up 35mm photography came from small improvements on age-old ideas. The camera itself was probably invented in the pre-Christian era, though a pinhole would have taken the place of a lens as the image-forming medium. The lens was added in the sixteenth century, and the camera—lens combination was progressively refined over the succeeding centuries. Well before Fox Talbot's time, it was possible to buy a reasonable camera (strictly speaking, a camera obscura) more or less ready-made.

Talbot's paper pictures were soon replaced by negatives on glass, and in 1889, Henry Reichenbach, an employee of Eastman Kodak, found a way to make flexible transparent film that could be coated with a light-sensitive layer of gelatine. Photography took one step closer to the form with which we are so familiar today.

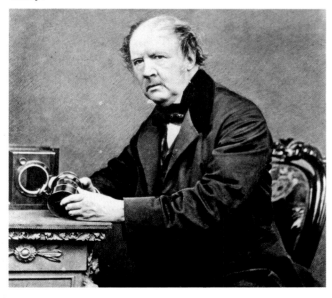

Talbot's first negative, of a lattice window (left), was made using a lens, but a lens isn't strictly necessary. The camera obscura (above) pre-dates photography by perhaps a thousand years, and forms images using a pinhole.

THE BIRTH OF 35MM

The phenomenal and enduring success of the 35mm camera can be attributed largely to the characteristics of the film format itself. But what is meant by "format"? Pick up a 35mm negative and a cassette of film, and take a close look at them. The film format consists of several different components: the most important is the width of the plastic strip, from which the 35mm format takes its name. There are other elements, though, that are equally important. Look at the perforations—their size, number and spacing are all part of the format. So is the shape of the frame, 24 × 36mm, or about $1 \times 1\frac{1}{2}$ inches. Finally, the cassette is crucial, because it's a standard size, which makes it suitable for use in any 35mm camera. It also has a light-trap to allow the film to be loaded in daylight.

These different elements came together in a sequence of events that was sometimes orderly, but often haphazard and coincidental. The width of the film strip illustrates this admirably. According to tradition, the width of 35mm film is derived from George Eastman's nineteenth-century factory in Rochester, New York. It was here that some of the first mass-produced photographic plates were made. Eastman coated light-sensitive emulsion on to the widest sheets of glass he could find, then repeatedly halved the glass plates in both directions, to make $\frac{1}{2}$, then $\frac{1}{4}$, then $\frac{1}{8}$ segments and so on. When flexible film replaced glass, the film sizes mimicked those of the glass plates, and 35mm is just an exact fraction of a full-width sheet of glass.

Eastman did not make the final division, though: his company, Eastman Kodak, supplied 7-cm ($2\frac{3}{4}$-inch) wide roll film for still cameras, and it was left to William Dickson, assistant to the movie pioneer Thomas Edison, to slit this strip in two and make 35mm wide film. Dickson also added the perforations, so that the new film size could be transported quickly and accurately through the first practical cine cameras. So both Eastman and Dickson contributed unwittingly to the 35mm still-camera format.

It was just a simple step from movie cameras to still photography, and there are many patents for still cameras designed for use with the 35mm movie film. Significantly, one of the first of these patents incorporated another crucial component of the format we know today—a magazine loading system. Three Spanish pioneers, A. Léo, P. Audobard and C. Baradat, took out

George Eastman (below right) was the founding father of popular photography, but his early contribution to the 35mm format was unintentional: by a quirk of history the dimensions of the glass plates used in his factory (below) eventually dictated the size of today's 35mm frame.

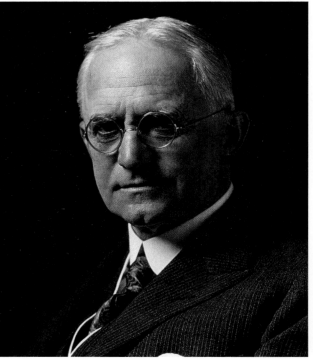

a British patent for this camera in March 1908, but apparently they never put it into production. The first 35mm camera to be sold was the American Tourist Multiple, which appeared in 1913. This took pictures 18 × 24mm (about ¾ × 1 inch) in size, the same size as the movie frames of that era. The camera contained enough film for 750 pictures—enough for "a complete European tour." Unfortunately, World War I called a temporary halt to American tourism in Europe, and production of the camera soon ceased.

The final element of the 35mm jigsaw—the frame size that's now so familiar—did not appear until 1923. In that year the Furet camera appeared in France, using a "double frame" format that is the same as today's 35mm picture size.

These early 35mm cameras were not commercially successful. They were often heavy and bulky, had fixed lenses and the controls were often awkward to use. Worse, few were made with sufficient precision to produce a good picture on the narrow strip of film, and none incorporated all the elements that are now associated with the 35mm format. Practical 35mm photography had to wait until 1925.

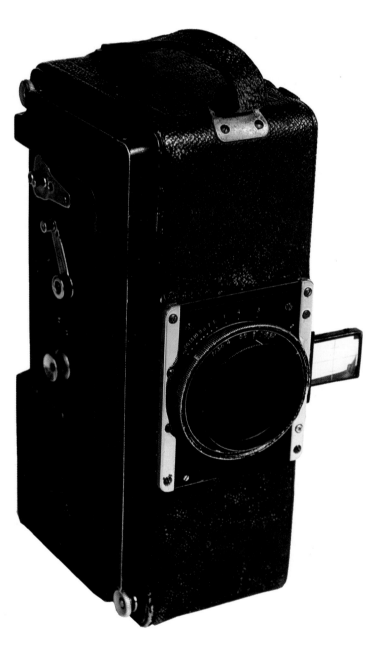

The Furet camera, introduced in 1923, was the first to use a full 35mm frame — earlier cameras crammed twice as many images on each roll. The camera is compact even by modern standards, and slips easily into a pocket.

The Tourist Multiple was the first still camera to use 35mm film, but it was not a great success. It was big and bulky and used very long rolls of film — few photographers wanted to take 750 pictures before processing the film.

THE ORIGINAL LEICA

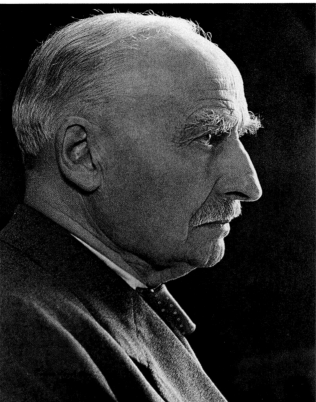

The genesis of the mass-produced 35mm camera took place in the German optical instrument factory (below) run by Ernst Leitz. Leitz himself (right) had the foresight to encourage one of his young engineers, who had produced a prototype for a compact and portable camera that was to become the Leica.

In the early years of the twentieth century, serious photographers had little choice but to use bulky, heavy cameras; though miniature cameras were available, many of them were no more than toys. In some applications, the size and weight of the camera were not important factors, but where portability was a priority, the choice of cameras was very poor indeed. It is therefore hardly surprising that the camera from which virtually all today's 35mm models are descended was developed by a mountaineer.

Oskar Barnack was an enthusiastic climber, and he longed to make a photographic record of his trips among the spectacular Alpine peaks. He was frustrated by the heavy, bulky photographic equipment then available, and when he joined the E. Leitz optical company in 1911, he set to work to find a better solution. Within a couple of years, he had crafted a compact and versatile camera. Barnack's prototype was small enough to fit into his pocket, yet was made with such precision that the pictures it produced could stand up to considerable enlargement.

The camera was very simple by today's standards. It had a collapsible lens to reduce bulk, with a pivoting cover that had to be swung into position to protect the

film from fogging when winding between frames. The shutter was crude, with a basic adjustment for spring tension to provide a narrow range of shutter speeds. Barnack loaded his creation with the "short ends" of 35mm cine film that were normally discarded by the film studios.

Despite the camera's simplicity, it caught the imagination of some of Barnack's colleagues, including Dr. Ernst Leitz himself. The Leitz company had never before made cameras for general use, but Dr. Leitz took Barnack's idea seriously enough to order thirty-one prototypes to be made for evaluation. Each one was individually hand made.

These cameras were called Leicas, from *Leitz Camera*, and although they had a mixed reception within the company, Leitz took the decision to go into full-scale production. In 1925 the Leica I was launched commercially at the Leipzig Spring Fair, and the 35mm camera as it is known today began its march into history. One thousand cameras were sold in the first year, and a succession of improvements and modifications soon established the Leica as a serious alternative to the roll-film and plate cameras which then dominated amateur and professional photography.

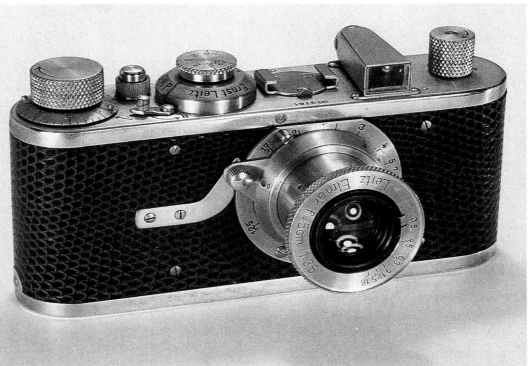

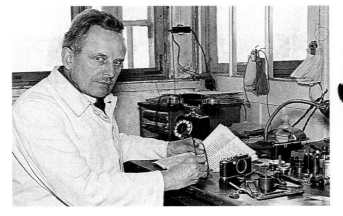

Oscar Barnack's philosophy was "Klein negativ, grosse bild": small negative, big picture. When he conceived the Leica he achieved the first objective, but large pictures had to wait: early 35mm film produced poor-quality prints when greatly enlarged.

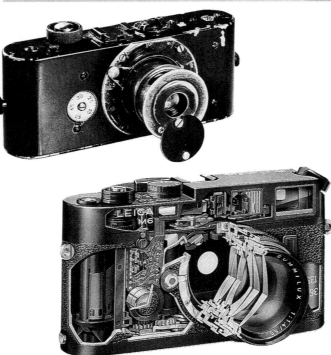

The Leica I is recognizably the great-grandfather of today's 35mm cameras. The film format was the now-standard 24 × 36mm (1 x 1½ inch), which the photographer pre-loaded into brass cassettes in the darkroom (commercially pre-loaded cassettes were a thing of the future). This system was an improvement on Barnack's prototype, which had to be darkroom loaded. The frame counter ran to 36 exposures, setting a standard that's still in use, and the accessory shoe has also been adopted as the universal size. Film advance was coupled to the shutter, so that turning the film-wind knob tensioned the shutter for the next exposure. The focal-plane shutter had speeds from 1/25 to 1/500 second, set on a dial on top of the camera. The 50mm f/3.5 lens was non-interchangeable, but telescoped down into the camera body to make the camera pocket size. The Leica viewfinder was a simple direct-vision type, and focusing was by guesswork. Rangefinders followed later.

THE FORMAT EVOLVES

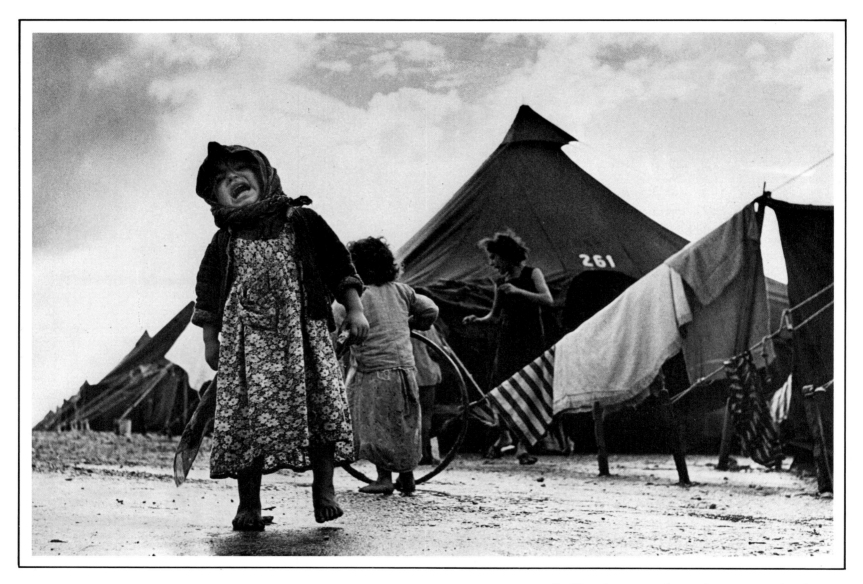

The 35mm format gave photographers a new way of looking at the world, and they were quick to grasp the potential of the medium. This image by Robert Capa epitomizes the unposed, informal style of reportage photography ushered in by the evolving 35mm camera.

*T*he Leica effectively established the 35mm standard, and the addition of interchangeable lenses and a rangefinder made the camera still more attractive. One camera couldn't hog the limelight forever, and within a few years other 35mm models appeared. All shared many of the features and characteristics of the Leica, including frame size and film length, and this standardization added to the momentum that the 35mm format was gathering.

In 1932, Zeiss Ikon produced a precision camera to rival the Leica. The Contax was more boxy in shape, but it had a similarly wide range of interchangeable lenses and a rangefinder coupled to the movement of the lens, which meant that focusing was quick and accurate. In addition, the Contax had a top shutter speed of 1/1000 second: fast enough to freeze really quick movement.

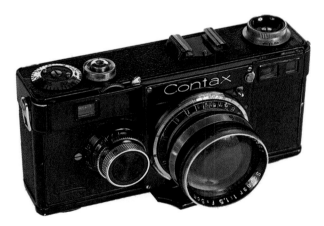

Throughout the 1930s and 40s, the two cameras were widely modified and improved, and the 35mm format gradually built up a following among the world's press. Unlike many cameras of the day, 35mm models were quiet and inconspicuous; they could easily be held in the hand; and the range of lenses effectively provided photographers with new ways of looking at the world. Among publishers there was initially some resistance to 35mm pictures on the grounds of quality and, to a certain extent, this remains true today. For news images, however, immediacy and speed is more important than fine definition.

One of the early pioneers of 35mm was the photographer Erich Salomon. He was a well-placed German lawyer, trusted and respected by the German upper class, whom he photographed at work and at play. He established his reputation as a photographer with an extraordinary series of candid pictures, notably of prominent politicians, taken using an Ermanox plate camera. But he found the Leica easier to use, and enthusiastically adopted it in 1932.

Salomon's 35mm work in turn influenced the young American photographer Alfred Eisenstaedt, who, along with others, began to exploit the unique possibilities of the 35mm format. He developed a very loose style of picture taking, in marked contrast to the carefully considered approach that more cumbersome cameras imposed on their users. Eisenstaedt shot pictures in rapid succession, taking full advantage of the 36-exposure length of the new format; roll-film cameras had to be reloaded three times as often, and plate cameras after every picture. He didn't confine himself to the central theme of the event he was covering, but also photographed small details that provided a greater insight into the principal action. With larger cameras, such an approach would have been too time-consuming and too expensive in terms of film.

Many other press photographers shared Eisenstaedt's enthusiasm for the 35mm camera, including Henri Cartier-Bresson, André Kertész, and some of the photographers involved in the Farm Security Administration project in the United States. It was World War II, however, that really established the 35mm camera as the standard for news and reportage pictures. For combat photography, larger formats were simply too cumbersome, and Robert Capa, Eugene Smith and David Douglas Duncan quickly demonstrated that the small negatives could produce pictures every bit as powerful as images shot on roll or sheet film.

THE SLR

*E*arly 35mm cameras were all of the direct-vision type: they incorporated a viewfinder separate from the main lens that took the picture. Since the viewfinder and the picture-taking lens were a couple of inches apart, each showed a slightly different view of the subject. For distant subjects shot with standard lenses, the difference was insignificant, but close subjects and long focal length lenses created framing and focusing difficulties.

This problem was solved for other formats very much earlier in the history of photography. In Thomas Sutton's 1861 camera, an internal diagonal mirror directed image-forming light from the lens up to a ground glass screen so that the photographer could compose the picture and focus the image. When everything was ready, the mirror swung up out of the way and the light exposed the photographic plate. Since light travelled the same distance to reach both plate and screen, the image on each was identical: when the picture was in focus on the ground glass, it was sure to be sharp on the plate.

Sutton's single lens reflex design thus solved the problems of focusing and framing, and the idea was applied to the 35mm format in the early 1930s. The first 35mm single lens reflex, or SLR, was the Russian "Sport" camera, which appeared around 1935, and in

meant that the viewfinder went blank when the picture was taken. Also, the image in the viewfinder was reversed left to right, making composition difficult.

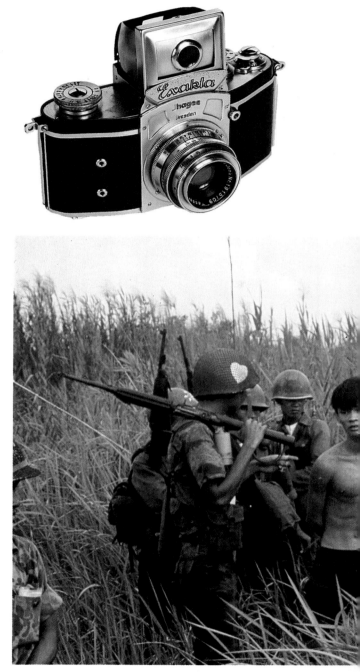

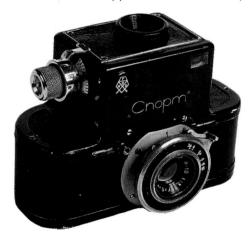

1936 the Kine Exakta was introduced. Although this camera was a true SLR design, it was nowhere near as easy to use as its modern counterpart. The mirror sprung up when the photographer pressed the shutter release, but didn't return until the film was wound on—this

These apparently simple problems took many years to resolve, and it was not until the late 1950s that the 35mm SLR developed into the camera that we know today. In 1957, the Japanese Pentax appeared with an instant-return mirror and a prism viewfinder that showed the subject the right way round.

Other SLRs added sophistication to the Pentax design, but the single feature that won most professional press photographers over to the SLR was probably the motor drive, pioneered by Nikon in the early 1960s. This unit was initially supplied as a motorized back and base that replaced the standard camera back. The photographer carried a heavy battery pack in the pocket, and a cable linked this to the camera.

The motor took the advantages of the 35mm format to the logical extreme. With a motorized SLR, photographers had the ability to shoot several pictures a second, and—perhaps more important—they could

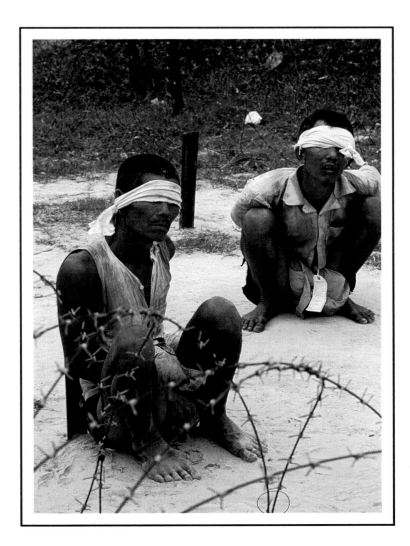

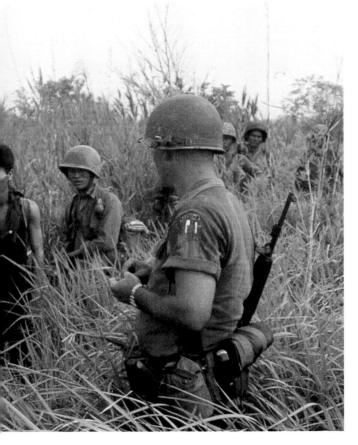

advance the film without taking their eyes off the subject.

Other manufacturers found it hard to follow Nikon's innovation, and the camera soon became standard issue for much of the world's press. But just as it took a war to establish the Leica, so, too, did a major international conflict consolidate the Nikon's reputation: in the jungles of Vietnam its rugged, modular construction endeared the Nikon camera to such photographers as Larry Burrows, Tim Page and Don McCullin.

Photography of the Vietnam War did much to turn the tide of public opinion, and thus indirectly end the conflict. Rugged, motor-driven 35mm cameras were the work-horses of the photographers who brought back graphic images of the suffering and horror of modern warfare.

CAMERAS FOR EVERYONE

What is this Miniature Photography?

More and more people are using 'miniature precision' cameras and discovering that there's practically no limit to what they can take. For real precision combined with *low price* there's nothing to touch the 'Retina,' made by Kodak. Simple to use—but its very fast lens and multi-speed shutter can give you all sorts of unusual photographs. Sharp pictures, say, of an aeroplane speeding just overhead—snapshots in almost any weather—indoor pictures—rapid movement—close-ups as near as 3½ feet. The film to use is Kodak 'Panatomic' Film in 36-exposure cassettes (costing only 3/6); it is specially good for fine clear enlargements. Get the 'Retina' and see what a camera *can* do!

Prices, according to lens and shutter, £10.10.0 to £14.0.0

RETINA
made by
KODAK

Kodak Limited, Kingsway, London, W.C.2

To a public brought up with cameras the shape of shoe boxes, the small 35mm cameras came as a shock. So too did the price—precision 35mm cameras were the exclusive province of the wealthy. Inexpensive mass-produced cameras, pioneered by the Kodak Retina and others, did much to popularize the 35mm medium.

The size and weight advantages of the 35mm camera made it attractive in the 1930s and 40s not only to professional photographers, but to amateurs, too. However, few could afford the precision of the German Contax and Leica: when the Leica was first introduced, it cost the equivalent of six weeks' wages for a skilled manual worker. It was clear that a cheaper alternative was needed to really popularize the 35mm format.

There was a problem, though: precision. By the 1930s, photography was already an immensely popular hobby, but most amateurs used simple roll-film cameras that produced big, postcard-size negatives. Because of the large film size they used, these box cameras were simple to manufacture, easy to use and almost indestructible. They could be made from just about anything, and even cardboard box cameras of that era still take acceptable pictures today. By contrast, the smaller 35mm format had to stand up to enlargement (box camera pictures were just contact printed), so lenses had to be better and the camera body itself needed careful design and manufacture.

Plastic, the new wonder material, came to the rescue, and in 1936 the International Radio Corporation of America launched the Argus Model A camera made of Bakelite and metal. At $9.95, the camera was an instant success, selling 30,000 in a few weeks. The Argus still wasn't a cheap camera, though, and a plastic roll-film box camera of similar specification sold for just one dollar.

Kodak then manufactured a camera called the Retina, which was somewhat more expensive. This camera was similar in construction to a folding roll-film camera of the time, in that the lens popped out of the camera on a cantilever arrangement, but folded back under a flap when out of use. The Retina cameras cost about the same in real terms as a mid-range SLR camera today, and sold in enormous numbers—over 250,000 in five years.

One factor that served to boost the fortunes of the Retina was the simultaneous introduction by Kodak of disposable 35mm film cassettes. This innovation made darkroom film loading unnecessary, in keeping with George Eastman's slogan: "You press the button, we do the rest." The Kodak cassette fitted existing 35mm cameras and it immediately became a *de facto* standard, resisting attempts by other manufacturers to introduce their own (arguably superior) cassettes.

After the war, technical innovation and design changes took 35mm photography further down market. Folding designs gave way to rigid-bodied cameras; better films made picture taking more reliable, even in dull light; and the introduction of automatic exposure control, even on cheap cameras, meant that more pictures per roll were successful.

The 1960s, 70s and 80s saw the introduction of various "foolproof" formats aimed specifically at the non-technical amateur. 126 Instamatic film introduced drop-in loading cartridges; this was followed by the smaller 110 size, and finally by disc film. These new formats only temporarily interrupted the dominance of 35mm as the most popular film size for the snapshooter and, today, the 35mm "auto-everything" camera offers a virtually foolproof picture-taking machine, at a price that is a bargain by any standard. The first Kodak snapshot camera cost the equivalent of two months' wages in 1888; today, a motor-driven autofocus 35mm camera costs little more than a day or two's labour.

Portability and ease of use were the key attractions of the first cheap 35mm cameras, so early advertising photographs such as these stressed outdoor views and spontaneous family subjects.

FILM AND LENSES - 1

*T*he evolution of the 35mm camera is inextricably linked with progress in optics and film technology. Of course, this is true of any film format, but especially so of 35mm. Larger formats of film need less enlargement. In the darkroom this meant that the photographer could close in on just a small portion of the negative, eliminating superfluous detail around the edges. With 35mm, this was impractical; early films were of such poor quality that even an enlargement of the whole frame showed pronounced grain.

For this reason, 35mm photographers were, from the start, compelled to use the whole frame rather than relying on cropping and selective enlargement. This in turn meant that a good range of lenses was vital for the success of 35mm, and recognizing this, both Leitz and Zeiss introduced a wide choice of interchangeable lenses early in the history of the Leica and Contax cameras.

Maximum aperture—a measure of how much light passes through a lens to reach the film—was especially important. Early films were not very sensitive to light, which made photography in dim conditions difficult. The first colour films were especially slow, or lacking in sensitivity, and, in response, lens manufacturers competed feverishly to offer the fastest possible lens, at whatever price. The Leica model I had a fixed *f*/3.5 lens, but by the early 1930s, there were *f*/2 lenses available, which admitted 150 per cent more light. By the start of the war, maximum apertures of *f*/1.5 were commonplace—though outrageously expensive.

During and after the war, lens manufacturers worked on new methods and materials for coating lenses to reduce reflections where glass elements, both internal and external, met the air. Unless controlled, these reflections cut the amount of light reaching the film, and placed an upper limit on lens complexity. By the late 1940s, coating had made possible much more sophisticated lenses with wider angles of view and larger maximum apertures.

Coating was crucial for the designer of SLR lenses. In a rangefinder such as the Leica, the rear lens element can be just a short distance from the film, but in an SLR, such a lens position would obstruct the swinging mirror that reflects the image to the viewfinder. SLR lenses, and wide-angles in particular, are therefore very much more complex than corresponding lenses for non-reflex cameras.

The advent of digital computers in the 1940s, and their wider availability in subsequent decades, provided a tremendous boost for the sophistication of 35mm camera lenses. Lens designers must calculate the path of dozens of rays of light through the lens to the film, and an additional lens element adds two further calculations for every ray. When lenses were designed using mechanical calculators and log tables, ray tracing for even simple designs was extremely time-consuming. Digital computers, allied to new coating techniques, at last made possible exciting breakthroughs in 35mm optics.

These innovations pushed out the extremes of 35mm format—photographers could "pull in" more distant detail; they could take action pictures in dimmer light; and they could cram the camera ever closer to the subject to create dynamic, unreal perspective. The ripples spread throughout every field of photography, but, looking back, the impact on photographic style was greatest in the areas of sports, reportage and fashion.

The most radical effect of the computer was to make the zoom lens a practical proposition. The first zoom lens for 35mm cameras was the Voigtlander Zoomar of 1959. This lens was limited by its restricted focal length range—36 to 82mm—and by the fact that it was sharp only at certain subject distances. Nevertheless, the Zoomar set the scene for the sophisticated zoom lenses that 35mm SLR users today take for granted.

Better film

The introduction of "modern" colour film coincided neatly with a period of rapid development in 35mm cameras. Kodak introduced Kodachrome movie film in 1935, and a 35mm still-camera version a year later. Around the same time, Agfa brought out Agfacolor Neue. These were not the very first colour films, but they were certainly the first that could be loaded into an unmodified 35mm camera and exposed just like black and white film.

This early colour film was painfully slow by today's standards, but was fast enough to permit hand-held exposures in good light at moderate apertures. Fast lenses extended the useful range of the films.

Both the Agfa and Kodak film were of the reversal type, producing, after exposure, colour transparencies for projection. Although prints are now by far the most popular form of colour pictures, the novelty of colour in the 1930s was so great that projection hardly seemed an inconvenience. In 1938, Kodak further popularized their film by returning processed pictures in the now universal 2-inch square mounts.

Professional photographers were quick to exploit the new colour materials, both when on commercial assignment and in their personal work. Pete Turner and Ernst Haas in particular were leading exponents during the infancy of 35mm colour.

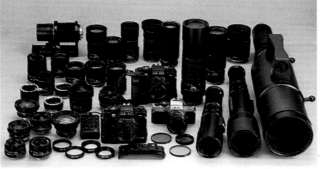

Manufacturers of 35mm cameras were quick to recognize the value of interchangeable lenses, and modern systems offer a vast range. Zooms take the place of two or three lenses in the camera bag, but they're a comparatively recent innovation — the first (left) became widely available only in the 1960s.

Kodak and Agfa brought out 35mm colour film (above) almost simultaneously in the 1930s.

FILM AND LENSES -2

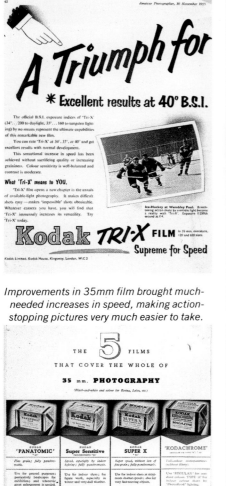

Improvements in 35mm film brought much-needed increases in speed, making action-stopping pictures very much easier to take.

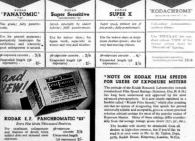

The first 35mm colour films were rushed to the market under tremendous commercial pressure, and though they initially yielded lifelike, attractive colours, chemicals that remained after processing quickly caused the images to fade. This picture, taken on Kodachrome in 1939, has lost virtually all yellow and cyan dye.

Changes in processing remedied the shortcoming of early batches of colour film, and Kodachrome soon developed a following of photographers who were attracted by the vibrant colours. By 1941, when this picture was taken, fading was less of a problem: hues are just a little muted four decades on.

Increased film speed has traditionally been associated with poorer image quality: fast film needs larger grains of silver salts to intercept the reduced amounts of light. Film choice was thus a matter of compromise: you could have fast film, or high-quality images, but not both. Tabular grain technology, introduced by Kodak in 1983, gave the photographer the best of both worlds, as these greatly enlarged cross-sections show. On the (far left) is old-style film, with roughly cubic grains. Tabular grains (near left) are more like plates, with their flat surfaces facing the light.

Subsequent changes in film and processing made Kodachrome the most stable of all colour films. This image shows no fading after twenty years and, stored in the dark, colours should remain bright for another century.

After the war, the first colour print film appeared, and by the end of the 1940s, this film was eclipsing 35mm slide film in popularity. Film speed was increasing, too, both for colour and black and white. Kodak's Tri-X film appeared in 1954, with a speed of 200 ASA, and the speed of colour slide film had increased to 32 ASA.

The process of refinement and improvement continued throughout the 1950s and 60s, but the introduction in 1977 of high-speed (400 ASA) colour print film proved to be a milestone not only for film but also in 35mm optics. Even faster film meant that the lens designer was under less pressure to increase maximum apertures and, since 1977, the emphasis in SLR lens design has shifted more towards lighter, smaller zooms with a greater focal-length range, at the expense of a smaller or variable maximum aperture.

The most recent development in 35mm film technology has been the manufacture by Kodak in 1983 of "tabular" grains with increased light-gathering power. This innovation has been described without exaggeration as the most significant breakthrough of the last fifty years; tabular grains make possible a doubling of film speed with no sacrifice of quality, and the new generation of emulsions comes very close to ending the quest for an "all-purpose" 35mm film.

THE RISE OF AUTOMATION

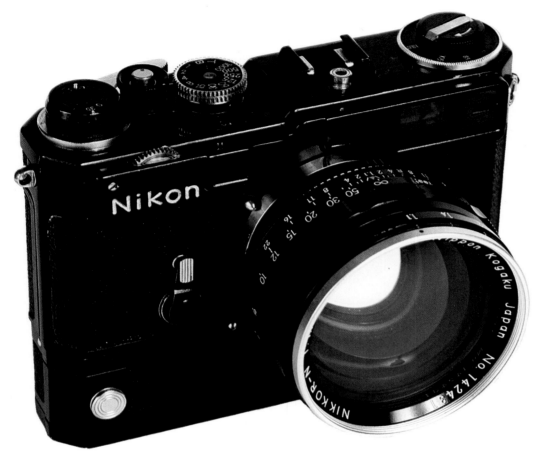

Rangefinder focusing hardly seems like an innovation today, but it was a breakthrough when it was first introduced. Turning a single wheel on this camera adjusts the lens, and simultaneously permits the photographer to measure the subject distance by aligning two displaced images in the viewfinder. The earliest rangefinders were non-coupled: you aligned the two subject images, read off the distance on a dial, and transferred the setting to the lens.

The first 35mm cameras were entirely manual—the photographer set each control individually. This was obviously very time-consuming, and an early development was to link the camera's rangefinder to the focusing ring. Looking through the viewfinder, the photographer saw a double image when the subject was out of focus. Turning the focusing control brought the two images together; when only one image was visible, the picture was sharp on the film.

Exposure automation was slower to appear. Though there were clip-on and built-in exposure meters as early as 1935, these offered few advantages over separate, hand-held meters, and they were not coupled to either the shutter speed or aperture. Part of the problem was size: in early electric exposure meters the light-sensitive cell had to be large in order to work properly in dim light.

In the 1960s, though, the cadmium sulphide, or CdS, cell appeared. This new light-sensitive element responded more rapidly than older photocells, but, more important, it could be made very much smaller. Manufacturers rushed to build CdS meters into new cameras, or to add clip-on meters to existing models. Nikon were the first to link the meter to both shutter speed and aperture, using a coupling prong on the aperture ring, and a pin protruding from the camera's metering prism. The meter cell was still on the outside of the camera, though, and only when Pentax produced the prototype Spotmatic camera in 1960 did through-the-lens, or TTL, metering become a reality.

TTL meters made the camera quicker to use and exposure more accurate. They were especially useful in the fields of close-up photography, where they eliminated complex exposure calculations, and with telephoto lenses, where an ordinary meter often measured light from too large a part of the subject.

Full exposure automation was a logical and perhaps inevitable step. It appeared first on the cheaper 35mm cameras, which were mechanically simple, and only later on the more complex SLRs. Today, all but a few 35mm cameras have a fully automatic exposure meter coupled to both shutter speed and aperture, so the controversy caused by this feature in the 1960s now seems hard to understand. Nevertheless, there was considerable resistance to exposure automation among professional photographers and, even now, 35mm camera models aimed at professionals still retain the option of total manual control.

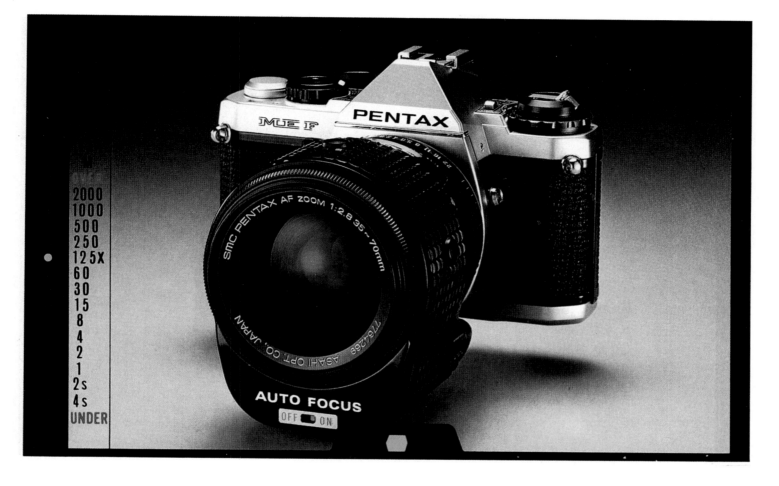

Front focus

Back focus

Correct focus

The debate caused by exposure automation has found an echo recently with the introduction of automatic focusing. Again, this appeared first on a snapshot camera, the Konica C35AF, in 1976. Konica achieved this world first using an autofocus module supplied by the Honeywell Corporation, and the same device was incorporated as an external autofocus unit on some SLRs. Technical problems prevented the installation of through-the-lens autofocus systems until 1981, when Pentax introduced the ME-F camera.

Full automation of exposure became practical only when the transistor appeared. Autofocus had to wait for the integrated circuit. Perhaps the next generation of 35mm cameras, with undreamed of sophistication, will appear when optical computing sweeps away today's lens technology.

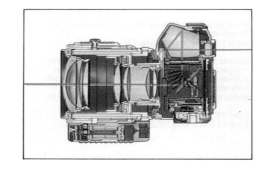

In their infancy, SLR autofocus systems were slow, and worked well only in comparatively bright light. The autofocus module also added considerably to the size and weight of the camera, as the cross-section (left) illustrates. With non-motorized lenses, the camera provided focus confirmation as the photographer rotated the focusing ring.

THE PAST—AND THE FUTURE

 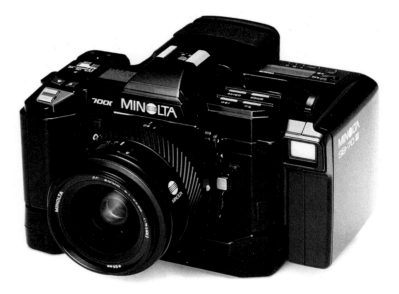

Electronic photography seems unlikely to displace conventional 35mm film in the immediate future, but will tomorrow's cameras borrow from both technologies? This camera back is perhaps a pointer to what the future may hold: a relay lens projects the image from a conventional camera on to a charge coupled device. This digitizes the image, which is stored on a floppy disc much as videotape stores moving pictures.

Progress in camera and image-making technology is so rapid that attempts to define the 35mm camera of tomorrow inevitably look ridiculous a decade later. However, it seems certain that many of the changes that are taking place today will continue for some time to come. But how far they will change the shape of 35mm photography remains to be seen.

Current trends suggest that externally, tomorrow's 35mm camera will be more rounded than today's, with smoothly sculpted body mouldings uniting the separate components into a more integrated form. With continuing improvements in the technology of plastics, still more of the camera's parts will be moulded from this material, and the use of metal will be confined to those parts of the camera that bear intense loads, are under constant friction, or where precision is of paramount importance.

The impact of electronics has so far been most noticeable on the automation of camera functions, with the introduction of autofocusing and sophisticated exposure programs. This trend seems set to continue, but the actual process of image formation is still firmly rooted in the silver halide technology pioneered by Fox Talbot and Daguerre in the mid-nineteenth century. A few manufacturers have shown prototypes of electronic imaging systems, and some of these are already on sale, but none can yet produce an image that even approaches the quality of 35mm film. This is hardly surprising. At a conservative estimate, a single 35mm transparency is capable of storing as much information as one high-density floppy disc for a personal computer. Existing electronic still cameras cram up to 50 images on a disc with even less storage capacity, and quality inevitably suffers. While advances in electronics are sure to narrow the gap, research into conventional photo-technology will also continue, thus maintaining the lead that 35mm has over solid-state imaging.

Ironically, rather than sweeping away 35mm film, electronics may even give the format a new lease on life. For more than a decade image enhancement systems have been used to improve the sharpness of strategic images, such as satellite pictures, and this technology is easy to apply to a 35mm frame. Enhancement techniques can hide inaccurate focusing and camera shake, and make far greater use of the information storage capacity of film. Hybrid systems may well hold the key to the future, with 35mm negatives being scanned and digitized, electronically manipulated and printed out using laser-scanning techniques again—but on to conventional photographic paper.

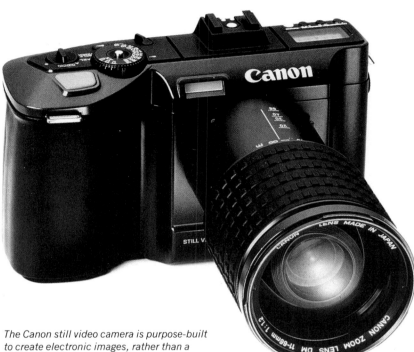

The Canon still video camera is purpose-built to create electronic images, rather than a hybrid of conventional and video technologies.

The shape of traditional cameras was constrained by the functions of the components inside, and by the mechanical qualities of the metal from which the camera body was made. Plastics and electronics have swept away such limitations, and the 35mm cameras of today increasingly resemble yesterday's futuristic prototypes.

Image enhancement can be considered as an extension to conventional photography. Indeed, some people have described the technique as the "electronic darkroom" where pictures can be improved by manipulating electronic signals provided during scanning of the original picture. The far left enlargement was made in the conventional way from a tiny part of a negative exposed under adverse lighting conditions. The print on the left was enhanced to improve tone and colour reproduction, to increase sharpness and reduce graininess. At present, image enhancement is confined to the research laboratory, but in ten years this procedure could become almost routine.

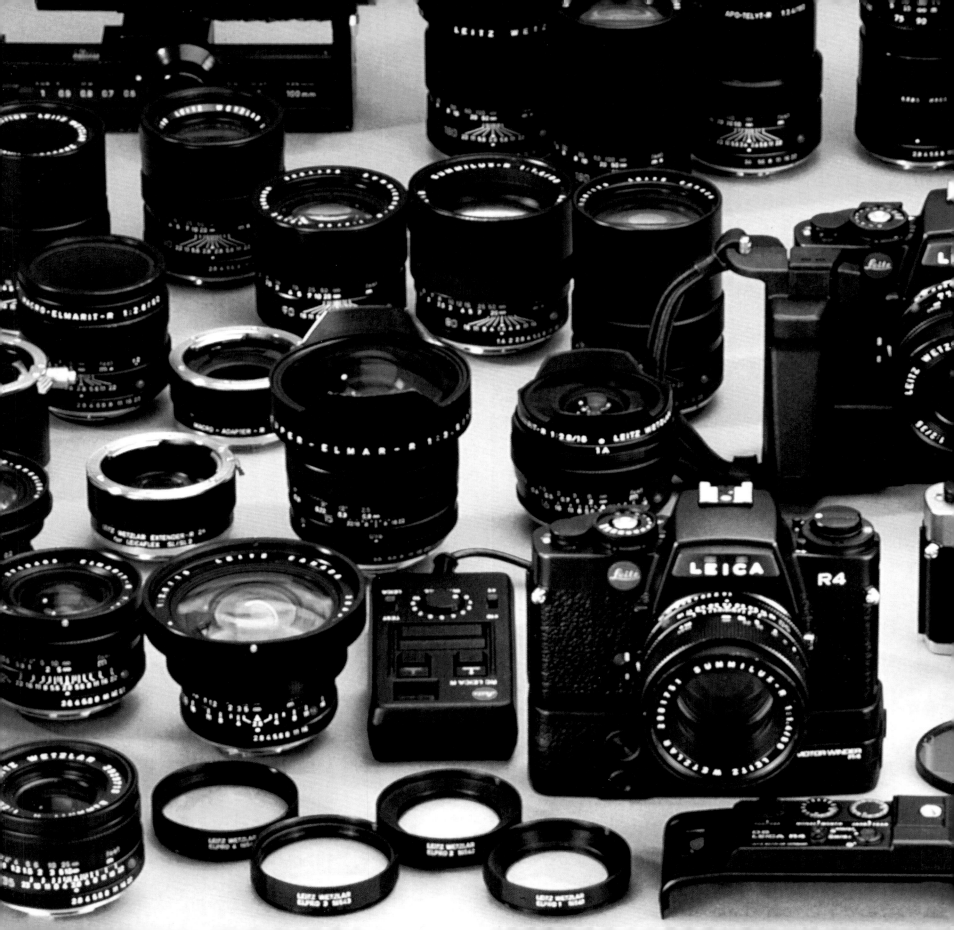

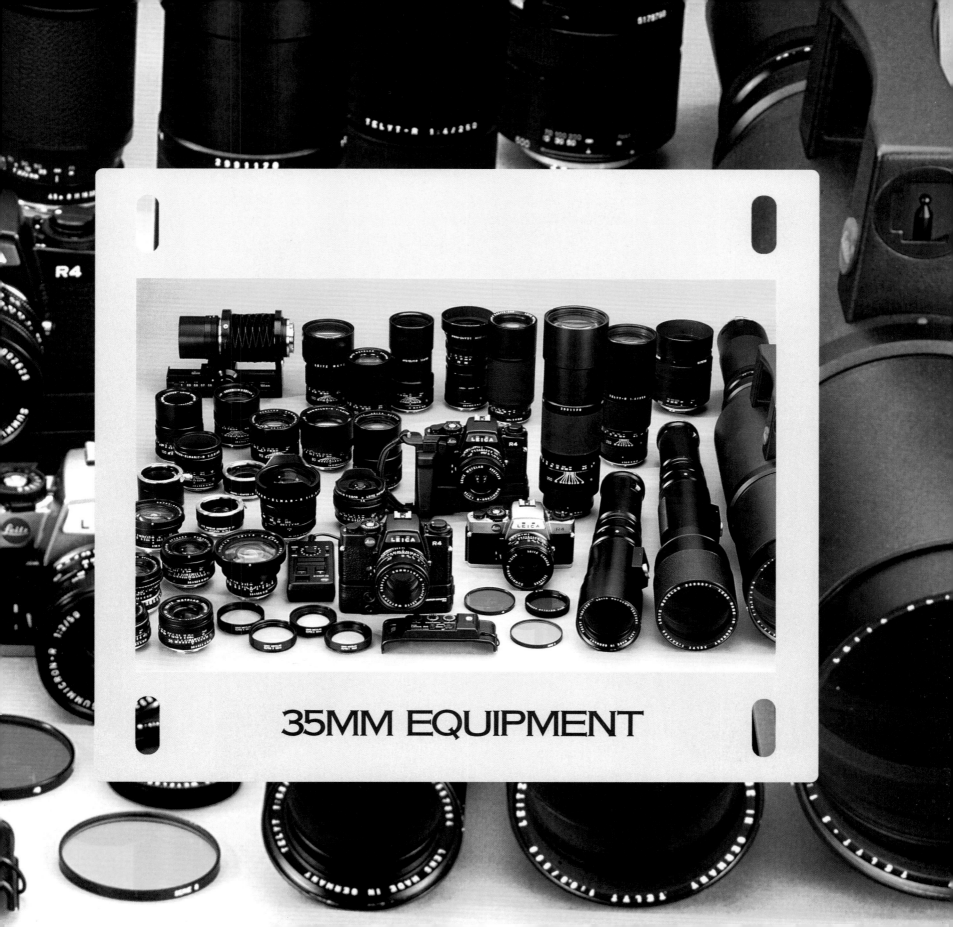

35MM EQUIPMENT

THE MODERN SLR-1

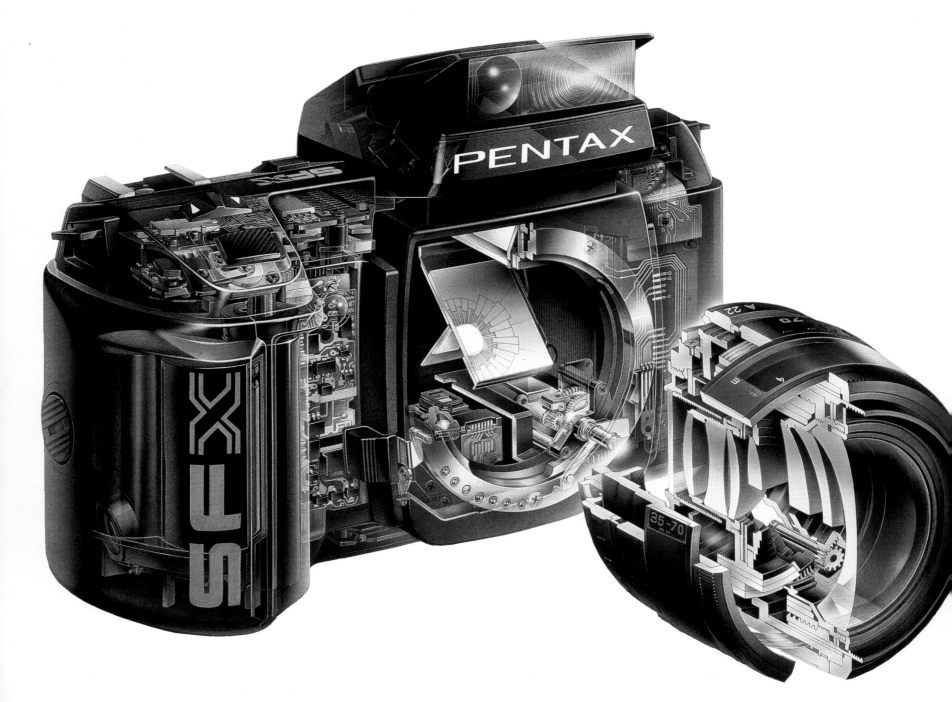

*T*he 35mm single lens reflex, or SLR, camera represents the pinnacle of small-camera design. The modern SLR is an enormously sophisticated picture-taking machine. Yet, to the photographer, the complex actions that take place in the heart of the machine are completely transparent. There is nothing to get in the way of creative picture taking. Let us take a look at what happens when you pick up a modern SLR.

Dropping in a cartridge of film and closing the camera back initiates a series of electrical and mechanical operations that prepare the camera for use. An integrated motor winds the film to the first frame, and a series of contacts in the cassette chamber "read" information about the film from a black and silver chequer pattern on the outer casing of the cassette. The simplest cameras pick up only film speed (its degree of sensitivity to light) from this "DX code," but the pattern also carries data about film type, the number of frames on the roll, and the amount of leeway for exposure error.

Lightly pressing the shutter release triggers another sequence of electrical and mechanical activity. The image from the camera's lens falls on a row of light-sensitive cells in the camera base. By analysing the signals from each cell, the camera determines whether the subject in the middle of the viewfinder is sharp. If it isn't, a tiny motor racks the lens back and forth until the picture is clear.

While this focusing action takes place, the camera also measures the brightness of the scene. Many cameras take measurements from five or more areas, and compare the pattern of results with a stored list of typical scenes, in order to determine the correct exposure. This "intelligent" system helps the camera to compensate for difficult subject conditions, such as backlighting.

After measuring the brightness of the scene, the camera uses more stored data about other factors before setting the shutter speed and aperture to appropriate values. The list is long: the camera takes into account the lens fitted; the film speed; the exposure "mode" chosen by the photographer (see pages 58-9); and perhaps whether the user has manually set the camera to provide a degree of under- or overexposure. Only after considering all these factors does the camera make a decision about exposure.

All this activity takes place in the blink of an eye, and far quicker than even the most adept photographer

Choosing an SLR camera

How do you pick a camera from the vast range available? Bear these points in mind when buying:

● **Make**
Cameras from the best-known manufacturers are expensive for a good reason: compared with lesser brands they are usually better made, become obsolete more slowly and are easier to repair.

● **Model**
Don't buy more sophistication than you need: most people rarely use more than one exposure "mode."

● **Lens availability**
Is there a good range of lenses available? Must you buy them from the camera manufacturer, or are (cheaper) lenses available from independent makers?

● **Automation**
Look for manual override—sometimes you will want to

control every element of the picture yourself.

● **Proven technology**
Cameras that have been available for a while may be less exciting than today's newest models, but rely on proven technology.

● **Adaptability**
System SLRs can be adapted to suit a wider range of picture-taking situations, as explained on the next page. However, such adaptability is costly to build in, and it is wasted if you just use the camera for snapshots.

● **Lenses**
A mid-range zoom lens, such as a 35–70mm, is little bigger than a standard 50mm lens, and provides far more versatility.

could set the controls manually. Furthermore, the camera keeps repeating all these processes right up to the moment when the photographer presses the shutter release down to initiate exposure.

This action "freezes" the focusing and exposure settings and triggers more tiny motors. The viewing mirror rises, the iris diaphragm in the lens closes down to the selected aperture and the shutter opens. After a precisely timed exposure, the shutter closes again to prevent light reaching the film, the iris diaphragm opens up, the mirror drops back into position and the film advances to the next frame.

The "feel" of a camera can be as important as the accuracy of the shutter or the sharpness of the lens. These two otherwise similar cameras have controls that feel quite different to operate: the model aimed at traditionally conservative professional photographers has controls that mimic the rotating dials and rings of conventional cameras. Amateur photographers are not so strongly influenced by tradition, so in the model aimed at them dials are replaced with pushbuttons.

THE MODERN SLR-2

SLR summary

Advantages:
Highly adaptable
Interchangeable lenses provide more ways to photograph the subject
Accurate viewfinder—what you see is what you get

Disadvantages:
Bulky, heavy and noisy
Expensive
Some are over-elaborate: few photographers fully exploit the most sophisticated features

The principle of the SLR

When you look through the viewfinder of an SLR, what you see is a view through the camera lens itself. Large format cameras show this view too, but lenses form images that are upside down and reversed left to right; on large-format cameras, this "flipped" image is what you see when you focus. On a 35mm SLR, however, a mirror and prism correct the image, making focusing and composition easier.

The system SLR
The modern SLR is an extraordinarily versatile instrument, and the camera body is often just a core module on to which the photographer can lock lenses and accessories to suit every imaginable application. System SLRs take this approach to the logical extreme, but these cameras often sacrifice some degree of automation in order to create a more versatile base for customization.

Camera body
This shell contains the shutter and mirror assemblies, and the electronics that make the whole system work.

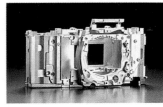

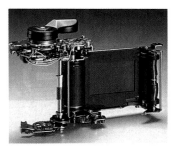

Lenses
The range of lenses available is a measure of a system camera's adaptability, but some of the more exotic lenses have very limited application, and are prohibitively expensive.

Motor drives
Some system cameras offer a choice of drives. The simpler drive winds film more slowly, and it may lack some of the automated features to be found on its bigger brother.

Focusing screens
A different screen can make focusing much easier, especially with lenses that have a small maximum aperture. On cameras that have fixed viewfinders, the screen is exchanged through the "throat" of the camera, after removing the lens.

Viewfinders
The basic prism finder is more than adequate for most picture taking, but special finders make focusing easier for photographers wearing glasses or safety visors, and can customize the camera for special applications, such as copying. Cameras with fixed prisms usually have accessory right-angle and magnifying finders that duplicate some of the functions of an interchangeable prism.

Eyesight correction
For myopic and long-sighted photographers, screw-in correction lenses make focusing possible without glasses.

Close-up accessories

These move the lens away from the film, to produce a larger image. There is more detail on page 96.

Camera backs

Accessory data backs imprint information on the picture edge, while bulk film backs hold long lengths of film of up to 250 exposures.

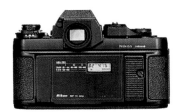

Remote exposure

Most system cameras can be operated by radio, or by an infrared control much like the remote channel-changer on a TV set.

Flash

The units supplied by the camera manufacturer take the fullest advantage of system SLR's automated features—flash units from independent manufacturers may omit off-the-film flash exposure control, for example.

Entry-level SLR

These economic cameras lack the comprehensive features and adaptability of the system SLRs, but they are nevertheless very much more sophisticated than comparable cameras made in 1983. Some entry-level SLRs share the same lens system as the more complex models, so that "upgrading" does not mean buying a whole new series of lenses.

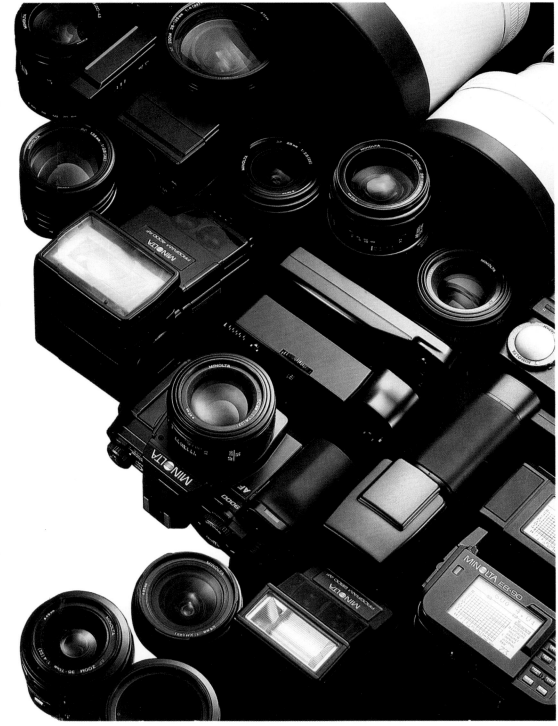

THE RANGEFINDER CAMERA TODAY

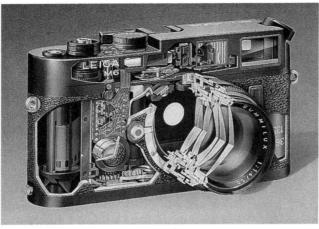

Modern Leica rangefinder cameras look so similar in outline to their predecessors of even 30 years ago that it is tempting to assume that the design has not changed. But within the familiar-shaped body there is a sophisticated meter and other advanced features.

The single lens reflex design may dominate 35mm cameras today, but in a few applications, rangefinder cameras still perform better than SLRs. Rangefinder cameras such as the Leica are almost silent in operation; with wide-angle lenses and in dim light they focus more accurately than SLRs; and some photographers argue that the viewfinder of this type of camera provides a closer rapport with the subject, leading to more perceptive, appealing photographs.

Rangefinder cameras are quieter because they dispense with the swinging mirror that gives the SLR its characteristic "klunk-click" noise at the moment of exposure. A rangefinder does not need this mirror, because it uses a completely different focusing mechanism. The main lens is used exclusively for transmitting the image to the film, and a separate optical system situated above the lens shows how much of the subject will be in the picture.

The camera's focusing ring is connected by a series of cams to a distance-measuring device in the viewfinder, and this mechanism shows the photographer a double image of out-of-focus subjects. Turning the focusing ring brings the two images closer, and when only one image shows in the viewfinder, the picture is sharp.

This rangefinder system measures distance with equal accuracy regardless of the lens in use; by contrast, the focusing accuracy of an SLR decreases with wide-angle lenses. Rangefinders also excel in dim light, because the double image is clearly visible even in conditions that would prove impossible for an SLR user.

Perhaps the most marked difference between rangefinders and SLRs is in their handling and operation. The viewfinder shows more than just that part of the subject that will appear on film; the true framing is marked out with bright lines. This means that the photographer can see what is happening around the edges of the picture, and anticipate, for example, when people are about to walk into the frame. A slightly more abstract advantage is that a rangefinder user looks *through* the camera, whereas on an SLR, the photographer sees an image of the subject on a ground-glass screen. Arguably, this screen creates a barrier between photographer and subject.

Like any design, rangefinder cameras have their limitations. Only a few have interchangeable lenses, for example, and the cheaper models don't show framing accurately at close distances. Also, no rangefinder camera works as well as an SLR when taking close-ups or when using long lenses. Nevertheless, some of the world's greatest photographers still prefer to use a rangefinder camera, and in situations where noise would be an intrusion, such as some court rooms, concert halls and operating theatres, these are the only cameras permitted.

Rangefinder cameras focus indirectly: the photographer judges sharpness using a system of lenses and mirrors that is separate from the lens that takes the picture. This sectional diagram shows the complex optical mechanism required: the arm and roller at the bottom protrude from the lens mount and engage a precisely machined cam on the rotating rear of the lens.

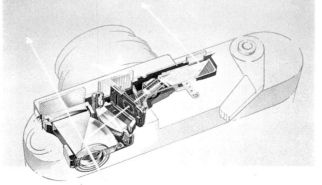

Summary

Disadvantages:
Can't handle close-ups and long lenses
Precision models are costly

Advantages:
Inconspicuous—almost silent
Smaller than an SLR
Some have interchangeable lenses
Focus well in demanding situations

In skilled hands the rangefinder camera passes almost unnoticed. Here the noise created by an SLR would have been intolerable, but the quiet shutter of the Leica enabled Henri Cartier-Bresson to capture the serenity of the occasion without seeming to intrude.

THE COMPACT CAMERA

Compact cameras resemble rangefinder cameras in outline, and to some extent the similarity continues inside. Like the rangefinder camera, the modern compact camera has duplicated optical systems, with one lens for taking the picture, and a separate one for viewing and composing.

The simplest compact cameras have fixed-focus lenses: the camera is permanently set up to give sharp pictures of all subjects that are more than about 2 meters (7 feet) away. This system is satisfactory for most snapshots, but has obvious limitations with small subjects—for example, it's impossible to take a full-frame picture of a child.

A few compact cameras get round this problem with a simple symbol focusing scheme. A ring around the lens is marked with symbols to represent subjects at different distances; a mountain, for example, marks the correct setting for distant subjects. A more common and reliable solution, however, is for the camera to focus automatically.

Most compacts do this by emitting a beam of harmless infrared radiation when you press the shutter release; a tiny mirror makes this beam scan across the subject as the lens moves away from the film, focusing on progressively more and more distant subjects. A

Compact cameras are all broadly similar externally, but they can vary widely in specification. In particular, check the minimum focusing distance when buying: to fill the frame with a baby's face, your camera must be capable of focusing on subjects as close as 50cm (20 inches).

Summary

Disadvantages:
Limited manual control
Fixed lens

Advantages:
Pocket size
Truly "decision-free" cameras
Usually inexpensive
Focus even in darkness

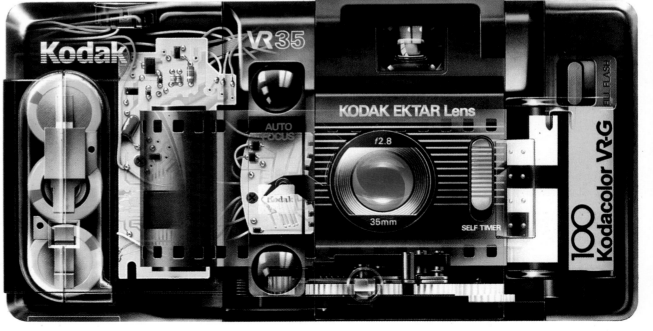

sensor detects when the infrared beam strikes the subject, and the camera's microprocessors arrest the movement of the lens. A split second later, the shutter opens to take the picture.

All other functions of the compact camera are automated to a similar degree, so that even a child can take pictures that are technically perfect. But the compact camera doesn't deserve the "point-and-poke" epithet which some photographers use to dismiss it. Because the autofocus system is much simpler than that used in SLRs, and because it is "active," the camera functions unaided even in total darkness—unlike some SLRs. Additionally, compact cameras live up to their name: they really are pocket-sized, and are instantly ready for action. Within the limitations imposed by the format, compact cameras are perhaps better than any other type at catching spontaneous action and tender family moments.

How sharp is sharp?

Compact cameras don't focus continuously. Instead, they estimate how far away the subject is, and then move the lens to focus on the most appropriate of several factory-set subject distances. Focusing is therefore exact only when the subject distance coincides exactly with one of the pre-selected settings. This system sounds sloppy, but it works very well in practice, especially if the camera uses many closely spaced zones. The best compact cameras use up to eight zones, but the cheapest use only two, so you really do get what you pay for.

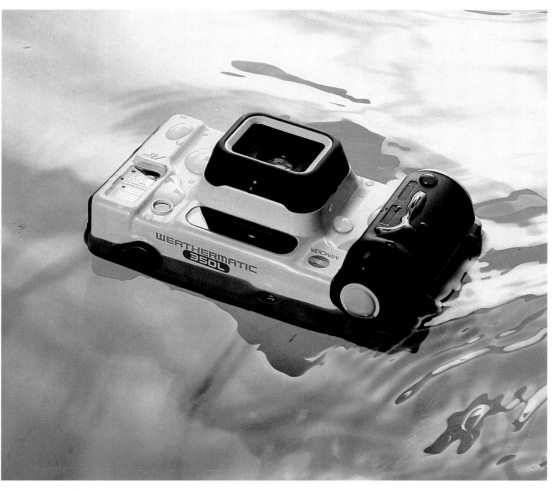

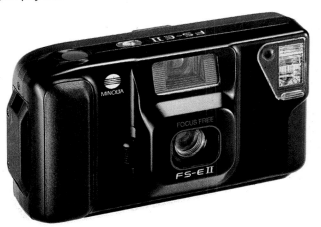

Splashproof compact cameras (above) aren't just for seaside use — they shrug off heavy rain and melting snow, too.

Pan-focus compact cameras (far left) have no focusing mechanism. Instead they rely on the lens's inherent depth of field to keep the image sharp. These inexpensive cameras are fine for distant views, such as this balloon festival, but cannot make sharp pictures of subjects closer than about 2m (7 feet).

SHUTTER

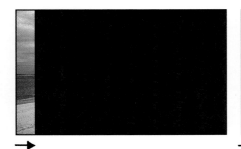

At shutter speeds faster than about 1/125, a focal plane shutter exposes the film sequentially, rather than all at once. A narrow slit opens at one side of the frame, as shown above, and travels across the film. Thus one side of the frame is exposed fractionally earlier than the other.

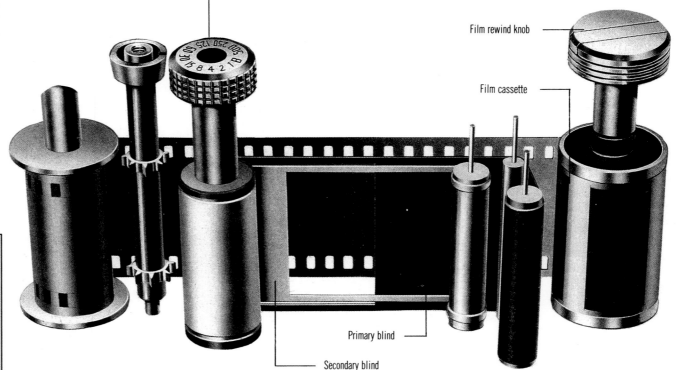

Shutter speed dial

Film rewind knob

Film cassette

Primary blind

Secondary blind

CONTROLLING THE SHUTTER
Traditional-style cameras control the shutter speed with a wheel, while more modern models use keys or buttons. In principle neither system is superior, but some photographers find dial setting more natural and intuitive to use, just as many people find it harder to tell the time from a digital watch, and would rather use a clock with hands.

The principal function of the shutter is self-explanatory: while it is closed, no light reaches the film. When the shutter release is pressed, the shutter opens and the film is exposed, usually for just a fraction of a second. For how long light strikes the film is of crucial importance, because this affects the level of exposure. Just the right amount of light must reach the film to create a well-exposed image: if the shutter stays open too long, the picture will be too pale; too brief an exposure makes the picture too dark.

If the object being photographed (or the camera) moves while the shutter is open, the image on the

(occasionally) metal foil, and usually run from side to side. Shutters with blades travel vertically, and are almost always made from metal. Both types work in a similar way, though: at slow speeds, the blinds or blades open to uncover the whole of the film area. The gap stays open for a timed interval, then closes. At faster speeds, the blades or blinds form a slit that travels across the film, as shown above.

The difference between these two modes of operation is important when taking flash pictures. Electronic flash lights up the subject for only 1/1000 second or less, so when the flash goes off, the whole image area of the film must be uncovered. At faster shutter speeds, only a portion of the film is exposed at any one time, so you can use flash only at slower shutter speeds. The maximum allowable shutter speed is usually in the range 1/30 to 1/250 second, and is marked on the shutter speed dial with an "X" or a lightning bolt symbol.

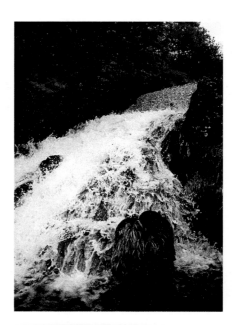

negative will be blurred. Although this is sometimes desirable—perhaps to convey a sense of speed, as explained on page 93 — it is more usual to choose a shutter speed fast enough to "freeze" the action and render everything as sharp as possible. The shutter speed needed to do this depends on the speed of the object being photographed, and the direction in which it is moving in relation to the camera.

The speeds marked on most common cameras conventionally follow a sequence of fractions of a second based on halving at each step: 1/2, 1/4, 1/8, 1/15, 1/30, 1/60, 1/125, 1/250, 1/500, 1/1000, 1/2000 and 1/4000. Usually these speeds are not printed as fractions, but as whole numbers, so "1000" represents 1/1000 of a second. And if you have an electronic camera, the speed set by the camera may be an intermediate setting somewhere between any two of these fractions—but the viewfinder display shows the nearest equivalent setting from the familiar sequence.

This halving/doubling sequence is a very useful arrangement when the time comes to change the level of exposure. Changing the shutter speed up to the next faster setting allows the light to strike the film for exactly half as long. Conversely, the next setting down allows light in for twice as long. The camera's aperture is marked in a similar halving/doubling sequence, and using the two controls together makes manual control of exposure very simple, as explained on page 57.

Shutter mechanism

The basis of a focal-plane shutter is a pair of roller blinds, as shown here, or a series of overlapping blades. Blinds are made of a specially treated opaque fabric or

Shutter speed and camera shake

Shutter speed does not just affect how subject movement appears on film: if, for example, you or the camera moves when taking a picture at a slow shutter speed, the whole picture will be blurred. This mistake is called camera shake, and you can eliminate it by using a faster shutter speed or by providing extra support for the camera. With a normal lens, set a speed faster than 1/60 second to eliminate camera shake when there is no extra support. You will need a faster speed when you use a longer zoom setting, as explained on page 99.

Shutter controls

Older-style cameras have shutter speeds engraved on a dial, but newer models often just have press buttons to increase or decrease the shutter speed. Either method is easy to use once you get used to it. Besides the increasing scale of numbers, you may see other settings: set the dial to "T" (it stands for time exposure) and the exposure starts when you press the shutter release and ends only when you press it again (or turn the dial to a new speed). Set to "B," the shutter remains open as long as you have your finger on the shutter release. "X" is the flash-synchronization speed, as explained (at right). "A," or "auto," hands control of the shutter over to the camera.

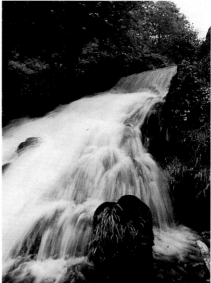

Subjects that move while the shutter is open appear blurred on film — and the longer the shutter speed, the more the blurring. At 1/500 (top) water appears icy sharp. A speed of 1/2 (above) produces a more flowing look.

FOCUSING AND AUTOFOCUS

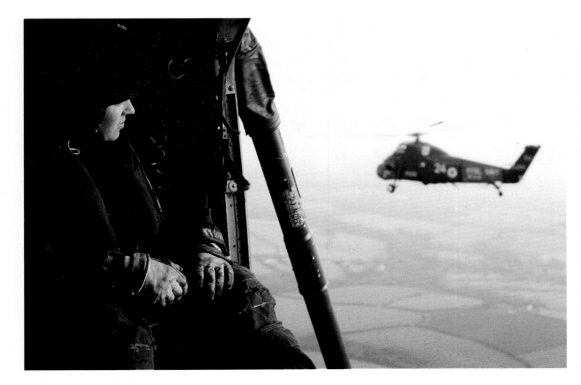

Automation relieves photographers of the routine tasks, but even automatic systems require some creative input. For example, autofocus systems monitor only the middle of the viewfinder image when judging sharpness, and offset subjects need special treatment. When taking this picture, photographer Martin Dohrn first pointed the camera at the airman in the foreground and lightly pressed the shutter release to focus. Then, holding the release down to lock focus, he recomposed the picture with the helicopter placed centrally and fully pressed the release.

Anyone who has used a magnifying glass to examine a tiny object will know instinctively about the action of focusing. To see clearly, you have to move the magnifying glass back and forth, until the lens is just the right distance from your eye and from the subject.

Focusing a camera lens is a bit different: the action more closely resembles the use of a magnifying glass in sunlight to burn a hole in a piece of paper. If you use a magnifier to burn holes, you move the lens back and forth until you get the smallest, clearest possible image of the sun. In a camera, the action of focusing does the same thing, but instead of focusing an image of the sun on a piece of paper, you form images of the subject on the film.

Many modern cameras focus automatically: when you press the shutter release, a motor moves the lens to the right position. Compact cameras focus with an "active" system that utilizes infrared beams, as explained at right, but SLR autofocus works in a way that more closely resembles manual focusing. The electronics and mechanics of autofocus SLRs are highly complex, but it is easy to grasp the principles, and a basic understanding will help you to solve autofocus problems.

Inside an autofocus SLR

Most autofocus systems in SLR cameras work in a similar way. Some of the light from the lens passes through a semi-transparent area in the middle of the reflex mirror, then bounces off a second "piggy-back" mirror into a series of tiny lenses in the base of the camera. These lenses form two images of the subject, and project them on to two rows of light-sensitive cells. When the picture is sharp, the image of the subject appears in the same position on both rows of cells; but when the picture is out of focus, the image falls in a different place on each of the two rows. By comparing the position of the image on each row, electronic circuits in the camera can decide which way to move the lens to bring the images into alignment.

This system works well as long as the subject has some sort of texture or pattern. Point the camera at a plain subject, though, and light of equal brightness falls on all the cells in each row, so the camera cannot "see" the subject. To obtain sharp focus, you have to turn the camera so that some clear vertical line comes into view. Note that it has to be vertical—the array of sensors in the camera is horizontal, so horizontal stripes do not make a good focusing target, unless you turn the camera through 90 degrees.

Other subjects that fool the system are repeated geometric patterns, such as a grid; very fine or indistinct textures, such as cat's fur; and dimly lit subjects. To be fair, however, all these subjects are hard to focus on manually, too.

The heart of the SLR viewfinder is the focusing screen — a sliver of etched plastic that catches the image projected by the lens.

Center the subject

Autofocus cameras measure sharpness in the center of the picture—so if your subject is off-center, you will need to use the camera's focus lock. This usually means that you must turn the camera until the main subject is centered, lightly press the shutter release to focus, then, while maintaining pressure on the shutter release to keep the focus setting locked, recompose the picture. Pressing right down takes the picture.

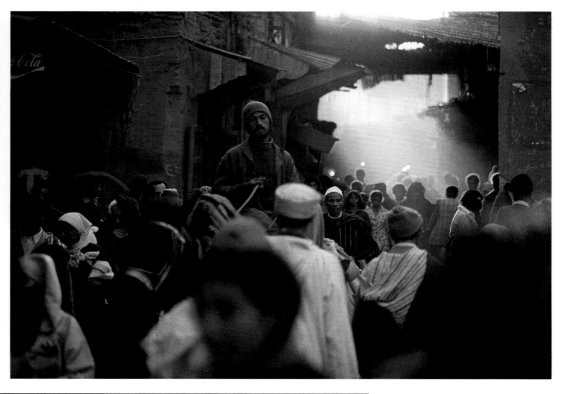

Autofocus modes

Many SLRs have more than one focusing mode: here is how they work:

One-shot mode Half-press the shutter release to focus; a beep or visual signal indicates that the picture is sharp; you cannot take a picture until this signal appears; focus is locked until you release the button and press again. This is the commonest arrangement, and it works well with most subjects. However, some photographers dislike the feeling that the camera has control over when to take the picture.

Tracking The camera makes continuous focusing adjustments to track moving subjects. Best for action photography.

Focus trapping You set the focus, the camera trips the shutter as soon as a subject at the correct distance enters the picture.

Depth mode You point the camera at the nearest and farthest subjects you want sharp, half-pressing the shutter release each time. The camera then sets the optimum focus and aperture to ensure that depth of focus.

Manual The autofocus system is disengaged and you turn the ring on the lens to focus. Some cameras have arrows in the viewfinder to show which way to turn the ring.

Autofocus systems excel in situations where manual focusing would be difficult or impossible. At this amusement park (above left) subject distances were changing constantly, and the photographer set his camera to tracking mode, thus keeping the image constantly sharp. The market (above) was better suited to one-shot mode, because the subject was static but reluctant to be photographed.

Aperture and Depth of Field

*T*he human eye adjusts very rapidly to changes in the intensity of light, and we notice the extremes of brightness only when moving between very dark and light areas—such as emerging from a dark theater on a sunny day. We can accommodate to changing light levels because each of our eyes has an automatically controlled aperture, called the iris, which restricts the size of the pupil—the hole through which light enters the eye.

A camera has a mechanism that exactly parallels the iris in the eye. However, unlike the eye, the camera's iris, or diaphragm, does not constantly dilate and contract in response to changing light levels. The iris in a modern SLR camera closes down to the selected aperture just an instant before exposure. You can see

this happening if you look into the lens and release the shutter with the camera set to a manual shutter speed such as 1/8 second, and a small aperture setting.

When the camera is set to manual or to "aperture-priority" mode, a ring around the lens barrel controls the size of the aperture. The ring is calibrated with numbers called *f*-stops, or just stops, and the numbers follow a sequence that is the same on every lens: 1.4, 2, 2.8, 4, 5.6, 8, 11, and 16; there may also be additional numbers at either end of the scale.

Moving from one aperture setting to the next halves or doubles the area of the hole in the middle of the iris, and thus halves or doubles the amount of light reaching the film. Setting the next larger *f*-number halves the light. Smaller numbers double the light intensity at each setting.

Depth of field is affected by both aperture and focal length: these nine images were shot using three lenses, each at three different apertures. Although all three lenses keep everything sharp at their smallest aperture (f/22), the balls behind the sharpest blue ball become blurred when the standard lens is set to a wider aperture (f/5.6). With the telephoto lens the effect is even more pronounced. At maximum aperture only the wide-angle lens keeps distant subjects sharp.

Wide angle **Standard** **Telephoto**

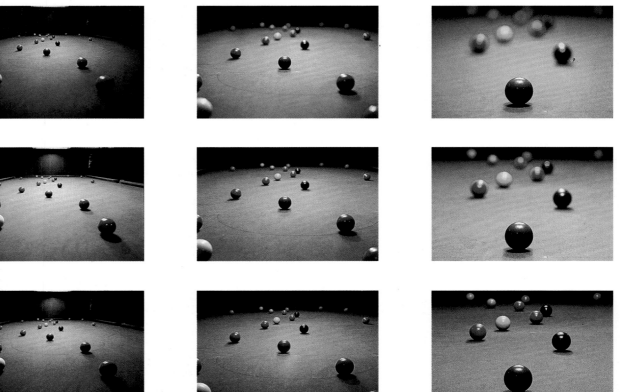

f2.8

f5.6

f22

This arrangement is similar to that adopted on the shutter-speed scale, and the similarity is no coincidence. Simultaneously changing to the next faster shutter speed and the next wider aperture has no effect on exposure—the light strikes the film for half as long, but, to compensate, the image is twice as bright. This means that if you wanted to choose the next faster shutter speed to stop action, you could just use the next wider aperture to maintain exposure.

Aperture and sharpness

The system works the other way round, too: if you want a wider aperture, you would choose a faster shutter speed. But why choose a particular aperture? Because, just as

shutter speed affects both the exposure and the appearance of movement on film, so too the aperture has a dual role.

When you focus the camera manually, you will notice that there is a zone of sharp focus extending some way behind and in front of the sharpest image plane. The extent of this zone is called the depth of field, and its size is controlled by the aperture. Small apertures (high *f*-numbers) create lots of depth of field; at wide apertures (low *f*-numbers) much less of the picture is sharp, as shown, right.

Controlling the aperture

If you use your camera only on the program setting, you will not usually need to be concerned with setting either aperture or shutter speed, because the camera does this for you. But sometimes, you will want to take full control over the aperture. Here, for example, the photographer deliberately sets a small aperture to restrict depth of field, and throw the background out of focus. There is more about how to use the aperture on pages 90—1.

You can think of a sharp image as being made up of countless tiny points of light; in an unsharp image, each point spreads out to form a circle. With an SLR camera you can see this effect in practice: at night, point the camera at a distant street lamp and gradually defocus the image. You'll see the point spread out to form a circle.

DEPTH OF FIELD IN PRACTICE
The extent of the sharp zone available when taking a photograph is governed by the focusing distance, the size of the aperture and the focal length of the lens being used. The first three columns illustrate how the depth of field grows as the subject moves away from the camera and the size of the aperture remains constant. The last two columns show how, with the lens focused on a given distance, the depth of field increases significantly as the lens is stopped down. With a constant distance and aperture, lenses of increasing focal length will again reduce the depth of field.

On newer cameras aperture may be controlled not directly, using a ring on the lens barrel, but indirectly, using a push-button or a knurled ring. This control feeds information about the chosen aperture to the camera's on-board computer, where it is stored until the instant of exposure. A liquid crystal display shows the aperture preset.

EXPOSURE AND METERS

Multi-area metering starts with a light-sensitive cell (above) divided into several different zones, and each zone reads the brightness of part of the image. To set exposure, the camera compares the output from each zone with a table—stored in the camera's memory (below)—of the brightness distribution found in the most common photo subjects, and then chooses the best match.

*A*s is explained on preceding pages, film needs just the right amount of light to make a good picture. We use the aperture and shutter speed together to control the exposure—the brightness of the light entering the camera, and for how long the image falls on the film. It is the camera's exposure meter, however, that determines how the aperture and shutter speed should be set in order to regulate the exposure.

The key component of the exposure meter is a light-sensitive element that measures the brightness of the scene in front of the camera. On the simplest compact cameras, this cell is positioned close to the lens, pointing forwards, but in an SLR there are often several cells, in various positions within the camera. On some cameras, the cell points at the focusing screen; on others, the main cell measures light reflected from the film surface during the exposure. Other models use a hybrid system.

In practice, knowing exactly how your camera's metering system works is less important than under-standing how to use it. The first step in this direction is to master the meter's controls, and to learn which areas of the subject most influence the meter reading.

Meter modes

On a simple camera, a small lens covers the light-sensitive cell, so that the camera reads the average brightness of the whole picture area, and is not misled by bright or dark areas that will not appear in the picture. Such *average* metering is adequate for snap-shot cameras, but it is easily fooled by non-average subjects.

Many SLRs have *center-weighted* metering systems: the camera attaches more importance to the middle of the picture than to the edges. This is an improvement on the average system, and gives good results with most subjects. The degree of center-weighting varies—some cameras base the exposure on just the central 30 per cent of the picture.

A few cameras have the facility for *spot metering.* Here, the camera takes a reading from a tiny central portion of the picture. For correct exposure, the photographer must take a meter reading from a very carefully selected part of the subject. This system has potentially the greatest precision, but also a comparable potential for errors.

Multi-spot metering allows you to make several spot readings and average them. For experts only.

Multi-area metering is a recent innovation, and it is quite different from multi-spot metering. The camera measures the brightness of several parts of the picture, and uses information stored in a computer memory to deduce the right settings. This system is usually highly accurate, even when the camera is used by someone with no knowledge of photography.

MANUAL AND AUTOMATIC
Traditional-style aperture-priority cameras generally have their auto mode marked with an A. Other marked speeds demand manual metering.

Average metering

Spot metering

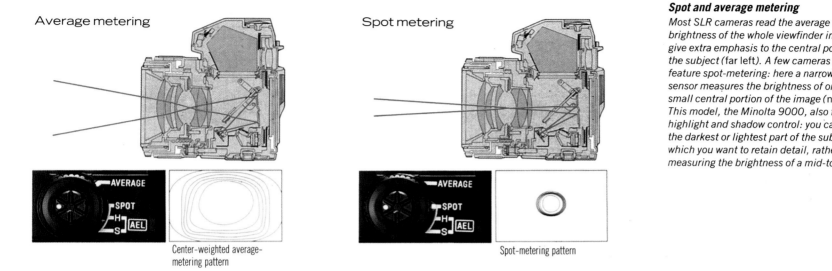

Center-weighted average-
metering pattern

Spot-metering pattern

Spot and average metering
Most SLR cameras read the average brightness of the whole viewfinder image, but give extra emphasis to the central portion of the subject (far left). A few cameras also feature spot-metering: here a narrow-angle sensor measures the brightness of only a small central portion of the image (near left). This model, the Minolta 9000, also features highlight and shadow control: you can meter the darkest or lightest part of the subject in which you want to retain detail, rather than measuring the brightness of a mid-tone.

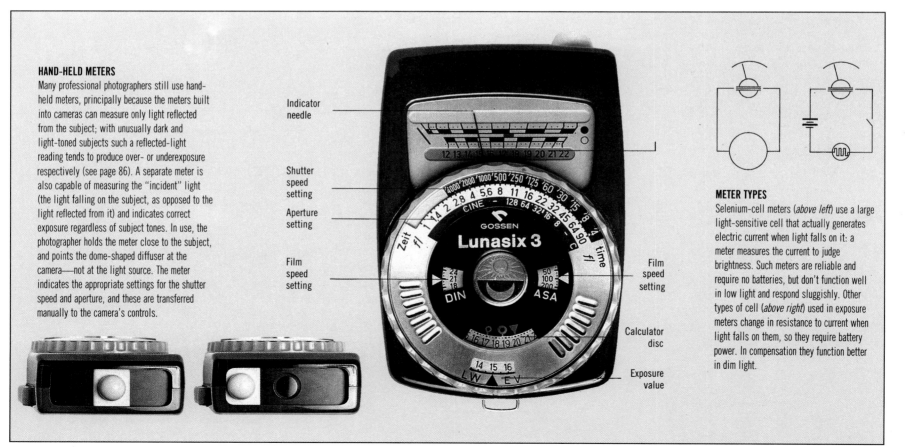

HAND-HELD METERS
Many professional photographers still use hand-held meters, principally because the meters built into cameras can measure only light reflected from the subject; with unusually dark and light-toned subjects such a reflected-light reading tends to produce over- or underexposure respectively (see page 86). A separate meter is also capable of measuring the "incident" light (the light falling on the subject, as opposed to the light reflected from it) and indicates correct exposure regardless of subject tones. In use, the photographer holds the meter close to the subject, and points the dome-shaped diffuser at the camera—not at the light source. The meter indicates the appropriate settings for the shutter speed and aperture, and these are transferred manually to the camera's controls.

Indicator
needle

Shutter
speed
setting

Aperture
setting

Film
speed
setting

Film
speed
setting

Calculator
disc

Exposure
value

METER TYPES
Selenium-cell meters (*above left*) use a large light-sensitive cell that actually generates electric current when light falls on it: a meter measures the current to judge brightness. Such meters are reliable and require no batteries, but don't function well in low light and respond sluggishly. Other types of cell (*above right*) used in exposure meters change in resistance to current when light falls on them, so they require battery power. In compensation they function better in dim light.

EXPOSURE AUTOMATION

*O*nce the meter has measured how brightly lit the subject is, you or the camera must decide how to set the aperture and shutter speed. As we have seen, the best setting for each control depends on creative decisions about sharpness, and on how you want moving subjects to appear on the film.

Cameras differ in the degree of control they provide. Snapshot cameras, such as many basic compacts, give you no control at all; the camera sets both shutter speed and aperture according to a fixed program. Most cameras, however, offer you a range of options, and these are called exposure modes.

Program mode

Set to "program," an SLR camera functions with point-and-shoot convenience. In dim light, the camera sets the lens to its full aperture and chooses the fastest possible shutter speed that will give correct exposure. If the light is bright enough to permit a shutter speed of about 1/60 second or faster, there is less risk of camera shake, so the camera alternately closes down the aperture or increases the shutter speed as light gets brighter. Program mode is ideal for casual snapshooting with averagely lit subjects.

Speed programs

If it's essential to freeze action, regardless of how little depth of field there is, choose a speed program. The camera will keep the lens at full aperture and set the fastest shutter speed it can. Only when the camera reaches a relatively fast shutter speed does it start to set smaller apertures as well as faster shutter speeds to maintain exposure in brighter light.

Depth programs

Use this setting when depth of field is most important. The camera chooses the smallest aperture that light levels permit, until it reaches the mid-range aperture. Then the camera sets a combination of faster speeds and smaller apertures as light gets brighter.

Weighted programs

Telephoto lenses, or the telephoto setting on a zoom lens, increase the risk of camera shake, so some cameras have a program mode that automatically chooses faster shutter speeds when you zoom from "wide" to "tele" settings.

Shutter priority

This is a semi-auto mode that resembles the speed program, but provides greater control. You choose the aperture, and the camera sets the shutter speed that will give correct exposure.

Aperture priority

Similarly, using this semi-auto mode, you choose the aperture and the camera sets the shutter.

Manual

In manual mode, you can freely set both aperture and shutter. An indicator in the viewfinder tells you whether the combination you have chosen will result in correct exposure.

Flash mode

Many cameras have a flash mode that provides special capabilities when you fit a flash unit. Features vary widely, however, and you'll find a brief description of a typical system on page 79.

PROGRAM.

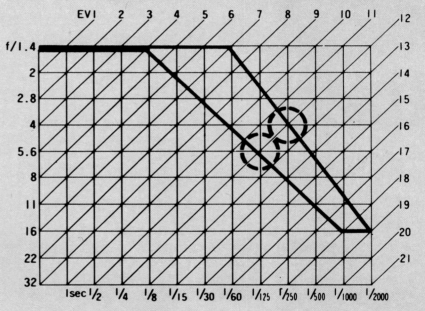

INTERPRETING A PROGRAM DIAGRAM
Camera manufacturers supply charts which concisely explain how a program works. The chart carries shutter speeds along one axis and apertures along the other. Diagonal lines indicate light of increasing brightness, calibrated in exposure values, or EVs. EV units just indicate brightness, independent of both shutter speed and aperture settings.

Dual Program Chart

(50mm f/1.4, ISO 100)

This chart shows a normal program and a high-speed program. You can see that on the normal program (lower line) the lens stays at its full aperture of f/1.4 until EV 4, when the light is bright enough to set a shutter speed of 1/8 second. In brighter light, the aperture gets smaller, and the shutter speed faster in equal degrees. The upper line shows the speed program: here the lens remains at full aperture until EV 7, when the speed reaches 1/60 second. Only then does the camera start closing down the aperture.

61

Ultrawide-angle lenses let you move closer, and they appear to stretch and distort the subject.

The lens on an SLR, and on a few other 35mm cameras, is removable, so that you can fit a telephoto or wide-angle lens. A zoom lens lets you change how much the camera includes in the picture without removing the lens.

A telephoto lens, or the "tele" setting on a zoom, allows you to select and magnify just one part of the subject, so you can fill the frame even when you can't get physically closer to what you are photographing.

A wide-angle lens, or the "wide" setting on a zoom, does just what its name says—it gets more of the subject into the picture, but makes everything smaller as a result, like looking into a convex security mirror, but without the distortion.

Comparing lenses

Lens makers describe the magnifying or reducing power of a lens by specifying *"focal length."* With a simple lens, such as a magnifying glass, focal length is the distance you must hold the lens from the film to make a picture of a distant subject. Camera lenses, though, are complex, and there is no physical distance that corresponds to the focal length engraved on the lens barrel. Instead, focal length indicates lens power. A "normal" lens for a 35mm camera has a focal length of about 50mm, so a 200mm lens magnifies the subject by 200/50, or about four times. Similarly, a 24mm lens takes in about twice as much of the subject as a 50mm lens. The maximum aperture of lens indicates its light-gathering power. You will see the *maximum aperture* engraved close to the focal length on the front of the lens, in the form of a ratio such as 1:1.4. This lens has a maximum aperture of *f*/1.4. Maximum aperture is important in dim light and with action subjects—the wider the aperture you can set, the faster the shutter speed you can use. Lenses with wide maximum apertures are called "fast" lenses, and though they extend your picture-taking range, they are much heavier and more expensive than "slower" lenses. You may prefer to use a faster film in order to obtain faster shutter speeds, as explained on page 67; this is a cheaper solution than the use of a fast lens.

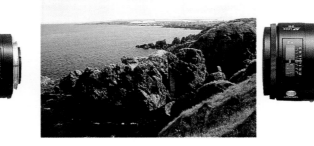

Ultrawide-angles: 20mm and wider
These lenses are rarely zooms, and at the extremes may even be manual focus designs. They take in a very broad view of the subject, and have very wide depth of field. They are ideal for photography in confined spaces and for landscape pictures.

Wide-angles: 24–50mm
Typical wide-angle zooms cover the range 24–50mm, and therefore provide a broad range of fields of view, up to standard focal length. Fixed focal length wide-angle lenses are cheaper, smaller and lighter than zooms, have wider maximum apertures, and may give better picture quality.

Standard lenses: around 50mm
Most cameras are sold with a 50mm lens as standard. These single focal length lenses give very sharp pictures, and have very wide apertures. "Standard zooms" have a range of focal lengths centered around 50mm, typically 35–70mm. They are more versatile, but the penalties are more weight and expense and smaller maximum apertures.

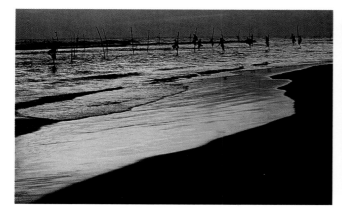

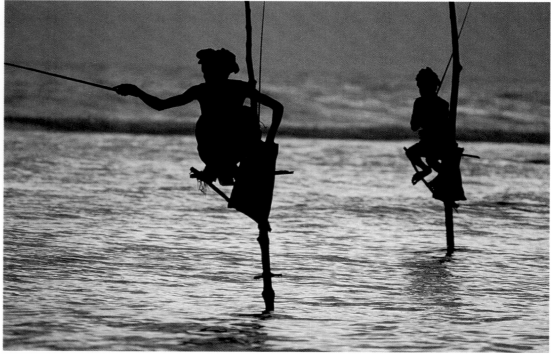

Telephoto lenses let you close in on the most distant details so that they fill the frame. These two images were taken from exactly the same viewpoint, with a 50mm standard lens (above), and a 300mm telephoto (above right). This degree of magnification is not without problems: fitted with the standard lens the camera can be hand held, but with the telephoto a tripod was vital to avoid camera shake.

Telephoto lenses: 80–250mm
Zoom lenses in this range generally perform very well, though again, fixed focal lengths may be smaller and faster.

Super telephotos: 250mm and above
These lenses are usually fixed focal length, and the longest ones also focus manually. They are specialist lenses that require considerable care in use.

LENSES-2

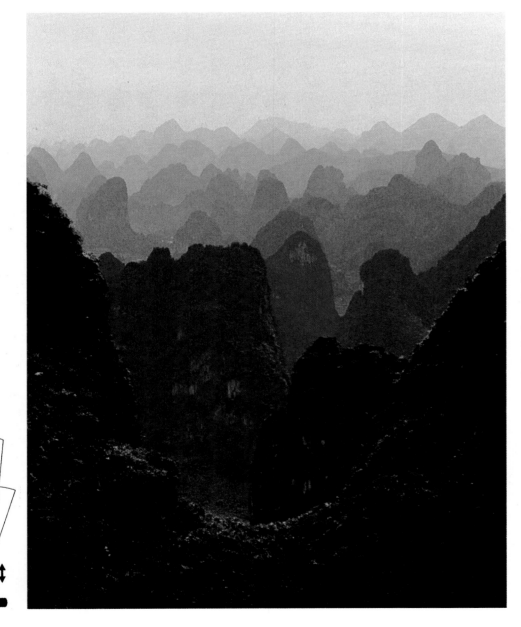

Shifting the zoom control or changing lenses allows you to alter radically how you portray the scene.

Back-of-lens converters

If you already own manual-focus lenses, you can often use them on an autofocus SLR camera by sandwiching a teleconverter between the camera body and lens. This small unit magnifies the picture, usually by a factor of 1.4× to 1.7×, and contains a moving element that makes automatic focusing possible. For manual-focusing cameras, there are similar converters, but these do not provide autofocus capability.

If you greatly enlarge pictures made with one of these converters, you will notice that there is a small loss of quality compared with a picture taken without the converter. However, this is a small price to pay for the convenience of autofocus, and the extra scope provided by the combination of converter and lens.

Depth-of-field scale

Fixed-lens cameras

Some fixed-lens cameras have a built-in converter which provides a choice of wide-angle or telephoto settings. A few even have built-in zoom lenses. Even if your fixed-lens camera has no such choice, you may be able to buy a converter to change the field of view.

This scale shows approximately how much of the subject is sharp at each aperture. Autofocus zooms don't have the scale, but some manual zooms do. The scale gives only a very rough idea of how much is sharp. If you find that your pictures have less depth of field than the scale suggests, use a closer set of marks. For example, when the lens is set at f/8, use the depth of field markings for f/5.6.

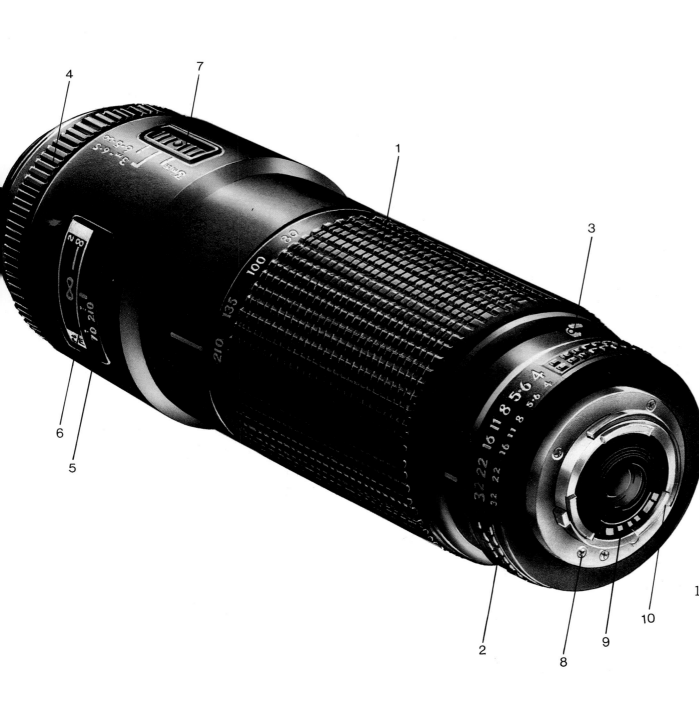

Lens controls

1 **Zoom control** Turning this zooms the lens from the wide setting to tele.

2 **Aperture ring** This lens, like many others, changes its aperture marginally when you zoom from wide to tele. So there are two index marks, to show the aperture at the extremes of the lens range.

3 **Aperture lock** For correct operation in some program modes, the lens must be locked at the minimum aperture.

4 **Manual-focus ring** Turn this to focus manually in conditions that fool the camera's autofocus system.

5 **Distance window** Distances are marked in feet and meters.

6 **Focusing index** The two adjacent marks are used only when the camera is loaded with black and white infrared film.

7 **Focus-range limiter** This sets the range over which the camera will seek sharp focus. Setting a limited range cuts autofocus time down.

8 **AF-drive coupling** This links the lens to the AF motor in the camera.

9 **Data terminals** Electrical contacts carry data about focal length to the camera's processor.

10 **Stop-down actuator** A mechanical connection closes down the lens to the chosen aperture at the moment of exposure. On some makes of camera, the connection is electrical.

FILM CHOICE

*O*f the millions of pictures shot each year, the overwhelming majority are taken on colour negative film, processed to produce wallet-sized colour prints. "Print film," as it is often called, is not the only film type, but there are sound reasons for its popularity: the prints are easy to look at; the colours are good; and extra prints can be made quite inexpensively and quickly from the orange-tinted negatives. A less obvious reason for the popularity of print film is its forgiving nature. Even large exposure errors do not impair the picture quality of colour negative film. So why use any other type of film? There are good reasons, as explained below.

Black and white film

Pictures may seem dull without the colour, but some of the world's finest photographs have been taken on black and white film. Many photographers turn to monochrome because it offers unparalleled control over every stage of image-making: the film is easy and cheap to process and print in a home darkroom. Others choose monochrome simply because they feel that colour is a distraction, and that black and white provides a "purer" way of seeing.

Colour transparency film

This family of film is sometimes called slide or, less usually, chrome film. The film produces a positive, full-colour image without an intermediate negative. So instead of returning strips of negatives and a wallet of prints, the processing lab gives you just the film, often mounted in 5-cm (2-inch) square cardboard or plastic frames. To see the pictures properly, you have to use a magnifier or a slide projector.

This may seem inconvenient, but slide film has advantages, too. Colours are more saturated than on print film, detail is sharper, and the slides don't fade as quickly as negatives. Professional photographers use slide film because the transparencies reproduce better when printed in magazines and books.

With slide film, creative changes in filtration and exposure levels have an exact and predictable effect on the finished picture. With negative film, on the other hand, creative manipulations at the exposure stage may be neutralized or disguised by the printing process. On the minus side, slide film needs careful exposure for good results.

How film works

Within the thin strip of film, there are actually many layers, as this cross-section shows. The image itself forms in the surface layers of the film, known as the emulsion, which is coated on a flexible plastic base. The emulsion actually contains not one image but three or sometimes more, each holding a record of just part of the subject. One layer records red light a second blue light and a third green light. All the layers are superimposed, creating a full-colour picture. Extra layers prevent the film from curling, protect it from scratching and filter out unwanted parts of the spectrum.

Film speed

Look on a film pack or cassette, and you will see a series of numbers and letters such as "ASA 200" or "ISO 400." These indicate the film's sensitivity to light, or its speed, and when loading film, you must set the number on the camera's film speed dial if this is not done automatically by the camera. The ASA and ISO scales are numerically equal, but the ISO is gradually superseding ASA. Low numbers indicate a slow film, which needs a lot of light for correct exposure; high numbers indicate a fast film that needs less light.

In general, slow film gives sharper, more colourful pictures, but forces you to use slow shutter speeds or wide apertures. Fast film provides a greater choice of shutter and aperture settings, but colours and sharpness aren't as good. For most pictures, ISO 200 medium-speed film offers an excellent compromise.

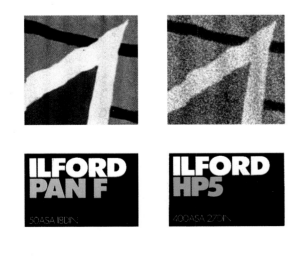

Colour balance

Negative film gives good results in all light sources without the need for filtration. With slide film, though, you must fit a blue filter over the camera lens when taking pictures by anything but daylight and flash. Even by daylight, you may have to use an amber filter when shooting in shadows or on a cloudy day.

DX coding

This pattern of conductive squares automatically sets the film speed and other parameters such as the number of frames—but only if your camera is equipped with the correct electrical contacts in the cassette chamber.

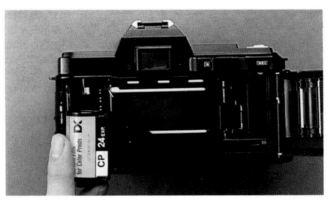

DX coding makes it unnecessary to set film speed manually, but simpler cameras have only one pair of contacts in the cassette chamber, and therefore produce perfect exposure with only ISO 100 and 400 films. Most SLR cameras have several pairs of contacts, and are therefore compatible with a wide range of film speeds.

CAMERA SUPPORTS

*O*ne of the most common causes of poor definition is "camera shake," the name given by photographers to their own frailty: in most cases it is the photographer who shakes. The effects of camera shake may not be obvious on contact prints, but enlargements will be ruined. It is particularly frustrating if a large sum of money has been spent on a high-quality lens, since the accurate definition given by the lens will be lost, and the final picture may even be less sharp than one taken with a simple meniscus lens in capable hands.

The slower the shutter speed the greater the risk of camera shake, and anything slower than 1/250 second should be regarded as a potential hazard. However, rather than restrict the flexibility of a camera that offers a full range of shutter speeds by never using speeds below 1/250, it is preferable to learn how to combat camera shake by holding and firing the camera correctly. In any case, fast shutter speeds will not solve the problem if the camera is handled badly.

The other critical factor affecting steadiness is the length of the lens used. Not only are long lenses heavier than normal ones, but they also tend to exaggerate the effects of the slightest movement. This is because the angle of view is so small that a minute change in the angle represents a large proportion of the whole picture: each movement is effectively magnified.

There are a number of attachments designed to improve the steadiness of hand-held cameras, but the best answer is to use a tripod wherever possible. Some indication of the wide range of tripods and grips available and their application is given by the illustrations on these pages. Some of the equipment is more specialized than most amateurs would need, but a general-purpose tripod is a valuable accessory.

KEEPING THE CAMERA STEADY
The key to hand-holding the camera is a stable posture. Always keep your arms close to your chest, and press your elbows in towards your body. If possible, brace yourself against a wall, or sit down and rest your elbows on your knees. These techniques are particularly effective with telephoto lenses.

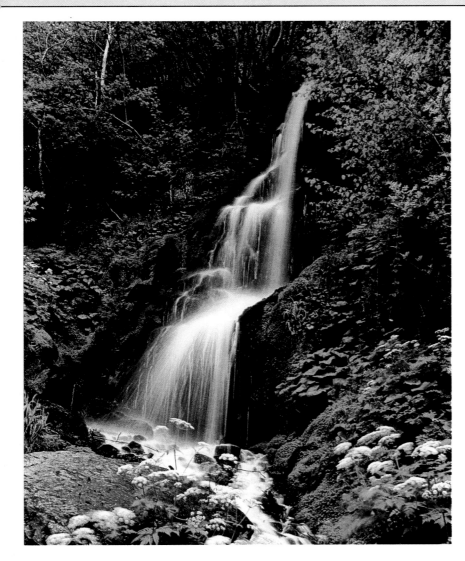

For longer exposures and focal lengths, hand-holding isn't practical. A tripod is the traditional, if rather cumbersome, solution, but there are many alternative forms of support. Clamps (top left) make a tripod from any rigid structure. A table-top tripod (left) is highly portable, and often as stable as its full-size cousin. A bean bag (below left) can be carried empty to save weight when travelling, and filled—with pebbles perhaps—on location. Monopods (bottom left) are especially suitable with long lenses, because you can turn them quickly to frame the subject. To stabilize tripods in windy conditions, tie a bag of rocks between the legs (bottom right).

Night shots (opposite page) almost always require extra support for the camera, since exposures of several seconds are the rule—too slow to hand hold even for the steadiest photographers. For general photography a tripod is valuable whenever you want to suggest movement: to blur the falling water (far left) required an exposure lasting four seconds.

Plain-coloured filters for slides

Film that is balanced for exposure by daylight gives excellent results when you take pictures in sunshine, but you may have noticed that pictures indoors without flash have a pronounced yellow colour. And in overcast weather pictures sometimes come out too blue.

You can use filters to solve these problems, and there is a full chart of filters and lighting conditions at the back of the book. The most useful filters for everyday photography, though, are the 81B pale straw-coloured filter, which eliminates the blue colour cast on dull days, and the deep blue 80A, which takes the yellow out of indoor scenes.

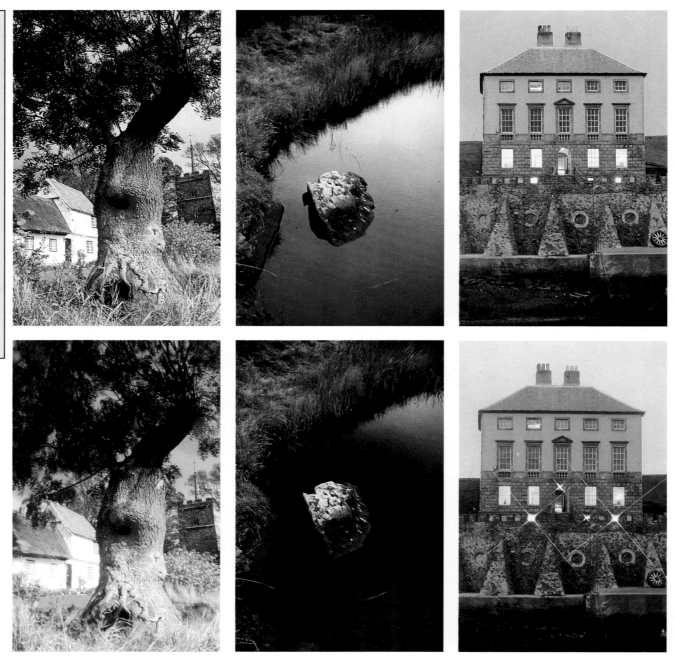

Diffusing filters spread the highlights to other parts of the picture, and conceal fine detail. No extra exposure is needed.

Polarizing filters cut reflections and make colours look richer, but require nearly two stops extra exposure.

Starburst filters create dynamic flashes from highlights—the effect varies with aperture. These filters don't need exposure compensation.

*F*ilters used over the lens of an SLR camera provide a valuable way of exercising creative control over the photographic image. Coloured filters can, for example, correct for a mismatch between the colour of the light and the sensitivity of the film; diffusing filters soften edges and hide unwanted details; polarizing filters cut down glare and reflections.

If you use colour negative film, however, filters may have less effect on the picture than you might expect. Subtle changes in colour do not show up when the pictures are printed, because the machines used to print your negatives interpret the colour shifts as errors,

Graduated filters enable you to selectively darken or tint just half the picture. Again, you don't need to adjust exposure.

Filters come in many shapes and sizes. If you expect to use a filter regularly, it's best to buy a glass filter in a metal mount (above). Such filters are compact and scratch resistant. Rectangular-system filters are cheaper, and adequate for occasional use. However, they scratch easily, so take extra care.

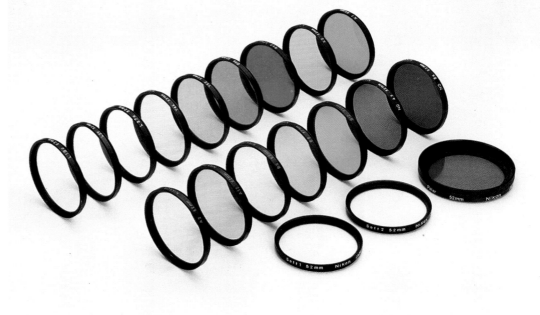

FILTERS-2

Filters intended for use with black and white film have deep, rich colours. Their use with colour film is confined to special effects—here an orange filter gives a dull park scene the sunset treatment.

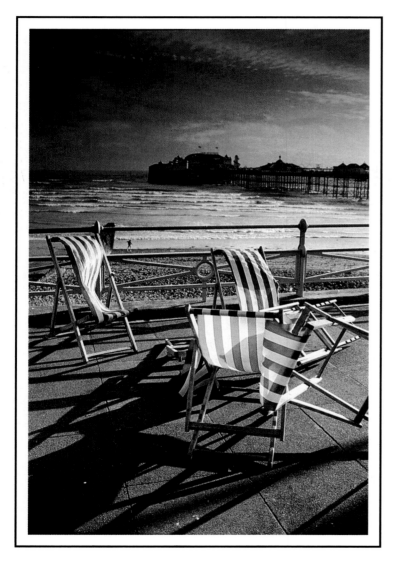

When it is overcast and the sky is flat and dull, a graduated filter adds colour to the top of the picture, making the image lively and bright.

and compensate automatically. To alter the overall colour of the prints, you must give special instructions to the laboratory.

With transparency film, though, you will frequently need to use filters of even quite pale tints. This is because most slide films are designed for subjects illuminated by sunlight or flash. If light of other colours falls on the subject, your pictures will look off-colour unless you use a filter, as explained in more detail on page 70 and in the chart on pages 218—19.

Filters and exposure

If you are taking pictures by daylight, you don't need to make any adjustments to your camera's exposure controls when using filters. The camera compensates for the light absorbed by the filter. Similarly, when you use a dedicated flash there is no need to make any adjustment. With other types of flash unit, though, and when using a separate hand-held meter, you will need to compensate for some filters by setting a wider aperture or a slower shutter speed.

Filter manufacturers provide information about the

Filters for black and white

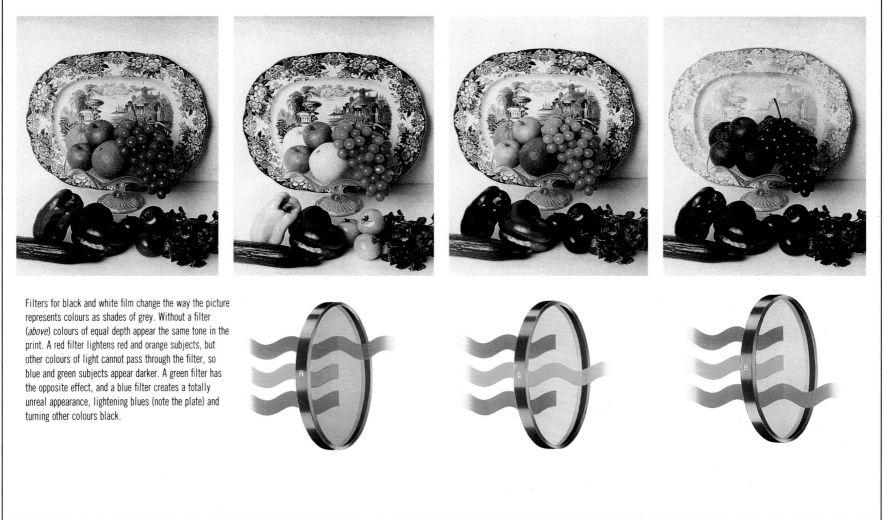

Filters for black and white film change the way the picture represents colours as shades of grey. Without a filter (*above*) colours of equal depth appear the same tone in the print. A red filter lightens red and orange subjects, but other colours of light cannot pass through the filter, so blue and green subjects appear darker. A green filter has the opposite effect, and a blue filter creates a totally unreal appearance, lightening blues (note the plate) and turning other colours black.

necessary compensation in the form of filter factors. A factor of $+1$ or $\times 2$ means you must give an extra stop of exposure (one setting slower on the shutter speed or one wider on the aperture scale); similarly $+2$ or $\times 4$ means two stops extra.

With flash, compensate by setting the film speed scale to a lower index. For example, with a $+2$ or $\times 4$ filter factor and ISO 400 film, divide the film speed by 4, and set 100.

Even if your camera compensates automatically, pay attention to aperture and shutter speed settings. Adding a filter may, for example, force the camera to use a shutter speed that is too slow to hand hold.

Special effects filters

There are many special effects filters available: this is just a small selection of the most popular types. While these filters can pep up a dull scene, they are no substitute for imagination and creative flair.

ACCESSORIES -1

One of the greatest strengths of the 35mm SLR is its adaptability and modular construction. As shown on pages 46–7, the photographer can customize the camera to suit almost any application. The commonest adaptation, of course, is to replace the camera's standard lens with a lens of different focal length, but other accessories extend the range still further.

Moving closer

Perhaps the most valuable accessories are those that enable the photographer to fill the frame with small subjects. Macro lenses are the ideal solution up to reproduction ratios of 1:2, when the image of the subject on film is half the size of the subject itself. At larger scales of reproduction, other accessories take over.

Most of these units move the lens and camera body farther apart, thus bringing closer and closer objects into sharp focus. *Extension tubes* are an economical way

to obtain closer images, but they restrict focusing to a series of "steps"; instead of focusing continuously through progressively larger magnifications, you can focus only within a narrow range, up to about 1:1. For significantly larger or smaller subjects, you must remove the lens and fit a new combination of tubes. *Bellows* units get round this problem, permitting continuous focusing over a wide range of magnifications up to a scale of about 3:1 (image three times life size). Reversing rings enable you to mount the lens back to front on the bellows: this produces better image quality at high magnifications.

Viewfinder options

Action finders and high-eyepoint finders let you focus with your eye farther away from the camera. With an action finder, the whole screen is visible from a distance of up to 6cm (nearly 2½ inches). Magnifying finders show a greatly enlarged view of the focusing screen, and

they are valuable for critical focusing—when copying, for example.

Some camera systems offer a choice of up to 20 focusing screens. Most are minor variants featuring different combinations of prismatic focusing aids, but some screens offer significant advantages for the manual focusing of telephoto or wide-angle lenses, and with lenses of small maximum aperture.

Eyepiece correction lenses make viewing much easier for those who wear glasses, though some cameras now have diopter adjustments built into the viewfinder for the benefit of photographers with imperfect vision.

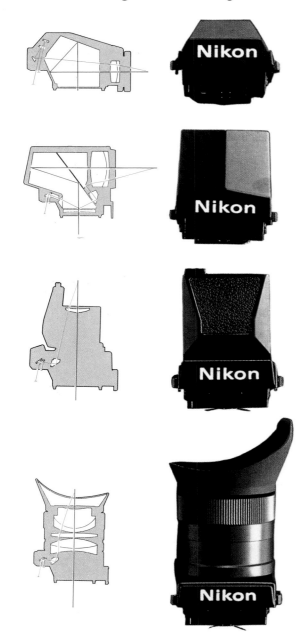

These interchangeable viewfinders provide considerable versatility. The standard finder (below far left) and the action finder (below second from left) form right-way-round images, but with the action finder you can see the whole focusing screen when your eye is a couple of inches away from the camera. Folding finders (below left) are useful for low-level viewpoints, and incorporate a magnifier for critical focusing. Rigid magnifying finders (below right) have a similar "straight through" light path, but correct the left-to-right image reversal that is a characteristic of the folding finder.

For critical focusing, a flip-up magnifier screws into place on the camera eyepiece and enlarges the central portion of the viewfinder (below). Eyesight correction lenses (bottom) provide a clearer view of those who wear glasses, and are especially useful with non-autofocus cameras.

ACCESSORIES-2

Camera backs and film options

The standard camera back is just a simple pressing of thin steel with a spring-loaded pressure plate to keep the film flat. Databacks add the facility of imprinting information on the film, either in one corner of the picture or (rarer but more useful) on the unused film edges. The simplest databacks imprint just the date, but others print time, frame or film number, exposure details and even short captions entered by an integrated keypad or personal computer. Intervalometer backs operate the camera shutter at a preset interval for time-lapse pictures when the camera is unattended. Other "program" backs allow the photographer to reprogram the camera's exposure modes, or to "bracket" pictures—to make a series of exposures at slightly different settings, as explained on page 87.

Program back

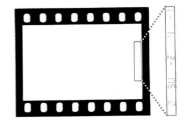

Databack

Bulk-film backs get around the restriction imposed by the 36-frame length of 35mm film. Some bulk backs hold up to 250 frames, wound on to special spools in the darkroom.

Instant-film backs provide a way of checking lighting, filtration and exposure settings. Most take a pair of contact print-size pictures on a single sheet of Polaroid film. However, to use the back, the photographer must first remove the conventional 35mm film from the camera, and replace the existing back with the Polaroid adapter. Mid-roll checks are thus impossible.

250 Exposure back

Bulk-film program back

Shutter-release options

Electrical cable releases make the operation of the shutter possible over distances up to about 20m (65 feet). Beyond this distance, you can operate the camera using a modulated infrared beam, but this has limitations. Like a TV channel-changer handset, the unit operates most reliably when the receiver on the camera can "see" the transmitter in the photographer's hand; range is restricted to 60m (200 feet) or so. Radio controls extend operation up to 700m (2300 feet), but generate and are susceptible to radio "noise," which may preclude operation in certain environments. All these accessories are of practical use only with a motorized camera, which will automatically advance the film and prepare the camera for the next shot.

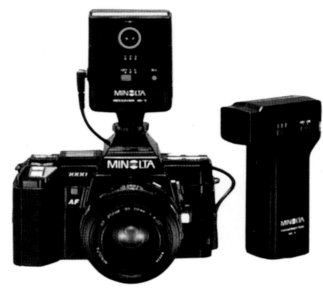

Infrared remote release

Motor drives

Many 35mm cameras now have integral motor drives, but cameras aimed at the professional market frequently lack this feature. The add-on drives are usually more rapid in operation, and offer more facilities, such as a control for shooting a preselected number of frames.

Electrical cable release

Motor drive

Intervalometer

LIGHTING EQUIPMENT

*A*fter dark and indoors, dim light may force you to use wide apertures and shutter speeds so long that you can't hand hold the camera. Extra light is the obvious answer, and electronic flash is a light source that has unique advantages for the photographer.

Flash relies on the fact that taking a picture is an instantaneous process: the camera's shutter opens for only a very short period, and the subject must be brightly illuminated for just that one instant. The small batteries in a flash gun would create a very dim light if you discharged their power continuously through a tiny bulb, but in a flash unit, all the light of a tiny bulb burning for a minute or so is stored in a capacitor and released in 1/1000 second or less. The flash is so brief that it effectively "freezes" subject movement on film.

Of course, to make a good picture, the camera's shutter must be fully open when the flash goes off, and the aperture must be set to a size that will yield the correct exposure. The maximum speed at which the camera's shutter is fully open when the flash fires is called the flash-synchronization speed, and it is usually marked on the shutter-speed display with an "X" or a lightning bolt. Most SLR cameras synchronize at 1/125 or 1/250 second, and you use any speed slower than this value without affecting the level of exposure caused by the flash, and without any risk of camera shake. However, if you set a very slow shutter speed, you may find that ambient light forms a secondary image of the subject of the film.

To make sure that the flash goes off just as the camera's shutter opens, the two units must be electrically connected. If the flash is mounted in the camera's accessory shoe, the central contact makes the neces-

sary connection. For off-camera flash, you must use a synchronization cable plugged into the camera's PC socket. PC stands for Prontor-Compur, the first make of shutter to use this type of socket.

To set exposure with flash, you cannot use the camera's meter in the usual way. However, some combinations of camera and flash set exposure automatically, as explained below.

Dedicated flash

Many new flash units are dedicated—they are designed to work with just one make of camera and offer only a limited range of facilities with other types. A dedicated flash unit performs a number of functions automatically, including setting the synchronization speed, though not all makes automate all of the features described below.

- **Flash mode** Switch the flash on, and the unit commands the camera to treat flash as the main light source. It sets the shutter to the synchronization speed and possibly sets the aperture, too.

- **Flash ready signal** The flash unit needs time to top up its capacitors between exposures. Some units have a "ready" signal light in the viewfinder when this process is complete. If you try to take a picture before the signal appears, the camera usually reverts to some other exposure mode, as if the flash was not in use.

- **Confidence light** Pulses briefly confirming correct exposure.

- **Through-the-lens flash metering** The flash measures the light reflected from the film surface during the exposure. This makes exposure control very accurate, and eliminates the need for exposure calculations even with close-up photography—a notoriously difficult application of flash.

Flash and autofocus

Most dedicated flash units for autofocus SLRs now include a tiny spotlight which projects a pattern on to the subject, so that the camera's autofocus system can operate at low light levels.

Using flash manually

There may be times when you wish to use the flash manually, and it is therefore useful to know how to set the camera's exposure controls. The shutter speed has no effect on flash exposure, so in darkness you can use any speed slower than the synchronization speed.

Set the flash to "manual" and choose the camera aperture using the guide number for the unit. This number is supplied by the manufacturer in the instructions, or printed in chart form on the flash itself. The guide number is specified for a range of different film speeds and for subject distances in either feet or meters. To find the correct aperture, divide the appropriate guide number by the subject distance. The result is the aperture.

For example: with ISO 100 film, a flash unit has a guide number of 40, when the subject distance is measured in feet. If the subject is ten feet away, the correct aperture is 40/10, or *f*/4.

Many flash units can, additionally, be used in semi-auto mode. Here, you don't need to do any arithmetic. You simply set the correct film speed on the flash calculator dial and read off the aperture from a scale.

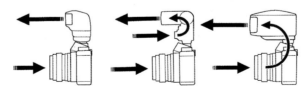

Manual flash units (above left) produce the same light intensity every flash: you must set the aperture according to subject distance. Automatic flash guns (above middle) quench the flash when the subject is correctly exposed—one aperture suits all subject distances. Some dedicated flash units (above right) measure exposure through the lens.

SPECIAL 35MM CAMERAS

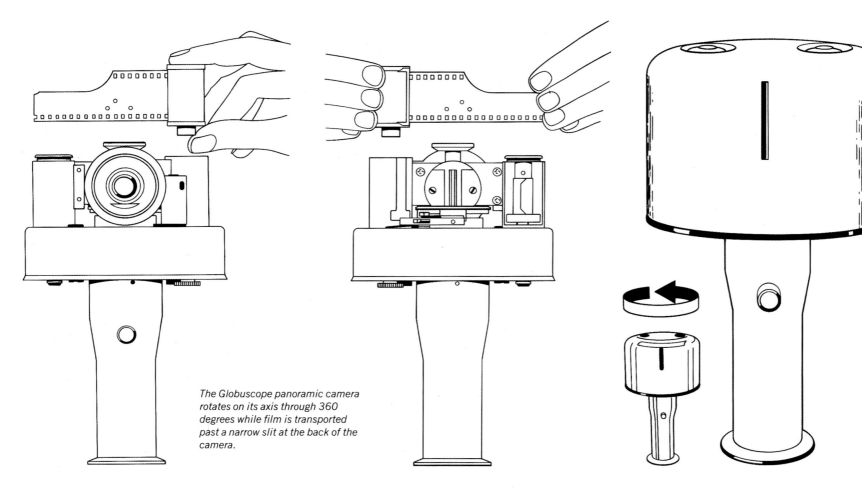

The Globuscope panoramic camera rotates on its axis through 360 degrees while film is transported past a narrow slit at the back of the camera.

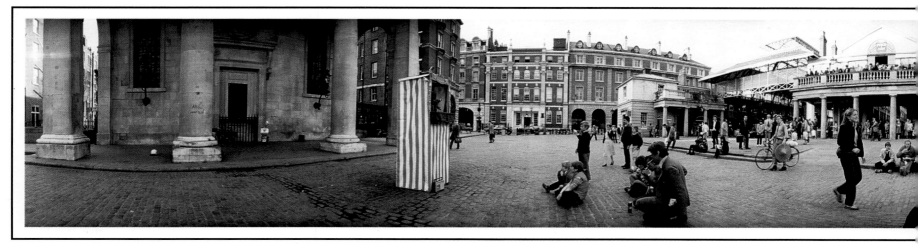

*A*lthough the 35mm SLR is an extremely versatile and adaptable instrument, there are still some photographic tasks that demand special equipment. In particular, hostile environments put extreme demands on the camera, and though adaptation is possible, it is not always the best solution. For example, waterproof housings will adapt most SLRs for use underwater, but these boxy housings are cumbersome, and lenses computed for use in air are not ideally suited for photography underwater. A specially built underwater camera is a better solution, as explained below.

Other special 35mm cameras are designed to take panoramic pictures, and to expose a sequence of frames at very high speed.

The Nikonos camera is purpose built for underwater use. A range of submersible lenses and accessories makes the camera as versatile and easy to use as any land-based model.

THE 35MM CAMERA IN USE

As we have already seen, most modern 35mm cameras are capable of functioning totally automatically: for casual picture taking, all you have to do is frame the subject and press the shutter release.

There is much more to photography, however, than simple button-pressing, because an automatic camera only literally records what you point it at. The camera measures the average brightness of the surroundings and the exact distance to whatever is in the middle of the picture, but only the photographer can interpret the scene and stamp the image with a personal hallmark.

One of the principal controls that photographers use for personal expression is selection. In later chapters we take a look at how choice of subject, composition and other selective processes affect the picture. But the medium of photography itself offers numerous ways to influence and manipulate the image on film, and you can use all these controls to create images that are recognizably your own.

Set to "auto" the camera simply adjusts these controls to the optimum settings and produces a picture that is as near technically perfect as possible. A technically perfect picture, however, isn't necessarily an interesting one, and you will always create more evocative pictures if, before pressing the shutter release, you visualize how you want the photograph to look, and then set the controls to realize your personal vision.

To do this, though, you have to know how photographic technique can alter the image on film. So in the chapter that follows we take a close look at the most important techniques of 35mm photography.

GETTING STARTED

The most valuable photographic technique you can learn is simple habit. If you are faced with an unrepeatable picture that needs slightly more depth of field, it is no use fumbling with the camera's aperture control ring—you will have missed that critical moment.

This partly explains why professional photographers rarely use the most up-to-date cameras; if you have ever seen seasoned press photographers at work, you may have been surprised at how battered their cameras are. Habit, not sentiment, is the motive for hanging on to old equipment: if you use a camera for years, you become so familiar with its nuances and foibles that you can load film without thinking.

Familiarity goes further than this. Old-time photo-graphers took pride in the fact that they could set the camera's controls to within a stop of the correct exposure just by "throwing a hand in the air to see which way the exposure's blowing." With the advent of accurate exposure meters, this skill is redundant, but if you take enough pictures, you gradually pick up an idea of approximately what settings the camera should be choosing in different lighting conditions. If the camera disagrees with your intuition, it is time to get the meter checked.

This photographic "sixth sense" comes only with experience, but, nevertheless, as is explained here, there are some good habits you can pick up from the moment you buy a new camera.

Film changing

Loading a new film is a simple task, but it is easy to get it wrong: most experienced photographers have stories about shooting 36 pictures without a film in the camera. Follow the procedure below and it won't happen to you.

Film loading time is also a good moment to make a number of routine checks on the camera, just to make sure that you have not left the exposure-compensation dial set to +2, or some similar error.

1 **Find shade** 35mm cassettes are practically light-tight in the shade, but direct sun can spoil the first few frames.
2 **Rewind** Always double check that you have wound the film back into the cassette before opening the camera back. The rewind lever should turn freely with no resistance.
3 **Check speed** Make sure that you exposed the film at the correct film speed, and that the exposure compensation dial was set to zero. Don't panic if you made an error—special processing could provide a degree of correction as explained on pages 94 and 223.
4 **Unload** Take out the film, wind the tongue in to prevent accidental re-use, then replace the film in the container; you may wish to label or number it in case the film needs special treatment.
5 **Check the camera** Operate the camera on manual at a variety of shutter speeds, making sure that everything functions normally. Point the camera at near and far objects, and confirm that the autofocus works correctly. If possible, operate the camera with the back open, and confirm the operation of the iris diaphragm and shutter.
6 **Check the meter** Compare the meter reading with the pictograms or settings printed on the film instructions. If there is no exposure guide, set the lens to $f/16$, and take a meter reading; in bright sun, shutter and film speed should be about the same. For example, ISO 400 film needs a shutter speed of 1/400 second, and the nearest equivalent is 1/500 second.
7 **Load film** Follow the camera instructions carefully.
8 **Check film speed** If the camera is DX equipped, verify that the camera has set the correct speed.
9 **Confirm film advance** Most cameras have an index that moves when film advances. On cameras that lack motorized rewind, watch the film rewind crank—it should rotate as you wind on after each exposure.

USING THE METER INTELLIGENTLY

What is the correct exposure? The lighter of these two pictures received five stops more exposure than the darker one, but neither picture is "better" than the other. They are just different interpretations of the same scene.

Bracketing

Your camera's exposure meter is a sophisticated light-measuring instrument. It may even incorporate a tiny computer, complete with memory banks and a database of the light patterns reflected by twenty or more "typical" subjects. Despite this apparent sophistication, however, your camera's meter is essentially an unthinking electronic device, and it is easily fooled by even quite everyday photographic subjects.

Virtually all built-in exposure meters, however sophisticated, make one fundamental assumption: they are designed to give good results with subjects of average tone. You will get good exposure if you point the camera so that the meter "sees" a mixture of dark and light areas, and you will get equally good results if the frame

is filled with a mid-toned subject (one that is neither a very dark nor a very light tone). But if you point the camera at a very light-coloured subject, such as a white cat, you will fool the camera into giving too little exposure, so that the cat appears grey on film. Equally, with a black cat, most cameras overexpose and, again, the cat appears grey.

The same is true with dark and light colours. Dark blue sky will be recorded as a mid-blue colour, and light blue sky comes out too dark on film, if the sky fills the area of the picture from which the meter takes its reading.

There are several ways of circumventing this problem, but, in each example, the key is to remember that the meter in your camera tries to make everything into a mid-tone.

Substitute readings
The simplest way to deal with non-average subjects is to take a meter reading from a nearby mid-tone that is lit similarly to the main subject. This way you "show" the meter a subject that should record on film as a mid-tone. Once you've taken the reading, store it with the camera's memory-lock button or set the controls manually.

Average readings
If you cannot find a mid-toned subject, take readings from the darkest and lightest areas, and use an intermediate setting.

Highlight readings
To make highlights appear pale on film, take a meter reading directly from the highlight, then give one or two stops more exposure than the meter indicates. Do this by opening the aperture by one or two settings, or using a shutter speed one or two stops slower.

Shadow readings
Similarly, you can measure the brightness of the shadows, then cut exposure by two stops.

Creative exposure control
Remember that you don't have to record subject tones as they appear to the eye. You may want to deliberately make a picture especially dark or light.

Bracketing
When correct exposure is essential, insure yourself against errors by "bracketing" the correct exposure with pictures half or one stop over and under the recommended setting.

Using the exposure-compensation dial
Constantly adjusting exposure for non-average subjects is tedious. When all your shots are very dark or light, set a constant compensation using the exposure-bias dial. For example, set two stops extra for snow-covered landscapes.

Get to know your meter
The meters in most cameras are sensitive only to selected parts of the frame. If you learn which area of the picture most influences the exposure, you will have more control over the shutter speeds and apertures that your camera sets.

The best way to deal with very light subjects is to treat them as highlights—take a meter reading in the normal way, then give an extra stop or two exposure.

CREATIVE FOCUSING

With the exception of distant landscape views, every scene contains elements at different distances from the camera. So which part of the scene do you focus on? As explained on page 54, the camera keeps sharp only part of the picture, so your decision about focusing is a crucial one. Areas of the picture behind the region of sharpest focus, and in front of it, will appear less clearly than the subject on which you focused, and they will therefore appear less important in the final image.

If you are taking a portrait photograph, the decision is not hard to make: you focus on the subject, concentrating on the eyes, as explained at right. But many scenes are not this easy: standing in a gateway, for example, the closest part of a fence may be just a few feet away from the lens, yet you may be able to see hills several miles away. If every part of the picture is important, it is hard to decide what should be sharpest.

To help you make up your mind, try to decide what part of the scene people will look at first. What caught your eye? Why are you taking the picture? What role does each element of the scene play in the overall picture?

Focusing isn't just a matter of getting everything sharp: here the difference in sharpness between the two parts of the scene separates the main subject from the background.

Some parts of a scene can be quite blurred without distracting the viewer. For example, if you are taking a picture through an open window, there is no need to keep the window-frame sharp. Equally, if you are photographing a horse grazing in a field, a distant river simply sets the scene and provides a picturesque backdrop. On film, even an indistinct flash of blue is enough to suggest a distant expanse of water.

If you still cannot decide on which element should be sharpest, don't despair: as explained on the next page, there is a way of choosing the optimum focusing point so as to maximize sharpness throughout the picture.

Autofocus solutions

If you have an autofocus camera, you will know that sometimes the camera gets it wrong. Few cameras, for example, can cope with rapidly moving subjects approaching the camera, or moving away from it. Here are other problem subjects, and how to cope with them.

Regular patterns
These include grids; uniform subjects, such as plain walls; and subjects composed of predominantly horizontal lines These subjects confuse the camera's sensing elements: with the camera in "one-shot" mode look around until you find a pronounced vertical line at the same distance as the subject, and focus on this; with subjects composed of horizontal lines, rotate the camera about the lens axis, so that the lines cross the frame parallel to the shortest side.

Subjects approaching or receding from the camera
Use manual focusing, and decide where you want the subject to be when you take the picture. Preset the lens on this distance and press the shutter release when the subject is sharp in the viewfinder.

Dim light
If it is too dark for the camera to focus, visual focus is usually difficult too. Use a focus-assist flash unit if you have one, or else estimate or pace out the distance, and set focus manually.

Off-center subject
Turn the camera to focus, then recompose and take the picture without refocusing.

Focus on the eyes

When we look at pictures of people, we always look first at the eyes, so when taking portraits, always focus on this part of the face.

This scene presented the photographer with a focusing dilemma since there was no obvious subject. However, when one of the troopers turned round, it was clear which part of the image should be sharpest.

CONTROLLING DEPTH OF FIELD

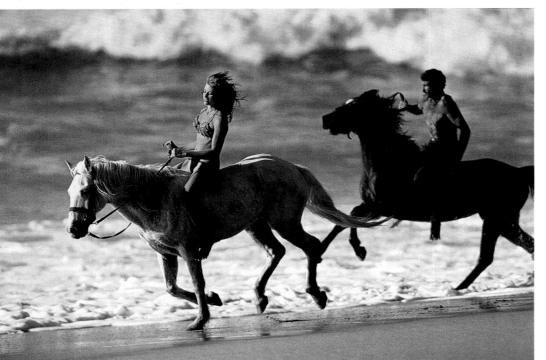

*T*he camera's aperture, coupled with careful focusing, provides a powerful control over the appearance of your pictures. Pick a small aperture, for example, and you can keep most parts of the picture sharp. On the other hand, if you use a large aperture, you will reduce the depth of field, so that unwanted details are hidden in the blurred areas of the image.

Visualizing which parts of the picture will be sharp is not always easy. If you use an SLR, you will focus and compose the picture at the widest aperture of the lens; this gives a false impression of depth of field, but it does make focusing quicker and more positive. With other types of 35mm camera, the viewfinder shows everything clearly, so you have no way of judging depth of field directly. Fortunately, though, there are several ways to estimate how much of the scene will appear sharp in the picture.

Depth-of-field preview

Many SLR cameras have a control that closes down the iris diaphragm from full aperture to the f-number set on the aperture control ring. The control is usually called "depth-of-field preview" or, sometimes, "stop-down control." When you operate the control, the focusing screen darkens, but you will see that, if you have chosen a small aperture, more of the image looks sharp. This gives you a better impression of how much is going to be in focus in the finished picture.

This control only gives you an impression of depth of field—it isn't a totally reliable guide.

Depth-of-field scale

If you have a fixed focal length lens, or a non-autofocus zoom, you will probably see a series of *f*-numbers engraved on the lens barrel, on either side of the focusing index. These marks show approximately how much of the picture will be sharp on the film.

The depth-of-field scale is accurate only for moderate-sized enlargements. If you find that the scale consistently indicates more depth of field than you see in the print or slide, use the next set of markings. For example, use the markings for *f*/5.6 when you set the aperture to *f*/8.

Maximizing sharpness

If you want to keep in focus both the far distance and as much of the foreground as possible, don't focus automatically, but instead use this simple technique. Move the focusing ring until the infinity symbol is aligned with the most distant depth of field marking for the aperture you are using. You will see that more of the picture is now sharp than would have been had you set the infinity symbol next to the focusing index.

Switching to a wide-angle lens, or the wide setting on a zoom, helps keep more of the image sharp; wide-angle lenses have inherently greater depth of field than lenses of longer focal length.

Minimizing sharpness

Sometimes you won't want the whole picture sharp. For example, if you are taking a portrait in an inner-city environment, you might want to suggest the setting, yet spare the viewer details of the scattered rubbish and the exact wording of the graffiti. You can minimize depth of field (a process called differential focusing) not only by setting a wide aperture, but also by moving closer to your subject, and by using a telephoto lens, or the tele setting of a zoom lens.

Controlling aperture automatically

You don't need to switch to "manual" to control aperture and depth of field. Choose aperture-priority metering, and your automatic camera will hold the aperture you select, setting a shutter speed that gives correct exposure in the prevailing lighting conditions. Depth programs on fully automatic cameras favour

aperture for maximum depth of field—although they don't give you as much control.

A few cameras fully automate depth of field. You point the camera at the closest and farthest parts of the subject that you want sharp, half-depressing the shutter release, and the camera moves the aperture and focus control to the optimum settings. A beep warns you if you have set parameters that cannot be accommodated.

Aperture and image quality

Most lenses give their best performance when the aperture is two or three stops smaller than maximum. When crisp, razor-sharp pictures are essential, don't set full aperture.

Differential focusing lets you concentrate attention on the most important part of the scene. Here an aperture of f/2.8 ensured that only the bust remained sharp.

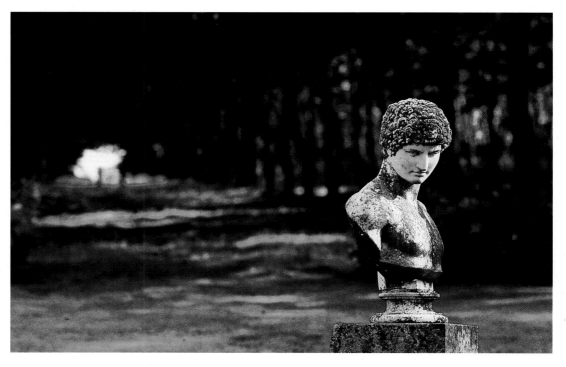

When using a zoom lens, remember that focal length can be a valuable way of controlling depth of field (far left). Zooming from 80mm to 200mm blurred the background, drawing the eye to the figures.

CONTROLLING THE SHUTTER

SHUTTER SPEEDS FOR ACTION		
Subject	Approx. speed	Camera to subject distance
Pedestrian, swimmer	3–8 kph/ 2–5 mph	5-10m/15-30 feet 15m/50 feet 30m/100 feet
Horse walking, sailing boat	8–15 kph/ 5–10 mph	5-10m/15-30 feet 15m/50 feet 30m/100 feet
Cyclist, runner	15–30 kph/ 10–20 mph	5-10m/15-30 feet 15m/50 feet 30m/100 feet
Horse racing, diver	30–50 kph/ 20–30 mph	5-10m/15-30 feet 15m/50 feet 30m/100 feet
Skier, train, car	50–80 kph/ 30–50 mph	5-10m/15-30 feet 15m/50 feet 30m/100 feet

Even with apparently static subjects, setting a slow shutter speed introduces the risk of blurring.

*M*ost people want moving objects to appear sharp and clearly defined in their photographs, probably because painters have always depicted speeding subjects as if they have been frozen momentarily on the canvas. When we see moving things whizzing past, however, this is not how we perceive them: think of the last time you stood on a railway platform as a passenger express hurtled by. If you turned your head to follow the train as it passed, you might have caught an impressionistic glimpse of faces staring back, but for the most part, the train passed as a blur.

The camera offers us the option of arresting motion by using a fast shutter speed, or of creating a total blur with a long exposure. Intermediate shutter speeds provide a range of effects between these two extremes.

How do you decide where to set the shutter speed control? This depends on what the picture is for. If you are a naturalist photographing a bird in flight for identification purposes you will want every feather as sharp as possible. But if you are making a picture story of the Formula I Grand Prix, perhaps an absolutely sharp picture isn't the ideal answer; if the racing cars were speeding past, you don't want them to look as if they are parked on the circuit.

Much of the time, a compromise solution is best, and using the techniques outlined on the right, you can combine sharp detail with a controlled degree of blurring to suggest motion without sacrificing information.

Stopping action completely

If you want to freeze rapid movement completely, the first step is to set the fastest shutter speed you can. Other factors, however, influence how movement appears on film. The size of the moving object in the frame is important, and so is the direction of movement. Distant subjects moving towards or away from the camera are easier to freeze; things moving across the picture close to the camera need much faster speeds. The chart above provides a useful working guide.

Using blur creatively

Some objects move uniformly—all parts of an aircraft, for example, move at the same speed, and if one part of

Motion at right angles to camera	Motion at 45° to camera	Motion towards or away from camera
1/125	1/60	1/30
1/60	1/30	1/30
1/30	1/30	1/30
1/250	1/125	1/60
1/125	1/60	1/30
1/60	1/30	1/30
1/500	1/250	1/125
1/250	1/125	1/60
1/125	1/60	1/30
1/1000	1/500	1/250
1/500	1/250	1/125
1/250	1/125	1/60
1/1000	1/1000	1/500
1/1000	1/500	1/250
1/500	1/250	1/125

the plane is blurred on film, so too are all others. A sprinter, though, does not move in quite the same way. When taking a forward pace, runners move their legs and arms at least double the speed of their bodies and heads. So, by choosing an appropriate shutter speed, you can take a picture that keeps runners' faces sharp—and identity intact—while recording moving limbs as an evocative blur.

Programs for speed

If your camera has a "speed" exposure program, remember that this favours *faster* shutter speeds. If you want to blur movement without having to worry about the precise exposure settings, choose the depth program instead. A better solution is to set the camera to its shutter-priority mode, where you have full control over the shutter speed.

Falling water looks most realistic at shutter speeds between 1/30 and 1/250.

93

HOW FILM AFFECTS THE PICTURE

Slow films (ISO 25–125) create images that are rich in tone and almost free of grain.

Medium speed films (ISO 160–400) have moderate grain and sharpness.

*T*here are bound to be times when you need to set a fast shutter speed to arrest movement, and a small aperture to increase depth of field. In bright sunlight, you might have few problems, but in dimmer conditions, you will probably find that the camera forces you to choose one or the other. If you override the camera's meter and set both a fast speed and a small aperture, your pictures will be underexposed.

There is one other choice, though—you can switch to a faster film. Fast film needs less light to make a good picture, so you can use a smaller aperture, or a faster shutter, or even both.

These advantages don't come free. Fast film has a more pronounced structure, called grain. When you enlarge pictures shot on fast film to about 20 × 25 cm (8 × 10 inches) or larger, you may find that areas of smooth tone, such as skin or sky, are broken up by a fine texture rather like sand. This need not be obtrusive, though, and can sometimes add atmosphere, particularly to scenes photographed in mist.

If grain is going to be a problem, it is best to use a slower film if you can. Slower film not only produces smoother tones, it also gives you richer colours, and is better able to render fine details in the subject. You will

Coarse grain (far right) needn't be a problem. Here the photographer deliberately chose a fast film (ISO 1000) to enhance the atmosphere of the misty scene.

find a chart of film speeds and types on pages 221–223 to help you choose the best speed for your purposes.

Pick your speed setting

The ISO value printed on the film pack is just a guideline speed. If your slides are consistently too light or dark, set a number 50 per cent higher or lower respectively. On prints, exposure variations are less easy to spot, and overexposure rarely matters because it can be compensated for at the printing stage. Underexposure is marked by muddy shadows on prints—set a slower film speed if you have this problem.

Changing film speed

When using colour slide film, you can control film speed during processing. If you need extra speed to compensate for dull light, just set the film speed dial to a higher index (up to four times the nominal speed) and ask the laboratory to compensate by prolonging development. This process—called pushing—does, however, reduce quality, and you must expose the whole roll at the same film speed.

Fast films (ISO 500 and faster) sacrifice quality to gain speed: grain is very much coarser.

Compensation processing can go the other way, too, so pushing and pulling can be used to rescue film if you forget to reset the film speed control after loading the camera with film of a different speed.

Exposure latitude

Different types of film tolerate exposure mistakes to differing degrees. Negative film—colour negatives in particular—has an extraordinarily wide exposure latitude, and you can overexpose by up to three stops before image quality begins to suffer. Negative film has less tolerance for underexposure, though, and as little as two stops underexposure is enough to lose detail in the shadows. Transparency film needs much more careful exposure; for the best possible quality, exposure settings have to be accurate to within 2/3 of a stop or less.

Lighting affects exposure latitude, too. In brilliant sunlight there is less margin for error than on a dull day. This is because contrast is greater—shadows are very much darker than brightly lit parts of the picture, and small errors turn highlights white and shadows inky black.

CLOSING IN

*J*ust as the light becomes dimmer when you move away from the window of a room, moving the lens away from the camera body to form bigger images also reduces the light reaching the film. If your camera has a through-the-lens meter, it will compensate for the reduced amount of light. On some cameras, even flash is measured through the lens, and with these models exposure for close-ups is no more complex than in regular photography of distant subjects. With other types of camera, though, you may have to calculate the extra exposure needed, as explained in the panel.

These formulas may seem rather intimidating, and many photographers who do a lot of close-up work prefer instead to use flash for all their pictures, standardizing magnification at several fixed ratios. A series of exposure tests establishes the correct setting for the aperture in each case, and these settings are then used for all subsequent pictures at the same magnification.

CLOSE-UP SUPPLEMENTARY LENSES
1/20 to 1/4 life size

MACRO LENS
up to 1/2 life size

50mm LENS WITH EXTENSION TUBES
1/6 to life size

BELLOWS UNIT WITH MACRO LENS
life size to 4x life size

BELLOWS UNIT WITH 28mm LENS
3x to 8x life size

EXPOSURE FOR CLOSE-UP

(a) $\text{actual exposure} = \text{exposure indicated} \times \left(\dfrac{\text{total extension}}{\text{focal length}}\right)^2$

(b) $\text{actual exposure} = \text{exposure indicated} \times (M + 1)^2$
where M is the Magnification.

To use either of these formulas it is first necessary to measure the light availale and calculate an exposure time as if for a normal photograph–this is the "exposure indicated".

The first formula, usually the more convenient to use, also requires the extension to be measured (either with a ruler or by reading the distance off the scale on, say, the bellows rail). The second method depends on the "magnification ratio", which is simply the image size divided by the size of the actual object.

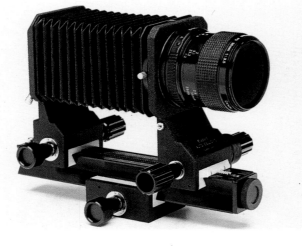

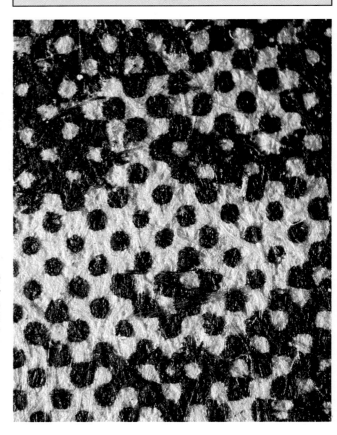

A bellows unit (above) *can magnify even everyday objects into abstract patterns: from a distance, the 15x enlargement of a newspaper photograph* (near right) *is recognizable as a face. The image of the iguana* (middle right) *required only simple close-up equipment: a 1 diopter close-up lens. For the tree bark* (far right) *the photographer used a macro lens.*

USING OTHER LENSES

Different lenses allow you to fill the frame with the subject from different distances, and changing viewpoint in turn alters the perspective of the picture. Shot on a 20mm lens (above), an isolated cross looms above the camera, but with a 200mm lens (above right) the shrine appears in more natural proportions.

Interchangeable or zoom lenses are, in some respects, unnecessary luxuries: you can take most pictures with just a single focal length. However, the ability to change focal length provides variety in your photographs, and often makes picture-taking very much easier. In a minority of instances, a camera with a fixed, standard focal length lens would be useless.

There may be an obvious reason for switching to a different focal length. At a zoo, a telephoto lens takes you right inside the hungry tiger's cage, without putting you on the luncheon menu. In a small room, a wide-angle lens seems to push the walls outwards, creating a sense of space.

Sometimes, however, the reasons for switching lenses are not so obvious. For example, when you are free to move closer to a subject, or farther away, you can use different focal lengths to change the relationship between subject and background. Walk away from the subject, and fit a telephoto lens, and you will pull the background forward, so that the subject appears in context. A wide-angle lens, on the other hand, lets you take pictures from a really close viewpoint, making the subject stand out prominently in the foreground while the same background recedes into the far distance. Thus, changing lenses gives you the facility to alter the apparent perspective of the picture. Other lens characteristics provide scope for further changes in the picture, as explained at right.

Filling the frame

The most common compositional mistake that novice photographers make is leaving too big a space around the subject. Moving physically closer almost always makes a better picture, and much of the time zooming in or changing to a telephoto lens has a similar effect. Unless there is a good reason for standing back, it is always best to pick a lens that will make the subject fill the frame.

Suggesting depth

Moving closer to the subject and fitting a wide-angle lens seems to expand space, giving the picture a feeling of depth and distance. Even in landscapes, where most of the subject is in the distance, wide-angle views look different. Why?

The answer lies at your feet, literally. A wide-angle lens takes in more of the foreground, so your pictures show the distant view in relation to nearby subjects. You can exaggerate the effect by pointing the camera down to create a high horizon.

Compressing subject planes

Long telephoto lenses (200mm and longer focal lengths) let you fill the frame from farther away, and this

distant viewpoint appears to "stack" subject planes one on top of the other. The effect is strongly suggestive of distance.

Lenses and camera shake

Telephoto lenses magnify the image on film, but they also magnify camera movement to the same degree. A rule of thumb is that you can hand hold the camera at a shutter speed that is approximately equal to the focal length. For example, if your zoom lens is set to 125mm, it is not safe to use a speed slower than 1/125 second without extra support for the camera; with a 200mm lens, the limit would be 1/250 second, and so on.

You don't have to carry a tripod to provide extra support because there are lots of ways to improvise. If you are sitting in a car, you can roll up a coat, rest this on the window and support a long lens on the pad of material. By winding the window up and down, you can adjust the support to make it a comfortable height.

If you use a wide-angle lens, you will find that it is possible to hand hold the camera even at quite slow shutter speeds without extra support. So switching to a wide-angle is often a useful way of getting rock-steady pictures as the light becomes dimmer.

Wide-angle "distortion"

Because of the way lenses form images on the film, you may see some distortion when you use a wide-angle lens. Objects at the edges of the frame appear squashed outwards and flattened. The effect is most pronounced at the corners of the picture, and becomes progressively worse as focal length shortens.

There is no real cure for this problem, so when using wide-angle lenses, keep familiar objects, such as faces, away from the frame corners.

Keeping the camera level

When we turn our heads upwards to look at a tall building, the parallel walls appear to converge towards the top—but the eye compensates, so we don't have the impression that the building is falling backwards. The camera does not compensate, however, and pictures with "converging verticals," as they are called, often look very strange. With wide-angle lens, even a slight upward tilt can cause dizzying convergence, so try to keep the camera horizontal unless you are specifically trying to create this effect. A focusing screen with etched grid lines makes it easier to level the camera.

A fisheye lens has a staggering 180-degree field of view (far left), but the curving, distorted images it creates are of value only as a special effect, or in certain scientific applications. A long telephoto lens distorts space in a different way (left), but we are accustomed to a similar perspective compression produced by telescopes and binoculars, and the images appear more natural than those from the fisheye lens.

COPING WITH LOW LIGHT

When the subject is close to the camera, flash is a good solution to the problems of low light. However, the intensity of light from the flash drops off rapidly, so distant parts of the scene are underexposed (right). Spotlit performers (opposite top) are much brighter than the surroundings: zoom in to take a meter reading, then zoom out to take the picture. Floodlighting (opposite bottom) creates fewer problems—an ordinary meter reading usually indicates correct exposure.

*T*aking pictures in dim conditions is not difficult, provided you go about it in the right way. The simplest answer, of course, is simply to slide a flash unit into the accessory shoe and leave your camera to do the rest. You will find all the detail you need to know about flash on the next page.

Flash is not a universal panacea for the problems of low light, however, and you will sometimes want to find another way to take the picture. In a concert hall, for instance, you will almost certainly be too far away to use flash even if it is allowed; the maximum "reach" of most small flash units is only about 5m (17 feet).

Most SLR cameras can take pictures in dim light even without flash, but you will have to take special precautions, as outlined here. You will rarely need to employ all the measures listed: some are helpful when light levels are slightly too low to permit hand-held operation of the camera, whereas others are more appropriate when it is so dark that you can barely see your way. All these techniques, though, make it easier to get good pictures in circumstances where flash would either spoil the atmosphere, or would not add significantly to the light levels in the scene.

Bright but distant

Brilliantly lit performers often fool the camera's meter. The camera "sees" mainly the dark surroundings, and does not fully take account of the brightness of the small spotlit patch in the middle of the frame. If you allow your camera's meter to dictate shutter speed and aperture, you may find that in the pictures the spotlit subject is both overexposed and blurred by camera shake.

One solution is to fill the frame with the spotlit area (by zooming in or fitting a longer focal length lens), and take a meter reading that excludes the dark surroundings. You can then set exposure manually. If this isn't practical, you may get good results by simply guessing the exposure. On page 216 you will find a guide listing light levels that are typical on stage, at floodlit events and in the circus ring. These are only typical figures, but colour negative film has enough exposure latitude to cope with even fairly major departures from the settings listed; with transparency film, bracket your exposures at one-stop intervals over a range of about three stops to be sure of a good result.

Making the most of the light

If there is just a little light, you will need to make it work hard if you are to get a good image. Maximize the ambient light with these tricks:

1 **Use fast film** A film with a high ISO number needs less light to make a good picture. The tables on pages 221 and 223 list all currently available films, together with their speeds.

2 **Set a wide aperture** Use the camera in manual or aperture-priority mode, and set the lens to full aperture (smallest *f*-number).

3 **Use a wide-angle lens** Wide-angle lenses are easier to hand hold at slow shutter speeds. If you use a zoom lens, set it to its shortest focal length. This has an additional benefit if, as many do, the lens has an aperture that varies as you zoom—the maximum aperture is greatest at the wide-angle end of the lens's zoom range, so more light reaches the film.

4 **Use a fast lens** If you have more than one lens, pick the one that has the biggest maximum aperture.

5 **Support the camera** Locked to a tripod or some other support, your camera can make exposures of many minutes without risk of camera shake.

6 **Push the film** If you are using transparencies, you can ask the laboratory to push development to squeeze every last bit of speed from the film.

7 **Move the lights** Try moving your subject closer to the source of light.

8 **Take a different picture** If you shoot from a slightly changed angle, you may be able to exclude some of the darker parts of the scene.

USING PORTABLE FLASH

Direct flash creates hard shadows behind the subject.

Taking the flash off the camera moves shadows to one side.

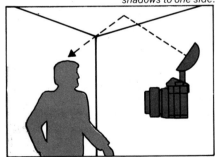

Bouncing flash from the ceiling creates soft top-lighting.

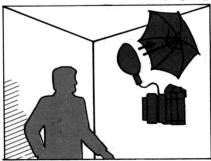

Reflecting flash from an umbrella yields soft, well-defined shadows.

*E*lectronic flash makes picture taking effortless, even in total darkness, because virtually all of today's flash units work automatically. The moment that the camera's shutter opens, initiating the flash, a sensor starts to monitor the light reflected from the subject. When the sensor detects that enough light has reached the subject, power to the flash tube is abruptly cut off, or quenched.

This system has many advantages: more distant subjects need more light, so the flash continues for longer; pale subjects reflect more light than dark ones, so the flash is quenched sooner.

Flash units differ widely in their capabilities and power. The simplest have just one connection linking them to the camera, and rely on you to read the correct aperture from a scale or dial. More complex *dedicated* units use extra connections to automate this transfer of information, and may additionally perform other functions, as detailed on page 79. The key to understanding exactly what your flash unit can and can't do is to read the instruction manual carefully—units from different manufacturers operate in quite different ways.

All flash units share the same basic mechanism, however, and perform the same function, so there are some steps you can take to realize the full potential of any flash, regardless of make or type.

Flash range

The light from a flash unit dissipates rapidly: 1.5m (5 feet) from the flash, light is four times brighter than at a distance of 3m (10 feet). And the flash lights a subject 6m (20 feet) away with only 1/16 of the brightness of the subject at 1.5m (5 feet).

You are probably familiar with at least one consequence of this drop-off in the light. Subjects close to the camera appear burned-out to white in photographs, while those some distance away appear too dark.

The solution is to keep all subjects approximately the same distance from the camera, and always to stay well within the specified maximum distance of the flash unit. In a restaurant, for example, don't stand at one end of the table to photograph your fellow diners, or those in the foreground will be much too light and people at the other end will be lost in gloom. You will get better results if, instead, you stand at one side, and ask the nearest row of people to turn round and face the camera. Everyone is now close together and will be lit equally by the flash.

Flash off camera

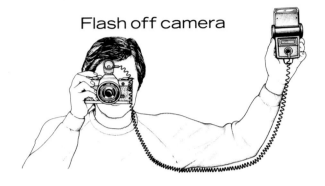

Fixed to the camera's accessory shoe, your flash produces very harsh, flat lighting. You can improve the appearance of flash-lit subjects by moving the flash out of the camera's accessory shoe and holding it off to one side, maintaining synchronization with an extension cord.

Bounce flash

Another way to soften the harsh effect of flash is to bounce the light from a white surface, such as the ceiling. Many flash units have a tilting head to make this easier. Bouncing light, though, absorbs much of its power, and unless you take care, your pictures will be underexposed. Professional flash units have lots of power in reserve, but follow guidelines below for bounce flash with any accessory shoe-mounted flash.

1 Bounce light only off white surfaces, not grey or coloured.

2 Keep very close to the subject—divide the specified maximum distance by 4.

3 Keep the flash close to the bounce surface.

Without flash

With flash

Without flash

With flash

Fill-in flash

In brilliant sunlight, you can lighten shadows using flash, but the brightness of the flash must be carefully controlled so that it does not dominate the picture. Many camera/flash combinations control such "fill-in" flash automatically—read your instructions to check. If there is no automatic facility available, set the flash unit to double the nominal film speed, then read off the smallest aperture from the available options on the chart or calculator dial. Set this aperture on the camera lens, with the camera in manual or aperture-priority mode. If you now use the meter in the normal way, you should be able to determine the appropriate shutter speed. But remember to keep the shutter speed lower than the maximum flash-synchronization speed.

4 Choose the widest aperture option available on the flash unit.

5 Watch the "confidence light" if there is one fitted to your flash—if it does not blink after the exposure, move closer.

In daylight, a portable flash adds sparkle and colour to pictures taken in overcast weather (above left and far left). Held to one side of the subject, a small flash unit helps reveal texture and form (top and above).

103

COMPOSING WITH 35MM

COMPOSING IN THE CAMERA

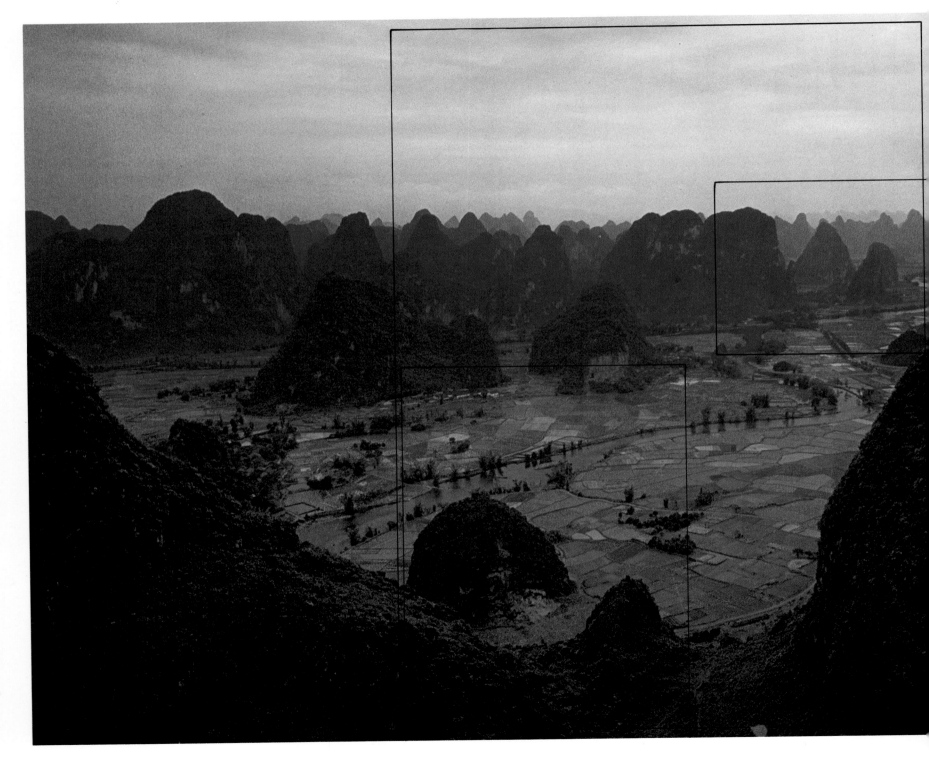

"My whole mind is a camera."

Don McCullin

*P*hotography, like music, is a universal language; it speaks with more force and with greater directness than words. But to communicate with the maximum impact in this medium, certain basic principles must first be understood, and an appreciation of both the potential and the restrictions of the camera is a vital preliminary to exploring the art and technique of photography.

Perhaps the most important fact the photographer should recognize is that the camera works in a way totally different from the human eye. To a certain extent there is an analogy between the two, but the similarities are only superficial.

However, the crucial difference is that the information collected by the eye is interpreted by the brain, whereas the camera is incapable of interpretation. Photographers, not cameras, take pictures. The person behind the camera will be influenced by sounds, smells and atmosphere, by mood, feelings and experience—and all will determine how the brain interprets the image seen by the eye. In this way the response to the information from the eye can be very different from the reality of the scene before it. Even experienced photographers can sometimes allow themselves to be influenced by outside factors.

The viewfinder of a camera is to a photographer what a blank canvas is to a painter. What goes into it is completely at the discretion of the photographer, but the photographer has much less control over the elements than a painter. In most cases the photographer has to find scenes, not create them, and can then record only what is seen. A painter, on the other hand, can physically alter and adjust the relationships between the elements of the picture. Thus, what a photographer sees and how the image is recorded is the essence of good photography.

This section of the book is designed to help you discipline your vision so that you learn to see more like the lens of a camera. Fortunately, much can be learned with a viewing frame without the expense of actually making an exposure.

The viewing frame

20 cm/8 in

25 cm/10 in

This simple device is a useful way of learning to isolate a potential image from the extraneous material or elements of which it is a part, and can save the beginner time and money. If you use this whenever there is the possibility of an interesting photograph, moving it around the field of view and at various distances from the eye, even as a novice photographer—although you may have no intention of actually taking a photograph—you will soon acquire the ability to use your eyes like a camera lens. Experienced professionals know the value of this technique, and film and art directors often use their thumbs and forefingers to make such a frame when lining up a shot.

To make a viewing frame, take a piece of black card about 20 × 25cm (8 × 10 inches) and cut an aperture 10 × 15cm (4 x 6 inches) in the middle. When this is held about 25cm (10 inches) in front of one eye, with the other closed, the field of view will be the same as that given by a standard lens on most 35mm cameras.

107

THE ART OF SELECTION

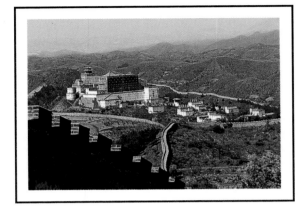

"To quote out of context is the essence of the photographer's craft. His central problem is a simple one. What shall he include, what shall he reject? The line of decision between in and out is the picture's edge. While the draughtsman starts with the middle of the sheet, the photographer starts with the frame."

John Szarkowski

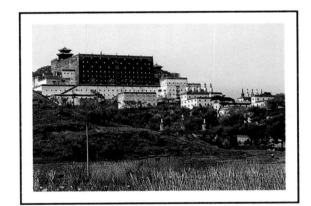

When the photographer has decided what he or she wants to photograph and why, and has identified the various components of the subject, the next step is to decide on their relative contributions to the image.

It is usually as important to know what to leave out as it is to know what to include. The viewing frame (see page 107) can be a great help in deciding which are the most important parts or features and which can be excluded. Sometimes it is necessary to be ruthless and include only the main point of interest; alternatively, by using the viewing frame, other aspects of the scene may be discovered, ones that heighten the impact and increase the interest of the photograph.

Professional photographers, to whom the cost of film is rarely an important factor, will often take many shots of a scene, experimenting with every possible combination of the components. They know that what they believe to be the most effective photograph may not necessarily be right for the purposes of their client.

Amateur photographers, on the other hand, have usually only themselves to please and can make these experiments without cost, using a viewing frame before starting to expose film. Nevertheless, taking several shots of the same object and comparing the results can be a most effective way of learning how to be selective.

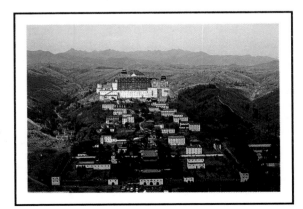

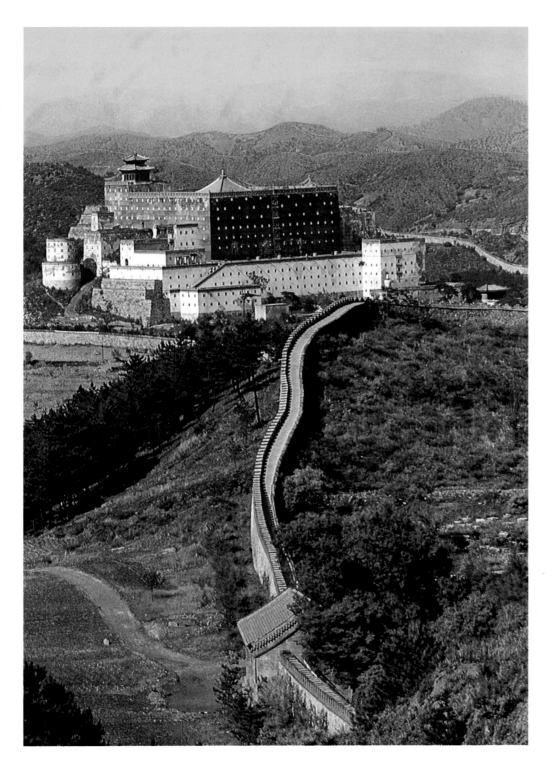

VIEWPOINT AND COMPOSITION

The photographer's ability to select and arrange the elements of a photograph is almost totally dependent on viewpoint. Indeed, where you place yourself to take a photograph is one of the most vital decisions you make, and often even slight changes in viewpoint can have dramatic effects on balance, structure and lighting. More than a century ago, in the early days of photography, the American scientist H.J. Morton summed it up like this: "The photographer cannot, like Turner, whisk an invisible town around a hill and bring it into view, and add a tower or two to a palatial building, or shave off a mountain's scalp. He must take what he sees, just as he sees it, and his only liberty is the selection of a point of view."

It is essential to move from one side to the other, closer in and farther away, higher and lower, in order to see the effect these moves would have on the photograph. With experience the selection of the best viewpoint tends to become instinctive, but the choices available should never be ignored.

Composition is simply the art of arranging the

"If the original viewpoint concept is not right, all technical procedures have small meaning."

Ansel Adams

elements of the subject—shapes, lines, tones and colours—in a pleasing and orderly way. In most cases, a well-organized picture is not only more satisfying to look at than a disorganized one, it is also easier to understand. "Composition," Henri Cartier-Bresson observed, "must be one of our constant preoccupations right up to the moment a picture is about to be taken—and then feeling takes over."

In addition to the basic "rules" there are a number of other simple but important items that should be checked every time a photograph is taken. Is the picture "level"? Are there any unwanted or distracting details in the viewing frame? Is the principal subject clearly defined and separated from the background? Such considerations may seem all too obvious to the experienced photographer, for whom they are automatic, but they can save the beginner both time and money.

While viewpoint is the most important control over composition—and in landscapes, architecture and photojournalism, for example, often the only control—there are many occasions when the photographer can physically alter the positions of some or all of the elements in the photograph. In portraiture you can move your model; in a room you can move furniture and pictures.

In still life all the subjects can usually be positioned precisely where the photographer wants them, and it is in this area that pictures can be genuinely created rather than just taken. Even if an individual is not particularly interested in still life, taking a number of simple objects and arranging and rearranging them against different backgrounds is one of the best ways of learning about composition. It is wise to start with a single object, preferably the one which is to be the most important, and then to add the others one at a time, stepping back repeatedly to examine the relationships between them. Though the unity of the composition can be helped by choosing objects that are related by a common theme, it depends more on the interaction of formal elements. It is not even necessary to photograph them: just to study the effects with a viewing frame as explained on page 107.

BREAKING THE RULES

*T*he existence of "rules" presents the adventurous photographer with a challenge. While there are guidelines to composition, they can often be ignored to good effect and no photographer should let the rules dominate his own taste or artistic instinct. For every rule there are hundreds of first-class photographs where it has been deliberately broken. "It is impossible to give you rules that will enable you to compose," claimed the English art critic John Ruskin. "If it were possible to compose pictures by rule then Titian and Veronese would be very ordinary men."

While this is true, most rules are based on sound principles, born of experience and trial and error, and it is unwise to break them merely for the sake of it, or in the hope that an unconventional composition—one with several subjects of equal importance, for example—will necessarily be an artistic breakthrough. It takes experience to distinguish between an arrangement that is successfully asymmetrical or eccentric and one which merely confuses the eye.

Some images grab the attention precisely because they break with tradition: these three subvert basic conventions of focusing on the eyes (above left) and of making the figure the main subject (above and right).

VIEWPOINT AND PERSPECTIVE

Perspective creates the powerful sensation of depth in this woodland scene: the trees appear to converge and decrease in size in the distance; and the texture of fallen leaves seems to get denser farther from the camera. Front-to-back sharpness enhances the illusion: the lens was set to f/16 to maximize depth of field.

*P*hotographs are two-dimensional, having breadth and length; to achieve the effect of depth, the third dimension, perspective, must be introduced.

In reality, of course, perspective is an optical illusion. If a book is held at arm's length it will appear to be as large as a house a hundred paces away. The closer the book is moved towards the house, the nearer to their actual relative sizes the two objects will become. It is only when the book is in exactly the same plane as the house that their *apparent* relative sizes become the same as their *actual* relative sizes. If the book is placed, say, a hundred paces away from the house, and the viewer then walks farther away from both objects, they would again begin to approach their actual relative sizes.

Recognizing perspective

Essentially there are three ways of creating perspective. The most important is diminishing scale, where objects of the same size appear to become smaller the farther

Tilting the camera upwards creates an unwanted perspective effect with architectural subjects: vertical lines converge. This picture was taken with a 28mm lens and the camera tilted upwards to include the top of the building.

The problem can be partly solved by using a lens with a wider angle of view (here a 20mm), and keeping the camera level. However, this solution makes the subject smaller, and the picture must be cropped to remove unwanted foreground.

A perspective-control or "shift" lens is the ideal solution. As shown (below right), a perspective control lens can be shifted upwards off the camera axis, to center the subject without tilting the camera.

A quite different approach is to move away from the subject and fill the frame using a longer focal length lens (here a 200mm). However, the changed viewpoint can make the proportions of the building look quite different.

they are from the viewer. The second, and perhaps more immediately obvious, is linear perspective—straight, parallel lines that appear to converge in the distance. The third method is overlapping perspective, where a feeling of depth is given by one object partially masking another. Shadows, too, can emphasize the feeling of depth.

An understanding of perspective will help you compose a better picture, for by using it you can control the relative importance of objects within the image area. Objects which progressively diminish in size create the impression of lines within the photograph—yet another factor of importance in composing a shot.

Depth and scale
However, many situations in photography present themselves where depth and perspective are positively

undesirable—when depth is of less importance than the scale of objects. A building at the foot of a mountain would gain in impact if photographed from a sufficient distance so that the depth was minimized and the true scale of the two elements allowed the mountain to dominate the building.

There are nevertheless many other occasions when introducing foreground and mid-ground objects, and thus deliberately creating a feeling of depth, can greatly enhance a photograph. Take a view from a mountain top looking down on to a village in the valley below: by introducing a rock and part of the mountain slope into the foreground of the picture the impression of depth would be dramatically increased.

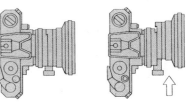

LIGHT, FORM AND TONE

> "The photographer can function as long as there is light; his work—his adventure—is a rediscovery of the world in terms of light."
>
> *Edward Weston*

Backlighting (top right) reveals nothing but the outline of the object, and provides little information about form and shape. Hard side-lighting (middle right) such as sunlight reveals more about shape, but still hides detail in shadow. Soft yet directional lighting (right) provides maximum information.

Mist produces very soft daylight that illuminates the subject from all sides (top right), thus suppressing form. Here, the qualities of mist have been used to turn woodland into a pattern of simple tones. Compare this picture to the woodland scene on page 114.

*M*ost everyday objects can be recognized by their outline alone. A vase silhouetted against a window will be immediately identifiable because we have all seen vases many times before. Yet you will not be certain whether it is round or square until you can see its form—and that is dependent on light.

Light is crucial to photography: the very term, coined by Sir John Herschel in 1839, comes from two Greek words that together mean "writing with light." Light creates shadows and highlights and it is these that reveal form, tone, texture and pattern.

Quality and direction of light

The two aspects of light that affect form are its quality and its direction. Quality is the term used to define the nature of the light source. This may be soft, giving faint shadows with imperceptible edges, such as daylight on a cloudy day; or it may be hard, like bright summer sunlight at noon, which casts dense shadows with sharp edges. There are also all the effects between.

The direction of the light is equally important to form. Light which is directed straight at the front of an object will not reveal much more information about its form than would a silhouette. There will be no shadows within the object itself, and unless it has a reflective surface—such as glass or metal—there will be few highlights. As soon as the object is moved so that the light source is directed from one side, shadows within the outline will appear and the form of the object revealed.

If the light source is hard, the shadow within the object will be dark, with little or no detail. The change between the highlight and the shadow will be abrupt, so although the viewer will begin to see the form of the object, the visual information will still be limited. If a soft light is directed from one side of the object, however, the transition from highlight to shadow will be much more gentle and the shadow itself less dark. The detail and form will then be seen more easily. In general a soft, directional light is more likely to reveal form than a hard one.

A common exception to this is landscape photography, where form (in this case the contours of the land) is much less pronounced than it is with objects — or indeed with people. This is one of the reasons landscape photographers prefer to work either in the early morning or the late afternoon, when the sunlight is strongly directional and yet still quite hard. But it should also be noted that where the contours of the land are extreme, as in mountain scenery, this results in dense shadow areas with little detail.

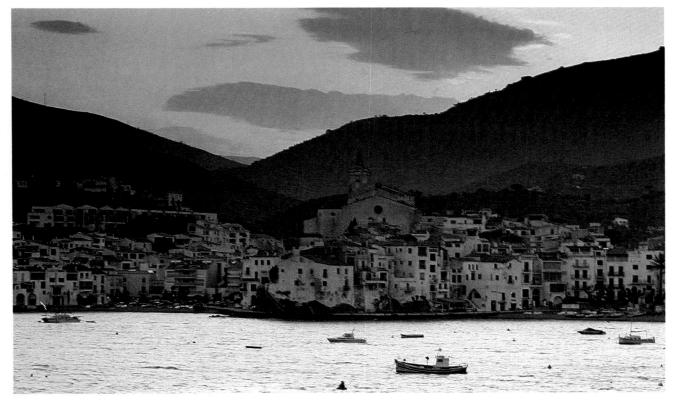

Low sunlight (above) vividly reveals the form of these white-washed windmills: duller weather would have made them look flat and uninteresting. By contrast, the harbour scene (left) is a much more subtle tonal study: sunlight would have brought out the busy shapes of the tightly packed old buildings, so the photographer waited until twilight before setting up the camera.

LIGHT AND TEXTURE

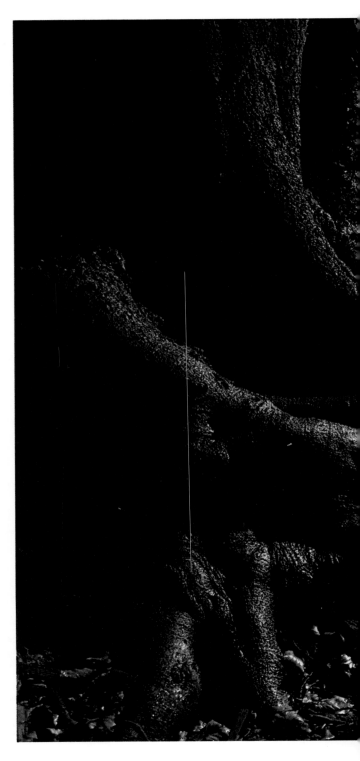

*T*exture and form are closely related, texture being the form of a surface. To a landscape photographer, for example, a ploughed field in the distance would be a texture within his image, but when seen from a few paces the individual furrows would have form in their own right. On the other hand, an egg viewed from a distance has only form, but when looked at closely the dry, pitted nature of the texture on the shell is apparent. The furrows in a ploughed field would also reveal the texture of the earth, of course, when viewed closely.

While form is generally best revealed by a soft, directional light source, texture usually needs a harder, even more directional light to be accentuated. But, as with form, the more pronounced the texture the softer the light source required. Powerful lighting will exaggerate the texture of a rugged surface and, although they can create a dramatic effect, the shadows cast by a strong directional light will tend to distort the true form of an object. These are generalizations; the more we become aware of the distribution of light and shadow in the subject the more we will be able to utilize light for maximum effect.

Adding the tactile element

Texture can be an important aspect of a photograph because it creates visually a sense of touch, giving a tactile quality to shape, form, tone and colour: not only can we tell what an object looks like, we can also sense how it would feel. Our perception is, of course, dependent on our experience of a particular surface, the photograph merely recalling its softness, roughness or gloss. The camera is unique in its ability to record extremely fine detail and texture sharply and accurately, and photographers can magnify the texture of a familiar surface to a point where it is unrecognizable.

Before the spread of photography in the mid-nineteenth century, painting was preoccupied with the faithful rendition and reproduction of detail, tone and texture. The advent of the camera was one of the factors which led to the massive changes which brought about Impressionism and abstraction in art. Now, when photographers attempt to be more "artistic," the first thing many of them do is to soften the image.

Hard lighting, from a flash (right), *or from low sun* (far right top), *shows texture, but in flat lighting you'll have to look for other ways to reveal surface qualities. In landscapes, for example* (far right bottom), *patterns of growth sometimes help to enhance texture.*

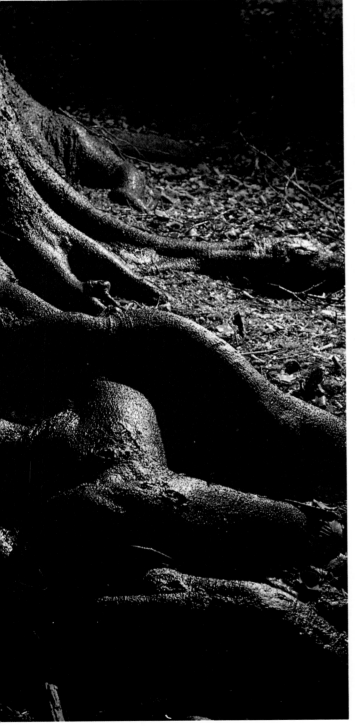

119

UNDERSTANDING COLOUR

The colour wheel is a schematic way of representing the relationship between colours. Adjacent colours harmonize fairly readily, while complementary colours (opposite each other) tend to contrast.

Similar hues (near right) create harmonious soothing images, and contrasting primary colours (far right) make for a more lively, active composition.

While an instinctive response to colour is of greater importance to the photographer than an understanding of the physical nature of light, even the most creative artists will benefit from a little curiosity in their medium. Moreover, some small knowledge of theory is essential to everyone wishing to make their own colour prints.

The basic principle of colour photography is that any colour can be reproduced out of a mixture of only three basic "primary" colours—red, green and blue. White light, consisting of a combination of the three primary colours, can be separated into its components, but can itself be produced by combining red, green and blue lights. These three colours are therefore called the "additive primaries," and the production of multicoloured images by mixing them together is known as "additive synthesis." However, the method is inconvenient in practice and not used to any great extent in photographic colour systems.

Most practical colour photography employs the method known as "subtractive synthesis." Instead of beginning with three coloured light sources, the subtractive method uses a single white light and creates various colours by filtering out the colours not contained in the desired colour. The filters used in this method are coloured yellow, magenta and cyan and are called the "subtractive primaries," because each of these colours has the ability to block or subtract from the light one of the additive primaries. Yellow subtracts blue, magenta subtracts green, and cyan subtracts red.

The colour wheel

Consideration of colour has to be related to psychology and physiology as well as to physics. The emotional effects of colours in various combinations and juxtapositions depend to a great extent on the individual, and generalizations about which colours "go well together" should be regarded with a certain amount of suspicion. Nevertheless, some explanation of the more obvious dramatic effects can be found in the relationship individual colours have to each other on the "colour wheel"; if a colour is placed side by side with its complementary colour the result is likely to be discordant, while colours close to each other tend to blend.

Perhaps the strangest aspect of colour photography is that it is not necessarily the brightest or most colourful

In additive colour synthesis, hues are created by projecting red, green and blue beams of light in different intensities. Adding red and green, for example, makes yellow. TV works through additive colour synthesis.

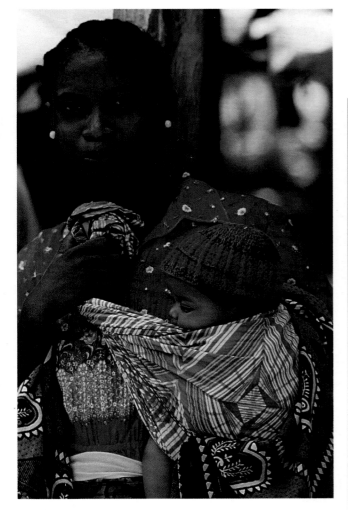

scenes that produce the most striking colour photographs. Often a very restricted range of colours with only one dominant primary will give the impression of being highly "colourful," while multi-coloured photographs may appear disappointingly weak.

Eliminating all but one colour produces punchy, graphic pictures, especially if you pick a subject that contains an element of pattern.

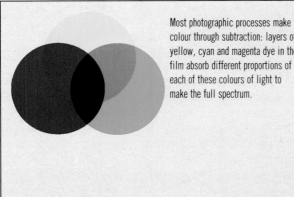

Most photographic processes make colour through subtraction: layers of yellow, cyan and magenta dye in the film absorb different proportions of each of these colours of light to make the full spectrum.

121

COLOUR SENSE

*T*hrough tones and hues colour defines form and communicates emotion and mood. Advertising photography is notorious for its control over our responses through its clever use of colour. These techniques of persuasion are not beyond the ability of the amateur photographer, who, rather than wanting to sell a product, wishes to give a picture maximum atmospheric impact.

A common myth about colour photography is that it is an exact reproduction of an image. Since the photographic process involves slight distortion, the colours of the result are hardly ever the same as the ones seen by the same person at the moment of exposure. Nor does this inaccuracy necessarily matter: as the Impressionist painters realized, colours are continually changing according to the hue of the ambient light and their proximity to each other.

Nevertheless, colour enables the photographer to record with a greater degree of accuracy than does black and white. A monochrome photograph is abstract

because it leaves out an important visual element. Yet because a photograph is a self-contained work of art rather than mere representation, the black and white photograph has by no means been eclipsed by colour; it simply offers other qualities.

Colour photography demands a different creative outlook—a visual change of gear. Colour photographers must compose with hue as well as tonal contrasts and values; the ways in which the temperature and distribution of colour can create space and form must be observed; they must be aware of preconceptions about colour, which are sometimes strong enough to blur judgements and lead them to see the grass as being greener than it really is.

Some people appear to have been born with a well-developed colour sense; they choose clothes and furnishings with an apparently instinctive ease. Yet it is possible for most people to develop a sound awareness of colour simply by looking hard and observing the ways in which colours affect each other. If taste can be cultivated through this kind of sensitivity, it has a good chance of becoming personal; otherwise good taste is likely to be dominated by fashion.

Colour theories, based on the structure of the spectrum, offer guidance only within limits. For example, colour harmony can be attained either by using many tones of the same colour or colours from any quarter of the colour wheel (see page 120). Having established harmony, however, it may be necessary to liven up the picture with a dash of discord. Colours from opposite sides of the wheel, known as complementaries, can sometimes enhance each other by contrast.

Neither bright colours nor subdued ones are automatic formulas for success. Contrasting and fully saturated colours can create too many focal points, all fighting for the viewer's attention. A large flowerbed in full bloom might appear an inviting subject, but the finished photograph may be a jumble of competing hues with no point on which the eye can rest. In such cases it is preferable to select and simplify.

Monochromatic images (far left *and* above left) *work best if you compose them with some focal point of a different colour. A large expanse of a brilliant hue is so overwhelming that the eye seeks relief—and finds it here in the white path and green foliage. Certain colours are so brilliant and evocative that even a splash is sufficient to bring a picture to life* (above).

COLOUR AND MOOD

Juxtaposed with the vigorous clamour of colours above, this quiet moment of family affection seems especially warm and peaceful.

*O*f all the formal elements in a photograph, it is colour that makes the most direct impact. In order to have control over the image, the photographer must be aware of the ways in which colour generates mood and atmosphere. A pink rose may endorse that flower's intimation of peace and gentleness; a dark crimson one may contradict it.

There is no generally accepted view as to why specific colours inspire certain feelings; nor are the same feelings universally applied to the same colours. European mourners traditionally wear black and brides wear white, but in India Hindus attend funerals in white and women are married in scarlet. Danger seems to be the only situation which is symbolized by the same colour (red) in almost every culture.

Some emotional reactions to colour may be conditioned by colours in nature. White, symbol of purity, recalls freshly fallen snow; black, a colour of gloom, is

associated with the absence of light and warmth at night; greens and blues suggest the tranquillity to be found among woods, hills, lakes and fields; yellows and oranges, colours of sun and fire, create an impression of warmth, brightness and happiness.

To the photographer the quality of a colour depends not only on its name but also on its tone, its "temperature" (see page 128), the area which it covers and, most important in a visual sense, the colours against which it is seen and photographed.

The nineteenth-century painter Delacroix said that he could paint the flesh of Venus convincingly in mud provided he controlled the colour against which it was juxtaposed. Since colours change and are changed by each other, the photographer must see each one in relation to the picture as a whole. The yellow of an armchair, which might appear soothing and happy in an expanse of green—its neighbour on the colour wheel—

might look discordant and shrill if placed next to violet, its complementary colour.

Since light is the source of colour, it affects the mood of an image. The photographer must be aware of more than just the dramatic changes in lighting, and must register the hues, tones and temperatures of a colour, which can fluctuate according to the weather and the time of day. Colours are very different under overcast skies from the way they appear in harsh sunlight, in the mellow afternoon glow or in the warm light of dusk.

Clashing yellows and blues add drama to this stormy landscape (below left); a polarizing filter made the colours brighter. Tinting the frame sepia with an 81EF filter (below) eliminated colour contrasts, creating a sense of intimacy.

Taking a Detailed Look

Focusing on details is often just a matter of observation and viewpoint: both these pictures were taken using a standard 50mm lens, with the camera set to automatic.

Observant photographers can find pictures within pictures indefinitely. We might begin by photographing a building, then a section, and then select a detail of one window before isolating a figure framed by that window. Often it is the detail which says more about a subject than the whole.

This awareness enables us to find an inexhaustible wealth of subject matter everywhere we look. Many situations which are conventionally dismissed as having little visual interest incorporate details which only have to be taken out of their original context to become dramatic or decorative images or striking patterns. Areas of colour, isolated from the object to which they belong, have powerful abstract potential.

An eye for detail is too often limited by a connoisseur's prejudice and a reliance on details of historic or artistic importance. Gargoyles, stained-glass panels and medieval turrets are undoubtedly fascinating, yet no more so to the detail hunter than things of less aesthetic significance. A broken and discarded house brick may have no intrinsic artistic appeal, but a close-up of its surface, revealing texture and colour, could make as interesting a composition as any detail of ornamentation. To most people, a scrapyard is a chaotic conglomeration of rubbish, devoid of any visual harmony or interest, but to the photographer it can provide innumerable opportunities for selective detail. Ernst Haas, a photographer who has recorded the surfaces of decaying walls and squashed metal cans, maintains that the "final stage of photography is transforming an object from what it is into what you want it to be."

The photographer should not overlook the human or animate details that overlap the static ones. Details of human life may mean anything from a shot of an insignificant face in a crowd to a revealing close-up of wrinkled skin or a part of the body.

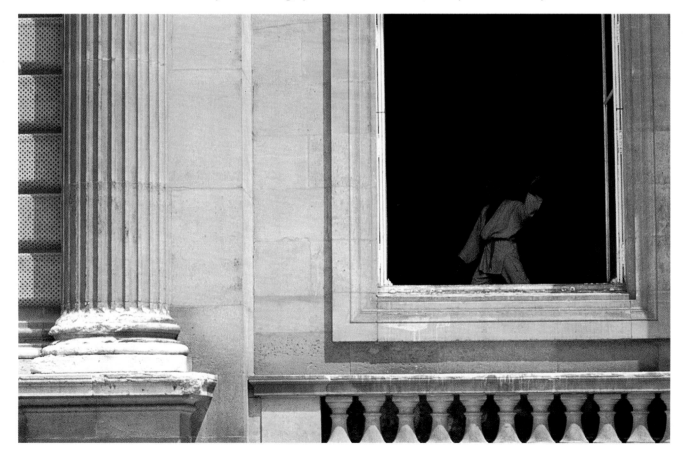

Focal length choice and framing are valuable techniques for picking out details of distant subjects. A 300mm lens separated out this rank of guardsmen (far left) from a much larger parade. Though the judo lesson (left) occupies just a small portion of the image, the architectural details draw the eye to the activity seen through the window.

LIGHT AND COLOUR

*M*any optical illusions are based on the fact that the brain interprets what is seen by the eye rather than accepting the information literally. This applies to colours as well as to shapes. The knowledge that an object is white, for example, can cause the brain to disregard colours reflected by the object, so that it continues to appear white even when viewed under a strongly coloured light such as candlelight, which is a warm yellow. Consequently, the brain does not normally notice quite dramatic changes in colour, such as the difference between candlelight and daylight. Colour film, on the other hand, records colours literally, making no allowance for an overall blue or red cast which may be characteristic of the light source. Many photographs, even though correctly exposed, have been spoiled by the presence of an unexpected colour for which the brain corrects but the film does not.

Colour temperature

"White light" can thus mean a whole range of different colours. It is possible, however, to measure the colour of light using a scale called "colour temperature."

This scale provides a way of checking the colour of daylight (which changes constantly) or of comparing daylight with candlelight used in the example earlier. To colour film, the difference between a reddish-white and a bluish-white is critical: every colour film is balanced for a particular colour temperature, the basic division being between daylight (relatively blue) and artificial light (relatively red). A film designed to produce "natural" colours when used in one kind of light will usually produce unpleasant results if used under the wrong conditions. It is possible, however, to use coloured filters to raise or lower the colour temperature of the light so that it matches the balance of the film. A pale blue filter, for example, will raise the colour temperature of ordinary indoor lighting, making it suitable for daylight film.

It is ironic that in terms of scientific colour temperature, those colours generally associated with warmth—reds, oranges and yellows—are cool, while blues and greens, normally referred to as cool colours, are hot. However, since the psychological responses provoked by certain colours have little to do with the system devised to measure colour, the difference in terminology rarely causes confusion among photographers.

Most colour film is designed for use in daylight, and when tungsten light bulbs illuminate the subject, pictures taken on ordinary film develop a strong yellow colour cast (near top right). Film manufactured to give its best results in tungsten light (far top right) shows the subject in her true colours.

With appropriate filtration, daylight-balanced film can give good results in almost all conditions. Sunlight yields the most natural hues (near right), but with a blue 80A filter, you can use the same film in tungsten light (far right).

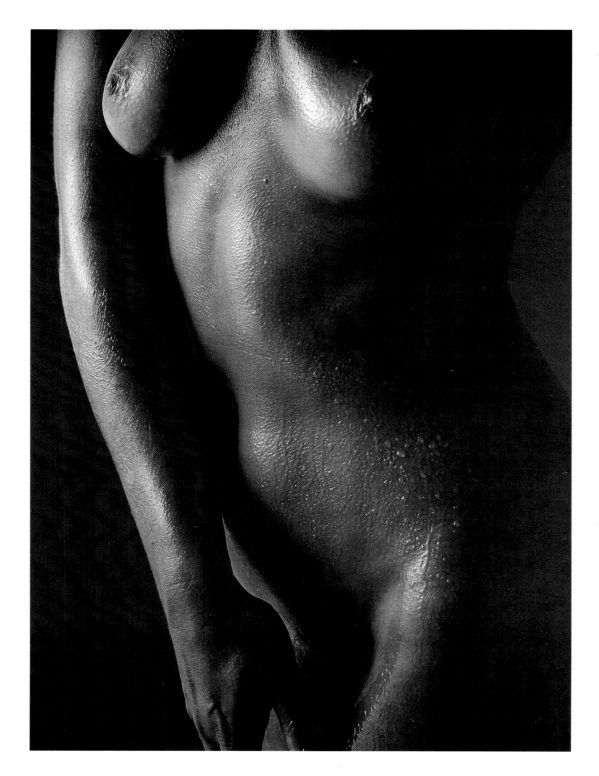

129

SPECIAL FILM TECHNIQUES

Wrap a flash gun in coloured cellophane and you can tint the foreground of the picture with exotic hues. Make sure, though, that the sensor on the flash unit is not covered by the coloured plastic, or your pictures may be overexposed. You'll get best results with colour negative film, because of its broad exposure latitude.

The 35mm format offers the photographer an unparalleled choice of film types, and the scope for experiment is almost unlimited. Even ordinary film can produce extraordinary results with a little creativity, as shown above, but infrared film opens the door to a fantasy world in which foliage appears white or brilliant red, and skies turn black.

Most 35mm cameras can take infrared pictures, but cameras with plastic or wooden bodies, shutters made of plastic, rubber, or rubberized cloth (and some types of close-up bellows) may transmit infrared, resulting in strange fog patterns on the photograph. The problem can be overcome by wrapping the camera in foil, leaving holes for the lens, viewfinder and shutter release.

As with normal colour film, colour infrared film has three layers, but they are sensitized to green, red and infrared. Because all the layers are sensitive to blue light, an overall bluish effect will result unless a yellow filter is used to compensate. The effect on most common colours, such as green, can usually be predicted, but a mixture of colours will provide a kaleidoscope of strange and unexpected shades.

Although camera lenses do not focus infrared rays in the same way as visible light rays, this is not a consideration with colour infrared film. Some cameras have a red dot on the focusing scale to give an average correction for infrared photography, but this focusing index should be used only with black and white infrared film.

The best results are usually obtained in fairly bright daylight. Since clouds absorb infrared, exposure times must be longer in overcast conditions. The safest all-round artificial light source is probably electronic flash, where the colour quality is similar to that of daylight.

Infrared film is more sensitive to heat than ordinary film and must be kept at a low temperature. Unopened film can be safely stored in a domestic refrigerator, provided the temperature is 13°C (55°F) or lower; for long periods of storage the temperature should be −18°C (0°F) or below. Film should be taken out of the refrigerator two hours or so before use so that it returns to normal room temperature.

Monochrome infrared film produces the wildest transfigurations if you use a visually opaque number 87 filter (above) and set the camera's exposure meter to ISO 25. Put the filter in place only after metering and focusing. With colour infrared film, use a number 12 or 25 filter and set the meter to ISO 100. Always bracket pictures; an exposure meter measures only visible light, and therefore indicates only the approximate exposure.

THINKING IN BLACK AND WHITE -1

People associate black and white images with the past, so monochrome film provides a simple but effective way of evoking a vanished era. Here attention to clothes and other details creates a flavour of the 1950s, and shooting in black and white completes the illusion.

It is easy to forget that up until half a century ago "Photography" meant black and white pictures to most people. Although the concept of colour photography was first demonstrated in the 1860s, all colour processes were at best cumbersome until the advent of Kodachrome film in the 1930s.

Today, of course, we take colour for granted, but black and white photography is far from obsolete. It offers opportunities for creativity that colour photography simply cannot match. The reason is simplicity: the medium is accessible—anyone can expose, develop and print monochrome images using inexpensive equipment and materials; and control and manipulation of images are also simple matters. By comparison, developing and printing colour film is complex and provides fewer controls over the appearance of the picture.

The simplicity of black and white, however, lies not just in its processing, but in the appearance of the images themselves. Without colour, we see a different, unadorned view of the world, and even clashing hues do not interfere with the composition of the image.

Monochrome composition

Success in black and white photography requires some different skills from colour photography. Because colour is absent in the picture, you must learn to disregard it, and see only differences in brightness when you look through the camera's viewfinder. This is not always easy, especially if there are strident colour contrasts in the subject, such as brilliant red and green subjects placed alongside one another. Each reflects equal amounts of light, so the two appear on black and white film as the same shade of grey. Colour film would capture the discord between the two objects, but on black and white film, the distinction would be meaningless.

So when you load black and white film into your camera, you must learn to take a different kind of picture. With practice, you will find yourself seeing images that perhaps you would not have noticed when shooting colour film.

Black and white film excels when depicting the interplay of light and shade. For example, everyone is familiar with the joy of wandering through dew-soaked woods on a spring morning, and watching shafts of

132

THINKING IN BLACK AND WHITE -2

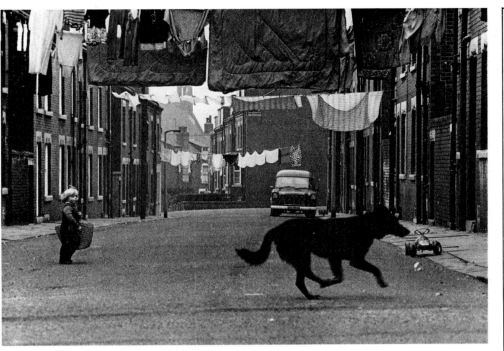

Monochrome has overtones of gritty realism: if the picture above had been shot in colour the bright laundry would have glamorized the mean city street. Black and white film provides total control over tones —here, burning in the sky draws attention to the church and oast houses (left).

sunlight lance through the canopy of leaves; monochrome film is uniquely capable of capturing the essence of such a scene. Colour film, on the other hand, introduces distractions: though beams of light seem bright to the eye, they actually make quite a subtle image on film, and are easily overwhelmed by colour contrasts in other parts of the picture. Green leaves in the foreground draw attention away from the sunbeams, and a distant figure in a red coat catches the eye and spoils the composition. In monochrome, these distractions don't compete with the chosen subject of the picture.

There is one other area of photography where black and white still has more impact than colour— photojournalism. Colour film has a tendency to glamorize anything it records, because colours that are completely incidental to the picture can easily conjure up an almost carnival-like atmosphere. Black and white images cut through this superficial appeal, and— ironically—produce a heightened sense of reality that draws the viewer right into the scene.

Dye-image film

If you want to experiment with black and white photography, but don't have access to a darkroom, you may want to try a dye-image monochrome film, such as Ilford XP1. Though this film makes black and white negatives, it uses the technology of *colour* negatives to produce the image, and is processed in the same C41 chemicals.

This means that you can take the film to any processing laboratory, and it will be developed and printed just as if it were colour film. The prints you get back may not have perfectly neutral blacks and clean whites, but they are good enough to enable you to assess which negatives are worth enlarging on to normal black and white paper.

A dye-image film has other advantages, too. It has enormous exposure latitude, and a chameleon-like image structure. Generous exposure creates very fine-grained, even-toned images; but exposing the film sparingly does not sacrifice detail in the shadows.

Some photographers take full advantage of this characteristic and use dye-image emulsions as "universal" films. Instead of keeping a slow film for detail and a fast film for action, they simply use one film, and change the setting on the camera's film-speed dial. Exposed at ISO 125, Ilford XP1 can match any film of comparable speed for quality, yet speeds up to ISO 2000 still yield perfectly acceptable negatives.

MULTIPLE IMAGES

There are several ways of making a multiple photographic image, including multiple exposure in the camera, the use of prisms and mirrors, projection on to a screen, montage in the darkroom and montage by hand.

One of the simplest techniques involves holding a small mirror close to the camera lens at approximately right angles to it. This produces a split image with one half a reversed view of the other.

A projector can be used in three ways to produce a multiple image. Back projection enables a background to be provided by a transparency projected on to a translucent screen positioned behind the main subject. The two elements are photographed separately on the

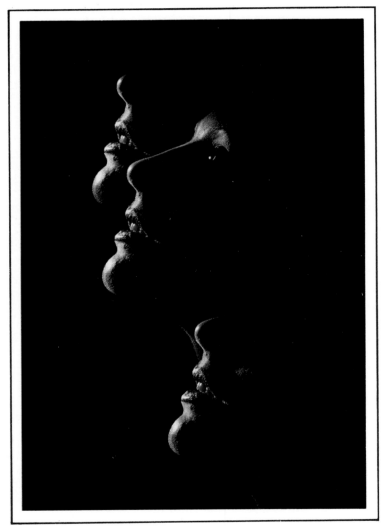

Multiple exposures such as this portrait are most effective when the background is dark, so that each exposure appears clearly separated on film.

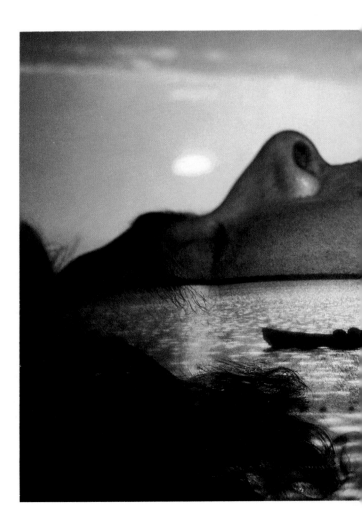

same frame, the foreground with the background screen covered with a black cloth and then the background image with the foreground in silhouette against it, ensuring, of course, that the exposure is correct for each element.

In front projection, the background element is projected from the front along the camera lens axis with the aid of a two-way mirror. The screen is made of a highly reflective material ensuring that there is enough light from it to enable the photograph to be taken at an exposure suitable for both elements.

A third method is by projecting a slide directly on to the subject—a landscape projected on to a nude, for instance.

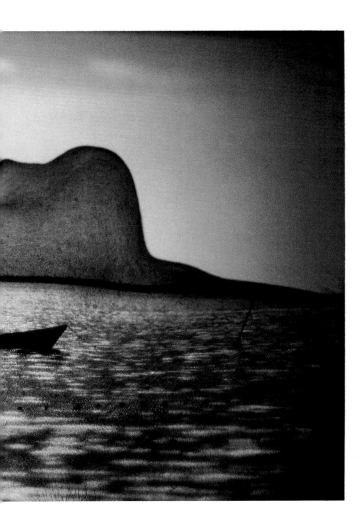

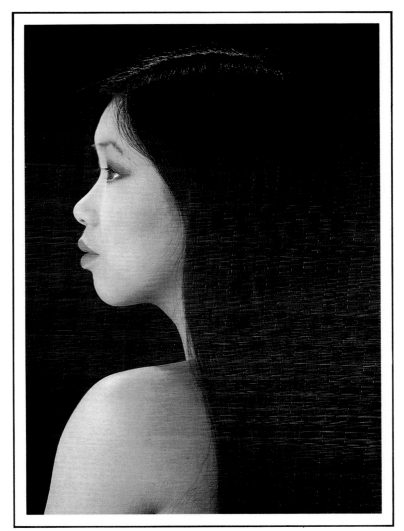

An ordinary slide projector was the only light source for this dream-like portrait (left), and the picture was made in a single exposure, but to add texture (above) the film was exposed twice. The first exposure of the model was made in the normal way, then the fabric was added by taking a second picture, two stops underexposed, on the same frame.

137

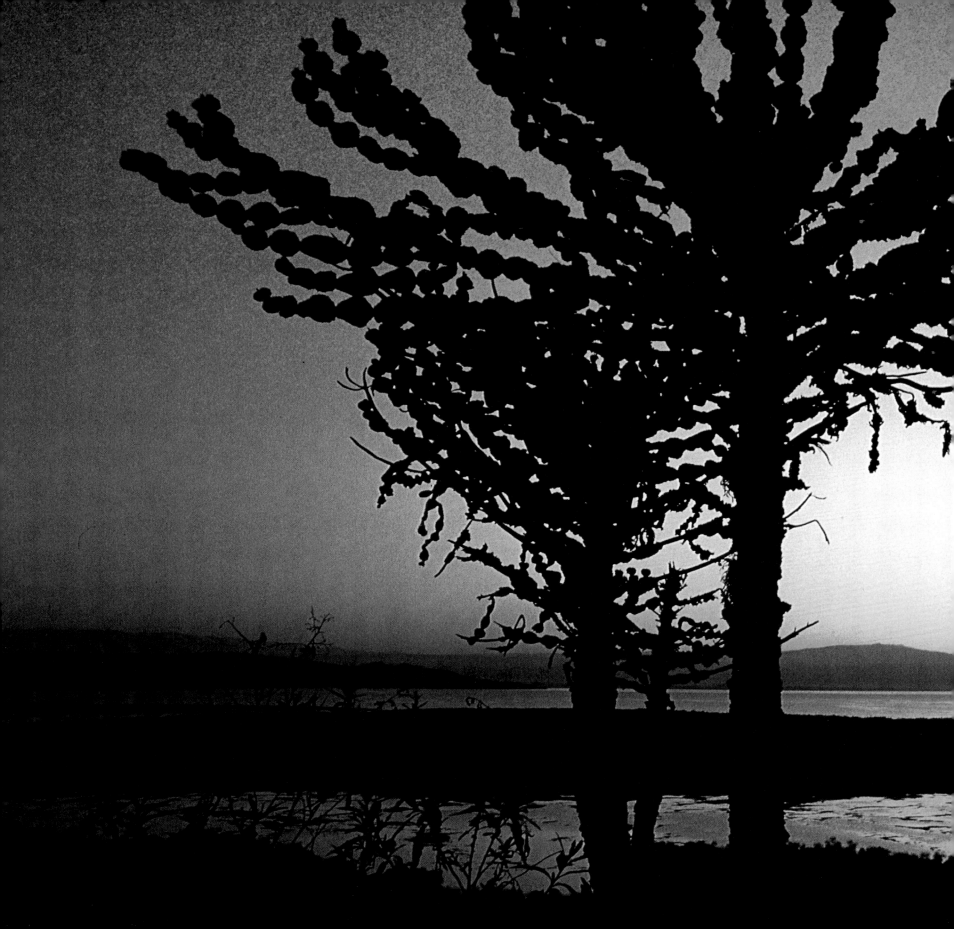

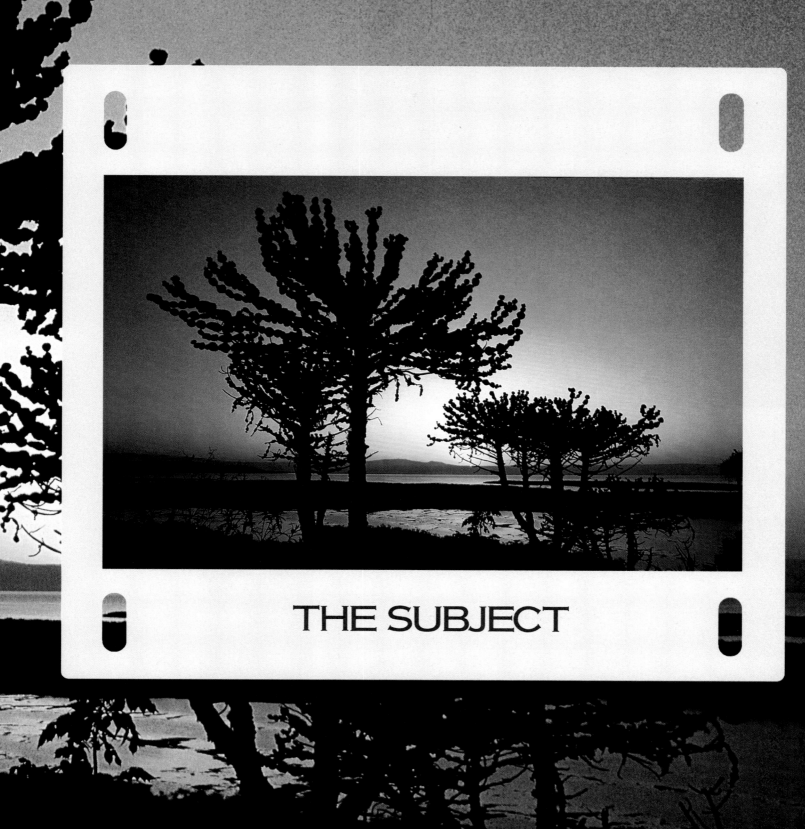

THE SUBJECT

PEOPLE—FORMAL PORTRAITS

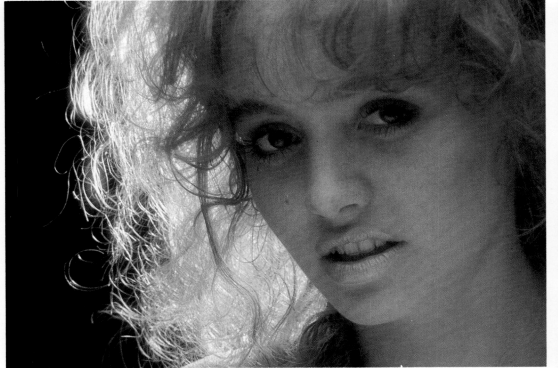

One light near the camera produces a harsh beam, and shows little of the form and character of a face.

Moving the lamp to one side and diffusing the beam improves the picture, but shadows are still too dark.

A reflector on the unlit side of the sitter fills in the shadows, without the risk of conflicting shadows.

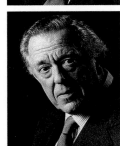

Backlighting reveals more texture, particularly with a snoot on the light to narrow the beam.

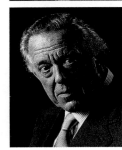

Adding a blue filter over the lens or light increases texture in the skin, but requires two to three stops more exposure.

Backlighting can create very natural-looking portraits (above) with just a single lamp; use a large reflector to bounce light back into the shadows. Sunlight (facing page) is not ideal for portraits; it creates harsh shadows under the chin and in eye sockets. As shown here, the answer is to move into open shade—but make sure that sunlit grass does not tinge the shadows with green.

*T*echnical proficiency and visual sensitivity are not sufficient in portrait photography. Two human beings are involved in the creative process and its success ultimately depends on their relationship. The celebrated theatrical photographer Angus McBean has written: "You have at your mercy that tender thing—a human being—with a lot of light on its most tender point, its personal appearance. . . . Do everything you can to make them unselfconscious."

To establish a rapport with his or her subject the photographer should be relaxed and confident; an appearance of uncertainty is inevitably infectious. There are no rules for relaxation, however; conversation may help the sitter to forget about the camera, or it may seem as disturbingly artificial as the soft music played to soothe the nerves of anxious air travellers.

As with all aspects of photography, it is essential to understand the purpose of a particular portrait. If it is taken at the request of the sitter, an element of flattery may be necessary; if taken for the photographer's own satisfaction, the emphasis may be on revealing or exaggerating character. Most of the best portraits are

not merely likenesses: they are interpretations of personality and character. The great photographer Irving Penn sees portraiture as "a kind of surgery; you cut an incision into people's lives."

The difficult task of choosing which facial features to emphasize and which to subdue depends to what extent and in what way the photographer wishes either to flatter or to reveal the personality of the sitter. As a general rule, features that indicate or betray character—age wrinkles, laughter-lines and dimples—should be retained, while features that tell little of character, such as skin blemishes or protruding ears, should be played down. In many outstanding portraits the face is almost eliminated or hidden in shadow, while others are given added impact by including the entire figure.

If the portrait is full or three-quarter length, careful attention must be given to the hands; their form and position can reveal almost as much about the subject and the background as can the face.

The type of lighting employed must suit the face in question: the best light for the main source is soft and directional, achieved either by bouncing light from a large white reflector or by using a white translucent screen between the lamp and the model. The effects of different lighting arrangements are illustrated on these pages.

INFORMAL PORTRAITS

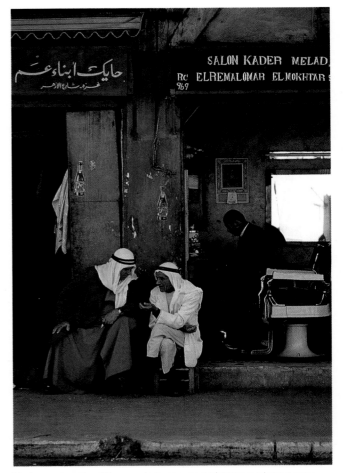

Timing makes the difference between good pictures and great ones—in conversations, wait for a telling gesture.

Nervous portrait subjects usually relax if you give them something to distract their attention from the camera.

*M*ost amateur and much professional photography falls under the umbrella heading of informal portraiture—a title which covers anything from children giggling at the camera to Buddhist monks absorbed in meditation. Any photographic portrait which has not in a sense been posed in the studio or home can be called informal.

Although less contrived, informal portraiture demands no less skill. The photographer has to be constantly on the alert to make instant decisions and catch a pose before it vanishes.

In the case of a genuine informal "portrait," where the subject is totally aware of the situation, he or she should be made to do something, such as reading a

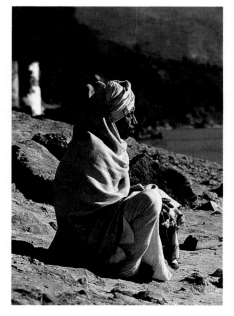

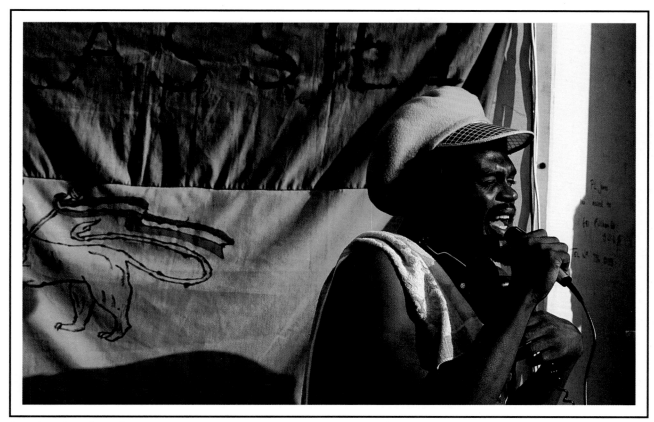

Portrait settings often tell a story—but keep backgrounds simple or they compete with the subjects.

Profiles (above and below left) evoke character very strongly, but watch the background as you compose the picture, because "false attachments" sometimes lead to disastrous or hilarious results. This is a particular problem with an SLR, because for viewing, the lens is always set to full aperture, so depth of field is at a minimum. Use the stop-down control to make sure that the greater depth of field at the working aperture doesn't bring into focus intrusive objects in the background.

book or just pretending to sleep in a chair.

The background, which is usually subordinate to the modern studio portrait, is a telling part of the informal picture. Any unsuitable setting will destroy mood and composition. Unless deliberately integrated, the subject should be separated from it by ensuring that the background is either less sharp or in strong contrast, or by photographing the figure against the sky. Backgrounds must never overwhelm or confuse the picture. A choice of viewpoint and lighting that separates the model from the surroundings helps to avoid this pitfall. A wide-angle lens enables the camera to be fairly close to the subject without severely limiting the area of visible background.

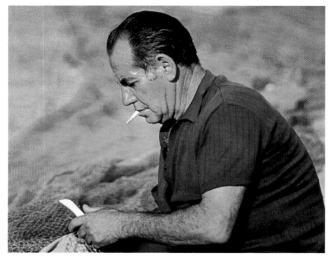

BRINGING OUT CHARACTER

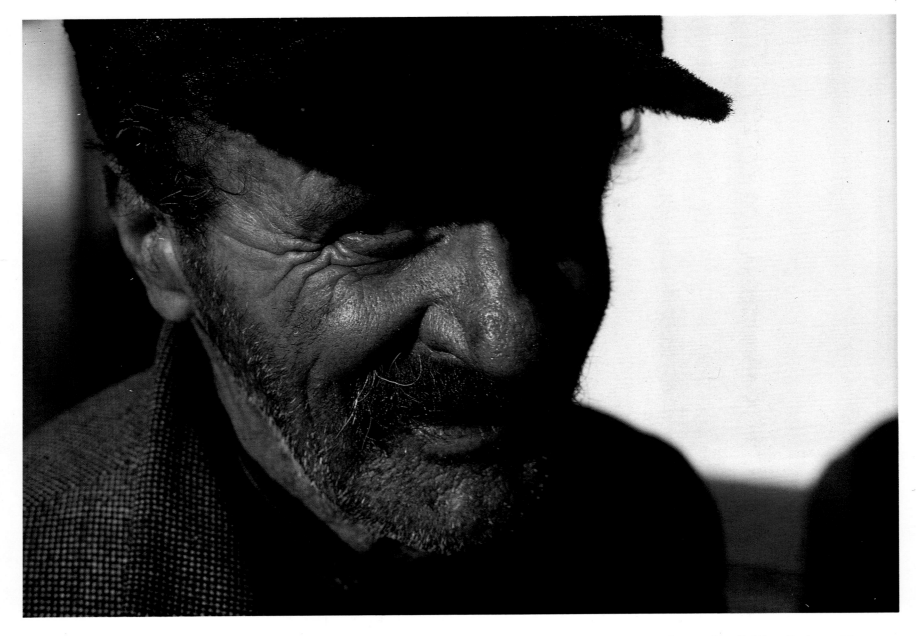

When detail counts, choose slow film. The wiry sharpness of this portrait, shot on Kodachrome 25, gives it texture you can almost touch. Faster film would have softened the stubble and lines that tell much about the man's character.

Hard rules are difficult to lay down in portraiture because no two faces are the same. There are, however, some general guidelines. The position of the head is crucial. A frontal view is usually unflattering and conveys an air of formality, while a profile can often give insufficient information about the sitter—although it will, of course, emphasize nose and chin lines. A three-quarter view, using lighting that provides some shadow to avoid broadening of features, often looks most natural.

The level of the head is also important. If it is raised and the camera is shooting slightly up, the face will appear broader and rounder; pointing the camera slightly downwards will emphasize the forehead and

144

The first of these pictures (far left) has a natural, happy feeling, but does not capture the girl's best aspects. The second picture (near left) is more flattering: turning her face to the light eliminates heavy shadows; the higher camera angle makes her rather round face taper, and gives prominence to the eyes; adding an extra light with a snoot puts a highlight in the hair. Asking the subject to pronounce a short, crisp word (not cheese!) produced a more open-eyed smile.

tend to make the face narrower. The normal height for the camera is level with the eyes. A model appears relaxed if leaning slightly forward, aloof if leaning back.

Revealing the model's personality is essentially a matter of observing mannerisms and characteristic expressions. The eyes and the mouth are the most emotionally expressive features and must be watched carefully for clues to the model's mood. Lines around the eyes and mouth are also helpful pointers to the habitual expression of the sitter's face.

Classical symmetry in the human form is rare: if an imaginary line were drawn from the hairline to the tip of the chin, it would be found that in most cases the two sides of the face were not identical. While these discrepancies are usually minimal and not evident at a casual glance, the camera will record them pitilessly. Most people have a better side to their face, which should be identified by the photographer.

Make-up isn't just for vain sitters. The camera has a tendency to exaggerate even slight facial blemishes, and to highlight characteristics that normally pass unnoticed. In this double-exposure, only the left side has been made up.

WORK AND PLAY

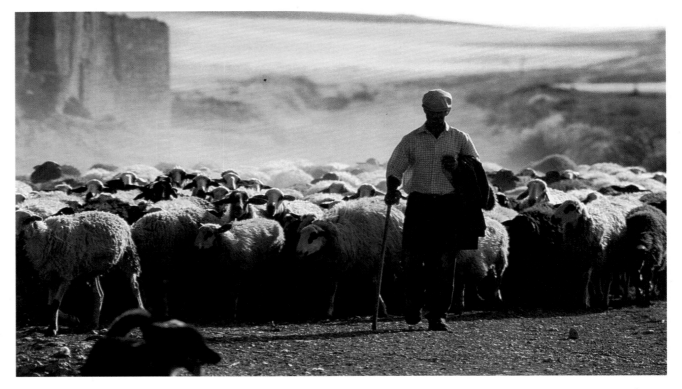

Victorian photographers loved to arrange their models against studio backgrounds of misty landscapes, intended to tell the spectator more about the sitter. In this case "more" usually meant a romantic suggestion of rustic harmony, simplicity and happiness. The modern preference for honest realism leads photographers to seek out subjects in their own environments. Rather than imposing theatrical, idealized settings on people, the photographer wishes to catch them at their own pursuits complete with familiar surroundings.

The movement and vitality of people at work and play are obviously fertile sources of photographic subject matter. The self-consciousness which blights so many portraits is often absent from casual pictures of people who are absorbed in their pleasures or work or—a happy coincidence—both together. The sculptor considering his chunks of stone, the rock climber negotiating an overhang and the child leaping to catch a ball are unlikely to be concerned with the presence of a sensible photographer, who can thus freely intrude on a scene of unmasked fear, pleasure, exasperation, anger or even embarrassment—provided the embarrassment is not caused by the camera.

Subjects may be fully aware of this intrusive eye, but because they are anchored to an activity, and especially to a familiar one, the subsequent self-consciousness leads less easily to the distortions of shyness. The boatman hauling on a rope may be looking into the lens, but his movements are automatic and he is confident about his role. There will be nothing artificial or contrived about his pose. This approach also helps define something of the personality, frequently the off-guard personality, of the subject. His response to his work or pastime is more interesting than the mere facts of it, however, and cannot help but be revelatory in a photograph. Sometimes, too, revealing human pictures can be taken of people watching those at work, such as a group engrossed by workers on a demolition site.

It is easy enough to watch people at play, and some "slice-of-life" photographers are satisfied with taking pictures of people at work in the local market or the nearest building site. Unusual subject matter does not necessarily make a good photograph, but it can inspire one. The photographer who wants to explore the theme

of people at work should be ambitious enough to try to find a way into hotel kitchens, down mine shafts, on to an assembly line or into an operating theater; permission will sometimes be forthcoming, and the keen photographer can but try to obtain it.

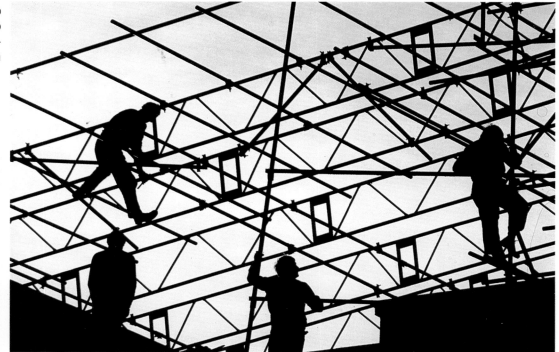

Every activity has its props—so use them to improve the composition, and give clues about what's going on. Oars (below) lead the eye to the figures beyond, and the scaffolding (right) links four silhouettes to make a team. Detail in the river obscured the fishing rod's shape (below right), but a slow shutter speed (1/8) blurred the water, focusing attention on the rod.

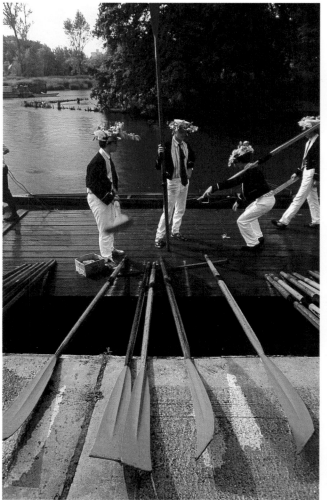

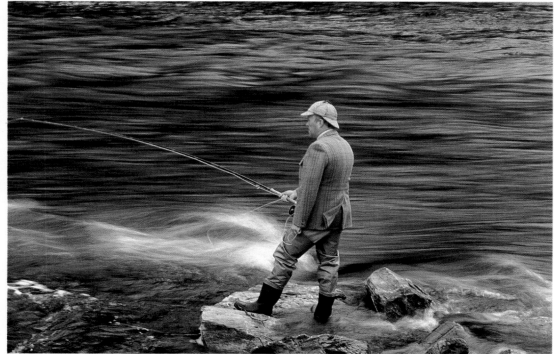

CHILDREN

C hildren's moods change rapidly, tears giving way to grins, shyness to exuberance. For this reason a formal studio portrait is seldom satisfactory: the child will all too often appear strained and inhibited.

Informal portraits have a much greater chance of success. Children are usually concerned with the presence of the camera for only a short time; the photographer can load film and accustom them to the strange clicking device until the children return to their own pursuits and once again behave more naturally. The key to successful pictures of children is a willingness to expose a generous amount of film, although haphazard

snapping is obviously not good enough and judgement and control are needed to capture the fleeting expressions and gestures; some of the best photographs of children look as if the subjects were caught unawares. At the same time the child's response to the camera can also make an interesting portrait.

Children are usually good subjects to be photographed in groups. Adults pose problems in this respect: it is not easy to group them in a way that does not look stiff and posed. Children, on the other hand, will play unself-consciously together, making ideal subjects for an informal group portrait.

If lack of cooperation causes problems, ask parents to give the child a toy or something to eat: simple bribery soon produces more natural images (far left). Children playing (left) move quickly and will flock to a photographer, so autofocus makes it much easier to get spontaneous photographs.

Low viewpoints create natural images of children at play, but shooting from "adult height" does have its advantages; a high viewpoint (above) turns the ocean's edge to a colourful, textured backdrop and lifts the distant shoreline above the toddler's head.

Children in tourist areas often pose with the skill of professional models—but make sure you have a pocketful of small change!

149

THE GROUP

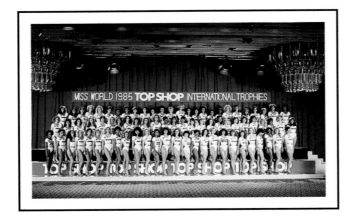

The formal group

*T*he formal group portrait can provide an acid test of the photographer's skill and imagination. The group must be attractively arranged and the attention of every member caught at the same moment. Although composition and lighting impose certain restrictions, an effort should be made to avoid the regimented monotony of the conventional formal line-up. Lighting cannot, of course, be adjusted to suit merely a few of the members; it must in some way attempt to create a group mood. The larger the group the more exposures are required to ensure that nobody is blinking, frowning or looking away at the crucial moment.

A line of more than three or four people looks awkward and should usually be split up into rows. It is advisable to put the tallest people farthest from the camera and in

The informal group

Informal group photography gives the amateur a chance to compete with the professional. In formal group photography expertise will tell; in the informal setting it will be less apparent because the intention is to take relaxed and spontaneous-looking studies. The amateur, who is also likely to be a friend of the group, has an opportunity to capture its members under virtually ideal conditions.

In this type of photograph it is not necessary for people to be looking at, or to be aware of, the camera. Even formal occasions are opportunities for informal portraits. While the professional is arranging the set group portrait, the amateur has a superlative chance to capture those interludes which can provide the most lifelike records of the occasion. Better results are often obtained by moving around with a camera and photographing people in natural situations rather than lining them up in front of the lens. Guidelines for such informal pictures are simple: select a viewpoint where the lighting is suitable; wait for an attractive composition; watch for the right expressions and actions; and use a fast shutter speed.

The essence of an informal group is its natural feeling, and though some of these Andalusian villagers (far left bottom) are looking at the camera, the overall effect remains casual and unposed. If you're not the only one with a camera, you have ample opportunity to catch candid expressions, both before (near left) and after (below) the "official" photographer takes the picture.

the middle. A third row should make itself taller or shorter by standing on benches at the back or sitting or kneeling in front. Where possible, natural supports— steps or an incline—can be used to achieve this vertical, staggered effect.

If kneeling figures look inappropriate—outside the church at a wedding, for example—the conventional solution is an arrangement of two lines with the faces of the taller members in the back row showing between the heads of those in front. Members of the group stand close together and the camera should be positioned fairly high. The composition can look more interesting if the ends of the rows are slightly curved towards the camera. Whatever the group arrangement, a tripod is essential since the photographer needs to move backwards and forwards between the group and the camera while making adjustments and checking the effect through the viewfinder.

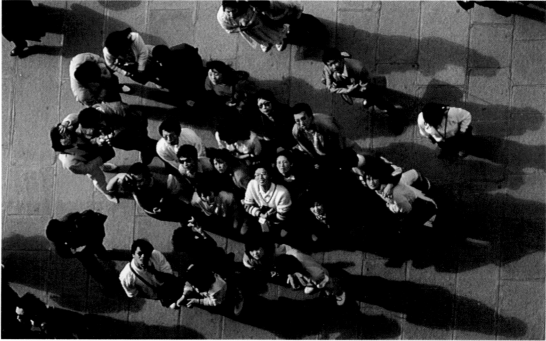

CANDID PICTURES

*T*he term photojournalism, or reportage, is an umbrella that covers a wide range of photographic subjects from the launching of a ship to a local dog show, from a burning building to a military parade. Essentially, photojournalism falls into two classifications: either the picture is a record of a single moment, whether anticipated or spontaneous, newsworthy or casual, or it is one of a series to make a story. Within these two categories lies a wide range of possibilities, from a newspaper assignment to a casual informal portrait.

Maximizing control

There is, nevertheless, one thing common to all pure photojournalism: it records facts without setting-up, manipulating or posing people or events. It is natural and informal. The photographer's only contribution, apart from talent and expertise, is to choose exactly which moment to record.

The diminished control which the photographer has over subject matter inevitably places even greater importance on the controls that can be exercised. Thus lighting and composition can sometimes be as important to a photojournalist as they are to a still-life photographer. When it is possible to prepare for a photojournalistic shot by selecting a subject and viewpoint, the photographer must wait for what Henri Cartier-Bresson, one of its greatest exponents, called "the decisive moment." This is the point at which all the available factors that the photographer is powerless to manoeuvre coalesce to the best effect. It could simply be the turn of a head, the flicker of a smile or a hint of a tear which adds the magic ingredient; or it could be something much more dramatic—the exact moment a crashing plane bursts into flame.

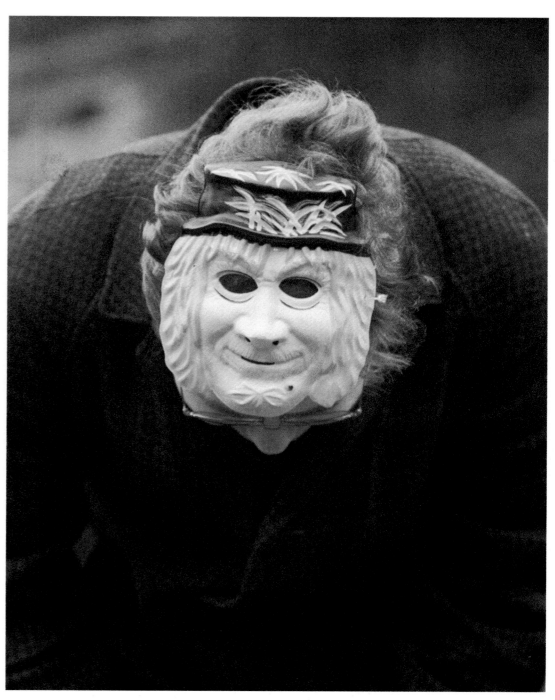

A short telephoto lens such as a 105mm is ideal for candid pictures—it enables you to close in on interesting scenes such as this from a discreet distance yet is easy to hand hold.

Body and Movement

Blurring is the camera's unique metaphor for movement, and carefully controlled blur at shutter speeds of 1/15 and slower can evoke the spirit of dance as vividly as a movie. In these two images (right and bottom right) panning to follow the movement has turned the dancers' limbs into graceful arcs, yet retained enough shape in their torsos to give a feeling of solidity and form.

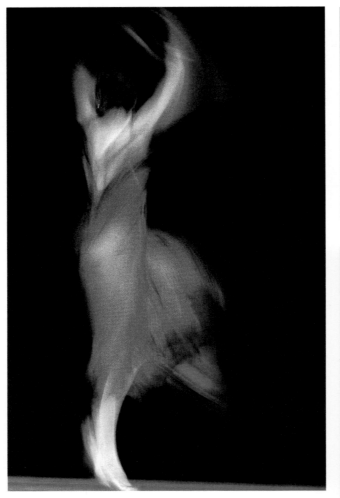

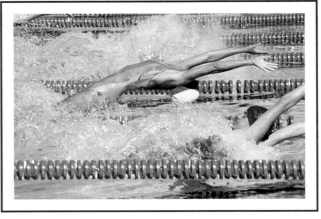

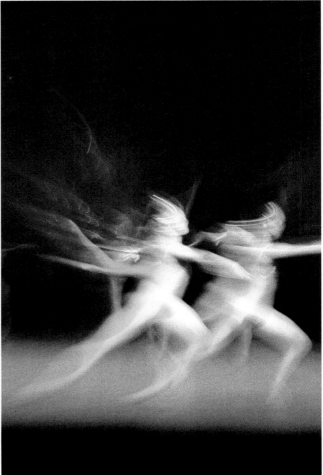

*T*he strength, grace and vitality of the moving figure is an irresistible subject for a photographer concerned with either the human form or human behaviour. Self-consciousness, so often present in static poses, is rarely a problem in pictures of the figure in action; the individual is too involved and preoccupied to be concerned with personal appearances. The activity usually takes care of the aesthetics.

To arrest movement, the unique prerogative of the camera, the photographer must obviously be as sensitive to physical change as possible. The speed of sport or dancing, however, is such that it is not always possible to anticipate results and the photographer must be prepared to expose a generous amount of film

154

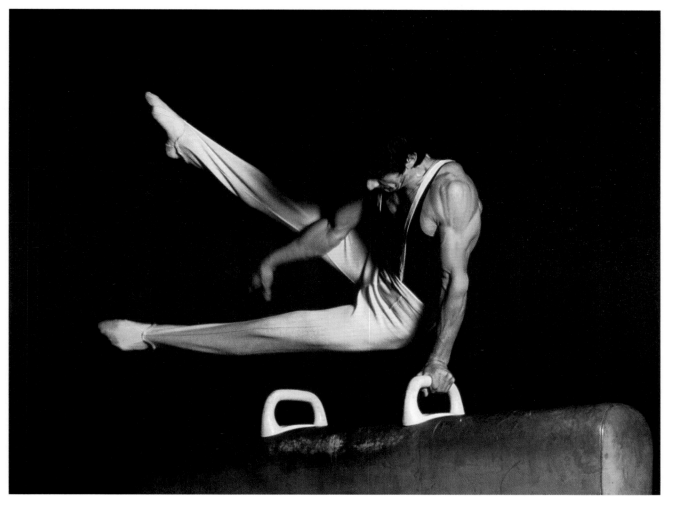

Razor-sharp images represent the body's actions in a quite different way (right and far right): frozen by a shutter speed of 1/1000, the swimmers' outstretched arms seem to reach out for winners' medals. In dim conditions where fast shutter speeds are impossible, flash provides an alternative way to arrest movement, though even in the 1/1000 second duration of the flash, this athlete's limbs have moved a little.

from which to select the telling picture of an energetic figure. The most intense moments of action can appear weak when reproduced from an uninteresting angle or without the necessary stress of a tight composition.

Movement exists in time, but the photographer, who cannot use time-space factors like the dramatist or the strip cartoonist, must imply it through a static image. Facial expression helps because the face registers tension, surprise, joy or whatever emotions the activity arouses. Composition is also crucial in conveying movement; in a carefully composed picture the eye is led along planned routes by shapes, lines and colours so that the suggestion of movement is accentuated by the movement of the eye within the picture. Several

methods can be employed to convey the impression of movement and speed—blurring, zooming, motor drive, multiple exposure and so on—and these are explained on pages 92−3 and 184−5.

NUDE AND GLAMOUR-1

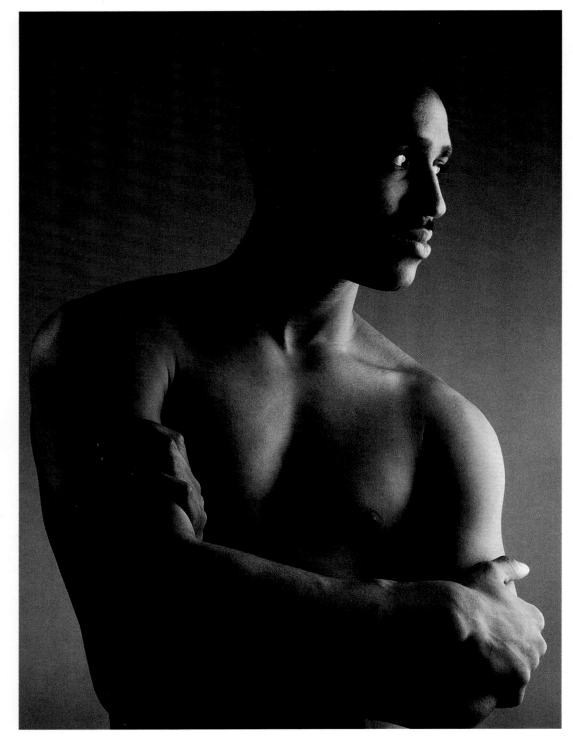

*T*he human body is a landscape of even texture and continually changing contours. The way in which its forms are defined or contribute to the mood of the photograph depends largely on the direction and quality of the lighting.

Lighting in the studio

Harsh directional lighting—sunlight or diffused studio lighting—will almost certainly be unflattering because it exaggerates skin texture and blemishes, limits the range of skin tones and causes powerful shadows that destroy softness. Diffused light is preferable when subtlety and roundness are required. Created in the studio by reflecting light from large white sheets or umbrellas, or by diffusing it with translucent plastic or fabric, it can be applied directionally to reveal form and texture to the maximum, or evenly to minimize this sculptural effect and allow the outline and position of the body to dominate.

Even slight movements of the figure alter the effect of strongly directional lighting, and the photographer must be continually aware of changing highlights and shadows. It is easier to control the adjustment of this type of lighting by moving the model rather than the light source itself. With very soft overall lighting, however, the model can change position quite freely without drastically altering its effect.

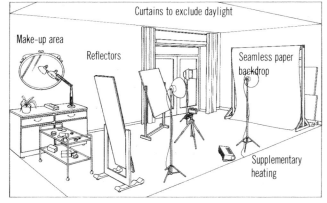

Curtains to exclude daylight

Make-up area

Reflectors

Seamless paper backdrop

Supplementary heating

Using natural light

The same principles apply to both studio and natural light. Dull daylight is usually sympathetic to the form,

tone and texture of flesh, but direct sunlight should be avoided and use made of any shade afforded by trees and buildings, which will soften the glare. By late afternoon the sun can create rich textures and soft contours, but the unrelenting light of noon and early afternoon is usually too sharp to be attractive, especially when directed at pale skin. Natural light indoors can be effective as long as the figure is protected from direct sunlight, but even then it may be necessary to use white reflectors to put light back in the shadows and thus modify tonal contrasts (see also page 140).

Aspects of the body

As in other areas of photography, parts of the body can appear more interesting than the whole. Shapes, forms and textures of the body can be interesting in their own right, independent of facial beauty or even physical identity. This concentration on form for its own sake may just involve cropping the head of the model, thus depersonalizing him or her, or it may be more extreme. A small area of curves can become an abstract image unrecognizable as a part of the human body.

The studio (inset) provides maximum control —and privacy—for glamour photography. Carefully lit images like this simply cannot be reproduced on location. Location glamour, however (below), has other advantages: the expense of the studio is avoided, and with ingenuity you can mimic some of the studio controls: sand acts as a makeshift reflector, lightening shadows and reducing contrast.

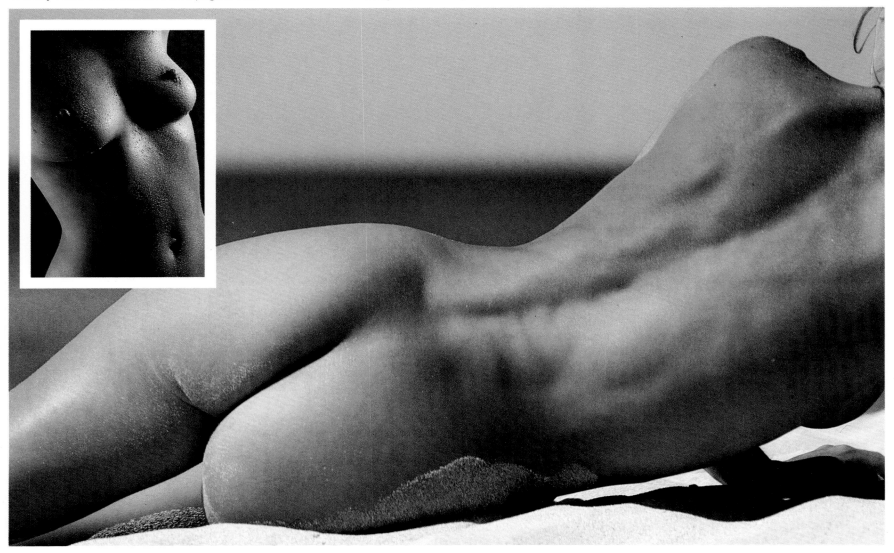

NUDE AND GLAMOUR-2

*T*he female form is one of the most common subjects at all levels of photography. Yet it is one of the most difficult subjects to photograph, because it either elicits several conflicting responses or merely looks "unnatural" naked. The nude can be many things—an imitation of another art form, a vulnerable human being, a sex object, a manifestation of beauty; the viewer's reaction depends on which ways and to what extent the body is any one of these things or a mixture of a number of them.

The painted figure, further removed from reality than the photographic one, is less likely to look plainly or shockingly naked, as opposed to self-confidently and discreetly nude. In an attempt to create art out of

nakedness, nineteenth- and early twentieth-century photographers posed their models according to classical paintings and sculpture. This was no real solution—the models looked either cold and statuesque or over-sentimental—and acceptance of the erotic in photography and the exploration of form for its own sake have subsequently made nude pictures more real and far more successful.

Sensuality and eroticism

It is difficult to imagine a photograph of a nude which would leave the viewer unaware of sexual content or induce an asexual response. If a selection of first-class

Posing creates pitfalls for the novice photographer of nudes: an amateur model invariably asks "What shall I do with my hands?" In this image the answer produces an atmosphere of decadent languor, which was enhanced by using a diffusion filter.

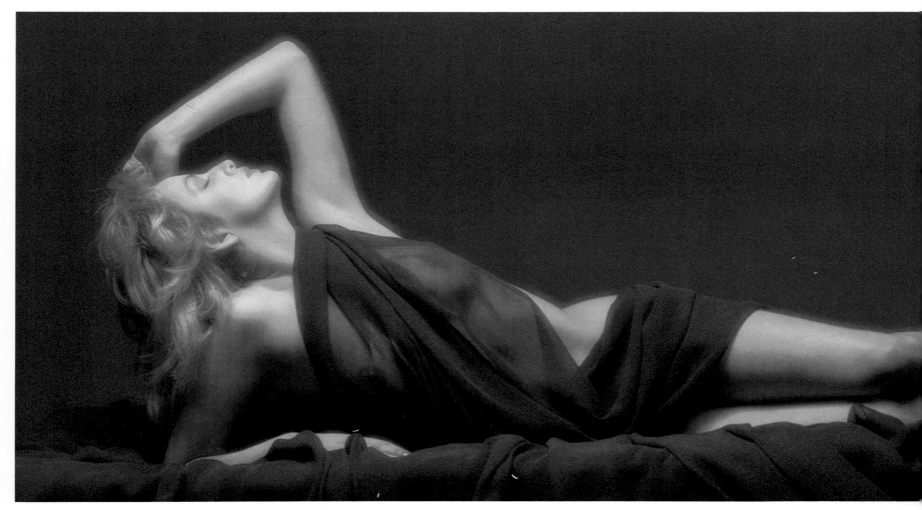

portraits and landscapes were displayed with some third-rate nude photographs, the attention of even the most visually aware spectators would be directed first to the nudes. For a nude photograph to sustain interest, however, it must have qualities other than those that are purely sexual, and photographers must be aware of the extent to which they want the sexual content to dominate the subject.

The degree to which a nude photograph is erotic depends not only on the viewer and the body itself but also on the pose, the facial expression, the lighting and the environment. Eroticism should not be confused with nudity; some of the most seductive photographs reveal surprisingly little of the naked body. As in portraiture,

the eyes are a dominant factor; when they are directed at the camera the feeling between the model and the spectator immediately becomes more personal and intimate. Even when the pose is in no way provocative, the expression in the eyes can heighten the sexual aspect.

Perhaps more than in any other branch of photography, discretion and judgement are critical; the erotic picture can so easily be as coy or as coarse as the most pathetic kind of pornography. To a large extent sensuality is more effectively achieved by implication and suggestion than by bald statement of physical fact.

Texture can strongly suggest sensuality. Here the highly directional sunlight picks out the texture of the wet fabric, creating an image that is erotic yet tasteful. Blue light from the sky and sea tinted shadows blue, but a pale straw-coloured 81A filter prevented these areas from looking too cool on film.

NUDE AND GLAMOUR-3

*B*etween pin-ups and formal studies of the naked figure there is a wide area of erotic chic much used in fashion photography. To a large extent it is generated by settings and clothes which help create a personality for the model and the mood for the photograph. A nude against a plain studio background can look alluring, but a sexually stylish or glamorous image can usually only be created by a special environment or by props. The nature of these "extras" may depend on being a step ahead of or in line with fashion; thus the photographer has to be aware of fashion trends, such as silk replacing denim or vice versa. The kind of glamour that money can buy has never died out, although it goes out of fashion periodically and photographers may put their models on bicycles, not in sports cars.

Most of this kind of photography swings between two extremes—the hard and the soft sort of elegance. The hard style idolizes the inhuman woman—poised, flawless and rich; the soft, innocent style favours the candid

country girl who lies in the meadow rather than in the apartment.

The setting

If its relationship with the figure is right, virtually any environment can be used to create style and glamour. Much depends on the model's type of looks as well as on the ingenuity of the photographer. It is the photographer's job, however, to discover new sources of sensual imagery or else make good use of the clichés. Photographers who take pictures of sleek or stylish models in building sites or scrapyards know how useful contrast can be in emphasizing the beauty or sexuality of a figure. An absurd setting also suits the dead-pan style of modern fashion photography, which must not appear to take itself too seriously. The desert, the zoo or the motorway are all suitable settings for the bored, disdainful, self-mocking modern model.

The model

Photographers may choose the theme or setting for their pictures, but models must be able to relate to it and relax within it. She must be as confident as possible, for the success of the photograph depends on her looking good—and knowing it. Shyness is rarely glamorous and the self-conscious model who cannot project personality is not likely to be an object of fascination to others.

The professional photographer has the advantage of working mostly with experienced models who are paid to be extrovert and who know how to adopt poses to please the public. Their expertise, however, brings with it a tendency to rely on a repertoire of stereotyped positions and movements; the amateur can sometimes offer a fresh appeal.

Glamour photography is a bit like theater: a good model is a performer, and should be able to improvise using props, setting or the photographer's ideas as a starting point. Good ideas needn't be elaborate: decadence (opposite page left) can be suggested using colour and texture alone. Outdoor settings (opposite page left) provide plenty of opportunities for experiment—look out for echoes and metaphors for the human form, such as this tree. Loose-fitting clothes or even bolts of fabric (far left) allow models to move freely and express themselves in casual glamour shots, but for tightly framed studio pictures (left) it is the photographer, not the model, who decides the pose.

LANDSCAPE—CHANGING LIGHT

*L*ittle remains constant in a landscape. The continual process of change brought about by the light, the time of day and the seasons of the year produces an endless variety of pictorial opportunities. Landscape work is thus one of the most exciting aspects of photography; it is also one of the most difficult. Ansel Adams, one of its greatest masters, succinctly described it as "the supreme test of the photographer—and often the supreme disappointment."

It is common to see in a scene a compelling image, which, when revisited a few hours later, will have altered or perhaps even disappeared altogether. Similarly, a sudden change in the weather or light can reveal a superb view in what had previously been an uninspiring scene. There can be a special type of spontaneity in landscape work that is almost on a par with sports or reportage photography.

In addition, there are the wider but more predictable changes wrought by the seasons. The sky changes continuously, at one time brilliant with summer sunshine, at another tempestuous with winter storm clouds. Snow gives way to lush grass, bare branches become green with foliage, flowers of different hues bloom and fade. No two weeks are the same, and a scene that is ordinary for the greater part of the year can suddenly produce inspiring textures, compositions or colours.

These pictures of southern Spain were taken in late spring to illustrate how light changes landscape throughout the day. At dawn tones are extremely soft and tend to merge; colours are pale and desaturated. Blue light from the sky creates a distinct blue cast.

The first rays of direct sunlight are yellow in colour, removing the blue cast and producing a warmer colour quality. With the sun very low in the sky, shadows are both long and dense. An extreme instance of this is the foreground, which is in deep shadow.

At mid-morning, light is more "normal" in hue and better matches the film's colour sensitivity. The sun is high enough in the sky to light the foreground, but shadows are still quite long and dense. Form and texture in the distance remain strong.

Assessing the light

Lighting technique in landscape photography is divided into three factors—direction, quality and colour—but it is impossible to generalize about lighting since each pictorial possibility and each desired effect presents different requirements. No photographer, of course, should automatically accept the first "favourable" lighting situation. If it is possible, the scene should be studied under differing light conditions and shot only when the light is best suited for the result sought. Although many landscape photographers prefer to work mostly in early morning or late afternoon—at those times sunlight is quite hard and strongly directional, revealing a high degree of form and texture—other times of day can also produce compelling results. Bright sunlight is by no means essential: the soft light of a dull overcast day can yield atmospheric images of delicate tones and colours. Rain, snow, mist and fog can, with careful thought and proper use of equipment, actually enhance or dramatize a scene. The important factor is awareness. It is easy to become oblivious of the potential in landscapes or to be too impatient to wait for the right conditions.

At noon the sun is overhead, and the picture shows a dramatic change in lighting: shadows are at their shortest and lighting at its most flat. There is little contrast in distant detail, and at this time of day many photographers prefer to pack up and wait for better light.

By late afternoon the shadows have lengthened again, and the tonal variation between foreground, middle distance and background is at a maximum. Sunlight is warm again, as it was early in the morning, just after sunrise.

The last picture was taken in late evening. The light is even warmer and more mellow and the sun catches little of the landscape, creating strong contrast and detail wherever it strikes. Just after dawn and before dusk are probably the best times for photography.

HORIZON, DEPTH AND SCALE

*T*he position of the horizon—the line where the earth and sky appear to meet—is nearly always a dominant factor in landscape photography. It divides the picture into two distinct areas, and the relative proportions of these areas will help govern the composition, balance and mood of the photograph. If the horizon appears nearer the top of the photograph than the bottom, the land will be the main point of interest; if it is in the lower half, the sky will tend to dominate.

For this reason the horizon should seldom run exactly across the middle of the picture, except when the composition and purpose of the picture is dependent on symmetry. If, for example, the foreground were the dominant feature and the sky devoid of interest, having the horizon running through the middle of the image would probably throw it out of balance. In such a case it would almost certainly be a better composition if the

horizon were two-thirds or three-quarters of the way up the image—the most common proportions in landscape photography. The proportion of sky shown will also have an effect on the feeling of space; at its most extreme, when the horizon is omitted the scene will appear enclosed.

The position of the horizon can be adjusted by tilting the camera. Although this will introduce some distortion of perspective, it is usually insufficient to be a serious consideration. A perspective-control or "shift" lens will let the horizon be altered without tilting.

The line of the horizon is usually broken by trees and buildings, and these will in turn affect the position and the balance of the image. As a general rule, the line should be interrupted before it meets the edge of the picture by selecting a viewpoint that includes an object to mask some part of it.

When sky and land are of equal importance, dividing the frame asymmetrically (far left) looks more dynamic than a 50:50 split. A high horizon (above middle) emphasizes the foreground, and when the sky is dull or an unbroken shade of blue, you may choose to eliminate it altogether (above). Conversely, an interesting sky (left) merits attention, so place the horizon low in the frame.

THE SKY

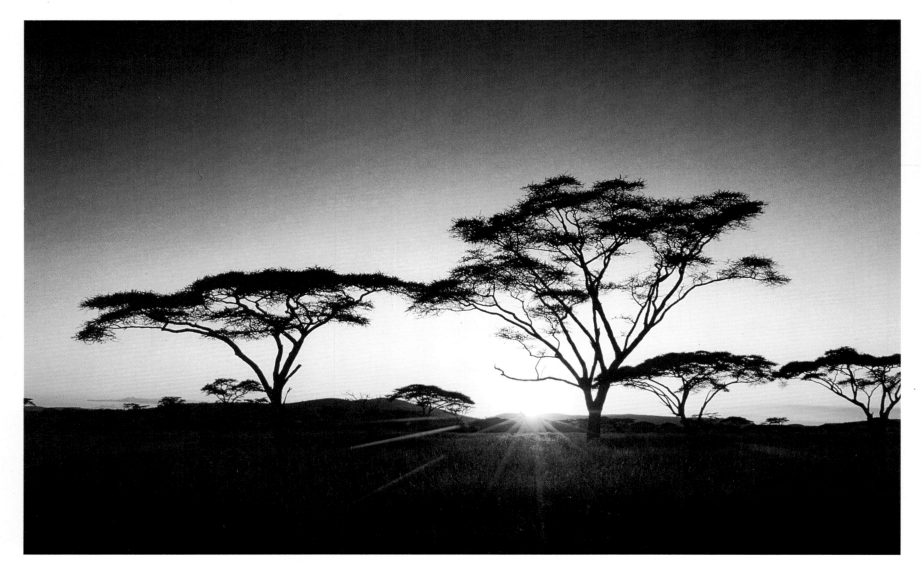

When there is a good sky, tilt the camera up and set exposure to automatic. This way you'll get maximum colour and detail in the sky, and the ground beneath plays a supporting role. If possible, though, frame the picture so there is a bold shape to provide some interest in the foreground, as shown here.

The sky can be a dominant feature in a landscape photograph—or it can be totally irrelevant. There is little that can be done about a sky when it is devoid of interest, except to minimize its role in the image or to exclude it altogether; there are, however, a number of considerations involved in making the most of detail and dramatic effect when they do exist.

The sky is one of the changing aspects of a scene. While houses, trees and fields remain essentially the same, the sky (like the light itself) can alter continually and make striking differences to landscapes.

Because the sky acts as a reflector it is part of the light source and the exposure calculated for foreground detail tends to make the sky overexposed, reducing its detail and tonal range. Thus it is important when the sky is a significant element in the composition of a picture to keep exposures to the minimum required for adequate shadow detail. In black and white photography, a great deal of control can be exercised at the printing stage by shading and printing in sky areas (see page 201) and, to a certain extent, when making colour prints from negatives. With colour transparency ma-

terials this cannot be done and the control must therefore come from exposure and the use of filters.

It is possible to buy graduated filters, both in neutral density and in a range of colours. These affect only half of the image and can be used to reduce the exposure of the sky without affecting the foreground. When the sky is blue and the photographer is shooting away from the sun, a polarizing filter can be used with colour film to darken the tone of the sky without affecting the quality of the other colours (see page 70). With black and white photography blue skies and the contrast of the clouds can be more effectively controlled by the use of yellow, orange and red filters—yellow having a subtle effect, orange somewhat stronger (rendering the blue sky a mid-grey) and the red filter producing a dramatic impact, converting the blue sky into a dark grey with the white clouds in strong contrast (see page 73). It is always worthwhile experimenting at dawn and dusk, since success depends on the sky's mood and atmosphere and they are often best revealed at those times.

167

THE URBAN SCENE

The word "landscape" conjures up a romantic picture of inland scenery with hills, trees, rivers and fields. There is an alternative landscape, however, one equally worthy of the photographer's attention. Created by man and composed of houses, factories, offices, warehouses, schools, churches, roads, canals and railways, the urban landscape may seem even more beautiful or more dramatic than the conventionally rural one.

In any case, attractive or interesting subject matter, whether it is a chemical plant or a view of a mountain range, is not always the essence of a successful photograph. The talented photographer can often create a powerful atmosphere or an arresting design out of the most mundane scene, no matter how unphotogenic it may appear.

As with all aspects of photography, the key to success is visual sensitivity. The photographer must be an acute observer of changing patterns—those which occur independently and those which can be effected by examining a building or a piece of industrial machinery from unusual angles.

Urban landscapes, usually a hotch-potch of various architectural styles and functions, provide the photographer with a wealth of visual contrasts and comparisons. A picture of a church dwarfed by modern offices neatly contrasts style, function, scale and historical period. The hard-edged nature of much modern architecture lends itself well to semi-abstract compositions. A simple image of a soaring tower block, for example, may emphasize the stark beauty of glass, metal and concrete, while the skeletal silhouette of a bridge can often inspire an interesting linear composition.

The juxtaposition of man-made and natural scenery can give an added force to the picture. The comparison may be as simple as clouds above a row of houses; it can be a "clever" shot of buildings reflected in a puddle or a canal; or it can be obviously dramatic—the sun sinking behind an industrial wasteland, or clouds and blue sky seen through a broken window pane.

The time of year, time of day, the weather and the light obviously affect the urban as much as the rural landscape. The weather is useful to reinforce a mood—gloomy sky over grimy cotton mills—or contradict it: try showing the same view in brilliant sunshine. The unexpected is always intriguing and, depending on the quality of light and the angle from which the picture is taken, the unprepossessing building could take on the grandeur of greater architecture.

People and their environment

The urban landscape also affords an opportunity for a photographer to make a social comment by emphasizing the beauty or ugliness of towns and the excitement and sadness of living in them. The relationship between people and their environment is an obvious theme for the urban photographer. The human figure, so often out of place in the rurality of a conventional landscape, is a natural element in scenes of street life.

Cities often look their best at night. The glare of artificial lights against blackness presents a dramatic picture, and the modern metropolis offers unlimited scope for abstract patterns. Again, the early hours of morning, before the town stirs, can look exciting because it is not how most of us usually see the urban environment.

A telephoto lens crams subject planes tight together (opposite top),
but a wide-angle lens makes incongruous juxtapositions easier (opposite
bottom) because a small movement of the camera creates a large
change in the composition. For maximum colour in urban landscapes, meter
natural and artificial light, and shoot when they're equal in brightness (above).

USING THE SETTING

A building's setting is often almost as important as the building itself. This is particularly true of old structures, which were usually designed with their setting in mind. A Spanish castle, for example, would be far less interesting without a glimpse of the rugged landscape it was built to defend; cathedrals were usually built on elevated ground, visible from all directions.

Weather is one of the most important factors in architectural photography, and styles evolved partly to meet different climatic conditions. Classical architecture, designed for regions of bright sunshine, rarely looks good on dull, overcast days, but Perpendicular Gothic, conceived for the damp misty conditions of northern Europe, can be at its most dramatic in poor weather. But light and shade are essential to architectural photography; usually directional light gives best results.

With old buildings, a background of snow or storm clouds will often better evoke a medieval atmosphere than the bright light of a summer afternoon. Ultramodern buildings, with their reflective glass and steel surfaces, can appear at their most attractive in sunlight, especially at sunrise and sunset, when they take on the colours of the sky. Rain, too, can enhance a picture with its reflective quality. It is also an aid in setting mood—for example, with rows of slate-roofed urban dwellings.

Yesterday's modern building is tomorrow's antique: to emphasize the contrasting styles, shoot from street level. Tilting the camera up produces dramatic perspectives and eliminates distractions in the foreground (below). Architectural details (above) can look especially bizarre when you show the setting. Here the cramped conditions forced the photographer to use a 20mm lens; its inherently wide depth of field kept sharp both the gargoyle and square below.

WATER

Lakes, rivers and the sea are important elements in landscape work because their reflective quality contributes a rich variety of tone and colour to pictures. The role of water in a photograph can vary from dominance in a seascape to the minor contribution of a stream or pool, but it will always tend to catch the eye.

The visual quality of water is largely dependent on three factors. The most important is sky, which gives water much of its colour. The blue of a sea is intense when the sky is very blue, while the same sea with a grey sky can be almost devoid of colour.

The second factor is reflection. In addition to reflecting the sky, water will also mirror other tones and shapes around it and, depending on the degree of movement, these can produce a wide range of effects.

The third factor is movement itself. Water is compelling when it scintillates in the sun, but when it is without motion it can lose its interest. A still canal may produce a mirror-like image of buildings overlooking it, and sometimes this is the desired effect; but a slight degree of movement (easily achieved by casting a stone to create ripples) can change the image to a more abstract one while still retaining a faithful rendition of tones and colours.

There are two ways of photographing rapidly moving water: a slow shutter speed records the blur of movement, giving an impression of speed and power, while a fast shutter speed will "freeze" it. The approach is dictated as much by the combination of light conditions, lens and film as much as it is by personal preference.

Falling water assumes many guises on film. Soften it to silken smoothness (far left) with a tripod and an exposure lasting several seconds. Freezing a breaker means taking the opposite approach (middle left) and using your camera's fastest shutter speed. Sunlight or fast film are essential here: to set 1/4000 on a sunny day with an aperture of f/4, you'll need a film of ISO 200 or faster. Water's reflective qualities make a picture in themselves (above), but there's potential, too, in eliminating reflections (left). Water polarizes light striking it at about 45 degrees, and a polarizing filter cuts reflections from the surface at this angle. More oblique rays are not absorbed by the filter, so in this picture, shot with a 20mm lens, the distant side of the pool appears lighter.

INTERIORS

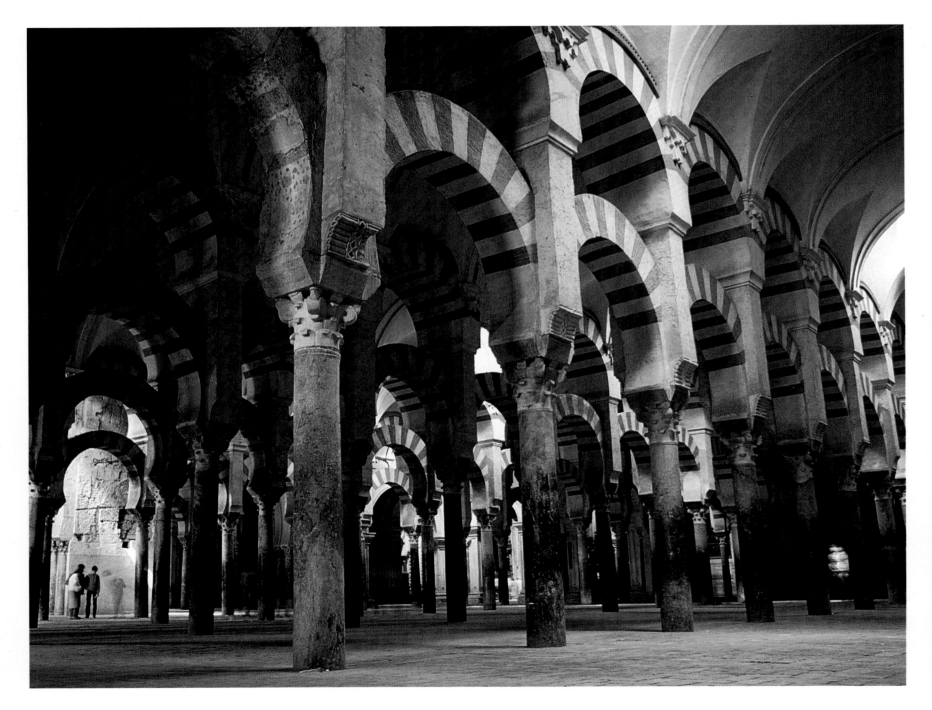

Patches of overexposure are hard to avoid indoors,
but if most of the picture is correctly exposed,
small bright areas don't intrude.

*T*he problems of adequate lighting make interiors far more difficult to photograph than exteriors. Unless the photographer is prepared to carry around and set up bulky lighting equipment, interiors of any size will necessarily be dependent on available light. This can nevertheless be highly effective and, provided a good tripod is used, long exposure will enable all but the very darkest interiors to be photographed. Ordinary flash will be almost useless.

Interior photography is usually easiest when the weather outside is bright but not too sunny. There will be no startling patches of sunlight or dense shadows and the illumination will be much more even.

The contrast may still be excessive, however, so that highlights such as windows will be burnt out or the shadows heavy and lacking in detail. A sensible choice of viewpoint will often eradicate these unwelcome extremes of contrast.

With black and white material it is a help to develop the negative to a low contrast, and skilful printing on soft paper can even out the highlights and shadows. With colour there is no such possibility and additional lighting may be needed, although the larger the interior being photographed the less effective this will become.

Not all colour films are suitable for the long exposures needed to take photographs by available light. Most daylight films are designed for short exposures and using them at several seconds will not produce satisfactory colour (see page 100).

When the sun shines through a window (below left), take a meter reading from an area lit by reflected light. Windows will be burned out, but this looks better than the alternative of solid black shadows. However, in large dark rooms (left) direct sun creates far too much contrast even when windows don't dominate the image. Wait for a cloud to cross the sun before shooting. Rooms lit entirely by artificial light (below) create problems of colour, not contrast. Check the colour of the primary light source, and refer to pages 218–19 to choose filters.

PARKS AND GARDENS

Landscape details often say more than general views. From farther away, the blooms on this rose walk were just white blobs. Moving close-in showed every petal, and stopping down to f/16 kept the whole scene sharp.

Parks and gardens of all sizes provide a rich source for photographers. The key consideration is viewpoint. Landscaped gardens were designed to be seen from certain angles and it is first necessary to locate these. A vista will in any case afford a more attractive composition than an attempt at conveying the size of a large garden, since size alone almost always results in extensive areas of uninteresting foreground.

In a small domestic garden, too, certain views will be more suitable than others. The main features—clumps of flowers, rockeries, lily ponds and so on—are usually on a modest scale that is easier for the normal-angle lens to handle. If there is no natural point of interest,

one can always be created by including a wheelbarrow or mower. Some gardens are best seen from the house, shooting through an open window or door. Another effective angle, especially to capture the whole of a small garden, is to photograph from an upstairs window. In general, however, the feel and character of a garden will come across better if one particular aspect is selected.

Because of their size, trees will nearly always be a focus of interest. They offer unlimited variation and scope, not only as part of a garden, park or landscape but as studies in themselves, varying from fine examples of perfect symmetry to unnatural and perhaps grotesque

configurations of branches.

In landscape composition trees can serve a number of purposes; the foreground use of branches can mask an uninteresting, cloudless sky, or frame a picture or help to give an impression of depth or space.

Flowers are probably the most attractive manifestation of nature and abound in a multitude of forms in almost all parts of the world. Apart from their obvious colourful contribution to a garden composition, there are essentially three ways of photographing them. A close-up will reveal the heart and detail of a flower. Second, selective focusing can help to isolate a bloom against a blurred background and capture the "charac-

ter" of the flower; here it is usually better to photograph the flower against a plain, contrasting colour, such as grass or rich earth, rather than against other, and perhaps conflicting, flowers. Third, flowers can be photographed in bunches or massed, where detail will be of less importance than the strong impression of colour.

The best time to photograph flowers is early morning, when the light from a soft, hazy sun gives sufficient contrast to show form and detail but does not "burn out" the softer colours. Flowers are also at their most fresh at that time: the dew has evaporated but they have yet to feel the full effect of strong sunlight.

Figures add human scale to a garden landscape and act as an antidote to rigid formality. If you cover these two strollers, you'll find the picture loses much of its impact.

177

WILDLIFE -1

*M*any of the problems of photographing animals in captivity are closer to those found with domestic pets than those encountered with their own species in the wild. They are easy to locate, they cannot stalk or endanger the photographer, and they are usually good healthy specimens of their kind.

As with domestic pets, most caged animals are restless as feeding time approaches but placid after eating. More exciting pictures will result if an animal's routine is watched to learn what to expect at different times of the day, and it is always advisable to consult keepers before photographing zoo animals; not only will they give helpful advice, but they will also know what is allowed. A flash, for example, should never be used without permission; if one were fired in a reptile house, snakes might strike instinctively and could damage themselves against the glass of their enclosures.

Quite simple cameras will take adequate photographs of animals in zoos, but a single lens reflex has the great advantage of versatility. Not only do animals differ in size: their behaviour, surroundings, speed of movement and their distance from the camera are equally diverse. A range of good lenses is desirable for zoo work, an ideal combination being a normal, a wide-angle and, perhaps most important, a reasonably long lens.

Photographing birds

Of all nature's creatures birds are perhaps the most rewarding, though perhaps the most frustrating, to photograph. The variation in birdlife is enormous. Some are brilliantly coloured, others drab; some hunt by day, others by night, yet all birds have one common characteristic: they are creatures of habit. They will constantly alight near their nests at the same spot and, excepting marauding birds, will usually feed from the same patch. This gives a photographer the opportunity to predict a bird's movements and take pictures at exactly the right moment. Nevertheless, a sound knowledge of a species is needed for anything more than a garden or local woodland environment.

Birds are easiest to photograph when they are busy at their nests, but even then silence and stillness are essential. This is true of all animal photography, but must be particularly stressed with birds; once alarmed, they may never return to their nesting sites.

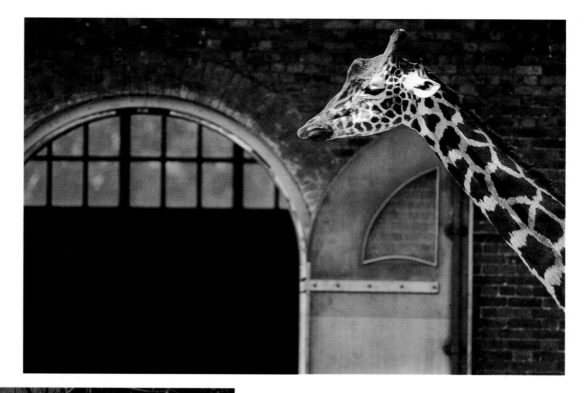

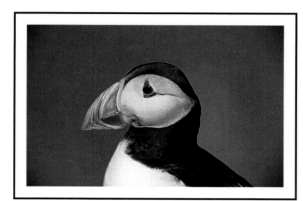

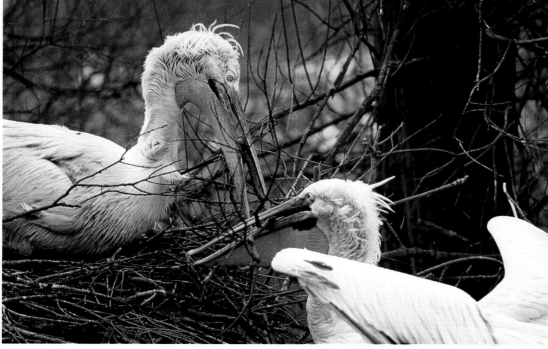

Frame-filling portraits of wild birds tax both photographic and ornithological skills. This puffin (above left) was shot from a hide with a 400mm lens; the bird was so close that an extension tube was needed to reduce the closest focusing distance of the lens. Zoo and farm animals (above and far left) present no such problems, and you can take good pictures with even simple equipment. In modern zoos, the artificial environment need not be obvious: the pelicans (left) were building their nest in a zoo, but careful framing with a 300mm lens cropped out all traces of the enclosure.

WILDLIFE-2

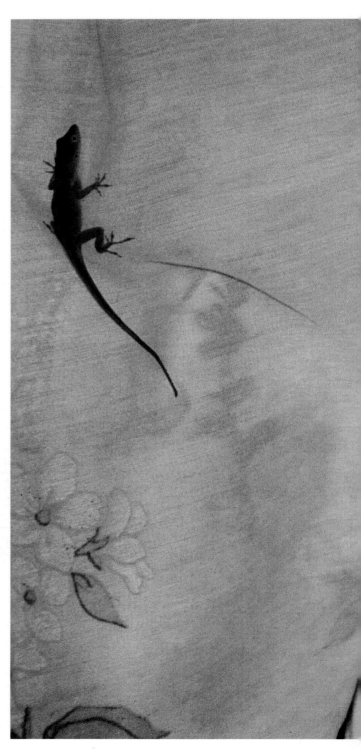

*E*xcellent photographs of animals are rare. Most animals are highly unpredictable and cannot readily be controlled. It is no more possible to direct the right pose by verbal command than it is with children. The photographer must usually do something to attract the animal's attention for a "portrait," but even then the expression or position will probably be held only for a brief moment.

There are, of course, ways of increasing the chances of taking a good photograph. One method is to be fully aware of the animal's physical appearance, build, movements and habits. A long-nosed dog will always look its most handsome in profile or three-quarter view; a horse jumping a fence will appear best when taking off or when half-way across a hurdle, but looks at its least elegant when landing on the other side and regaining its stride.

The animal's coat is also an important consideration. Dark fur, for example, absorbs light to a surprising degree, so when photographing dark-coated animals it may be necessary to open up a stop or two more than usual. Background, too, is always important: unless camouflage is the essence of the picture, contrast is essential.

Finally, animal photographs can be ruined if sentimentality is allowed to intrude too far. Appealing shots of kittens in baskets of knitting wool with ribbons around their necks may help to sell boxes of chocolates, but they do little to reveal the animals' individual personalities.

In some ways animals are easier to photograph in the wild than in captivity, since there are no distracting bars or buildings. The chief problem, of course, is to locate the animal, for most creatures keep themselves, and especially their young, out of sight and many species are endowed with keen noses that can detect humans long before they are within "shooting" range. Smaller animals, such as mice, remain hidden most of the time, while others are nocturnal and almost impossible to photograph naturally.

Some animals are aggressive and cannot be approached; others, and these include nearly all reptiles, are difficult to identify since their colouring is usually very similar to their natural surroundings. Once located, however, the free animal offers the photographer many more exciting opportunities than the captive one.

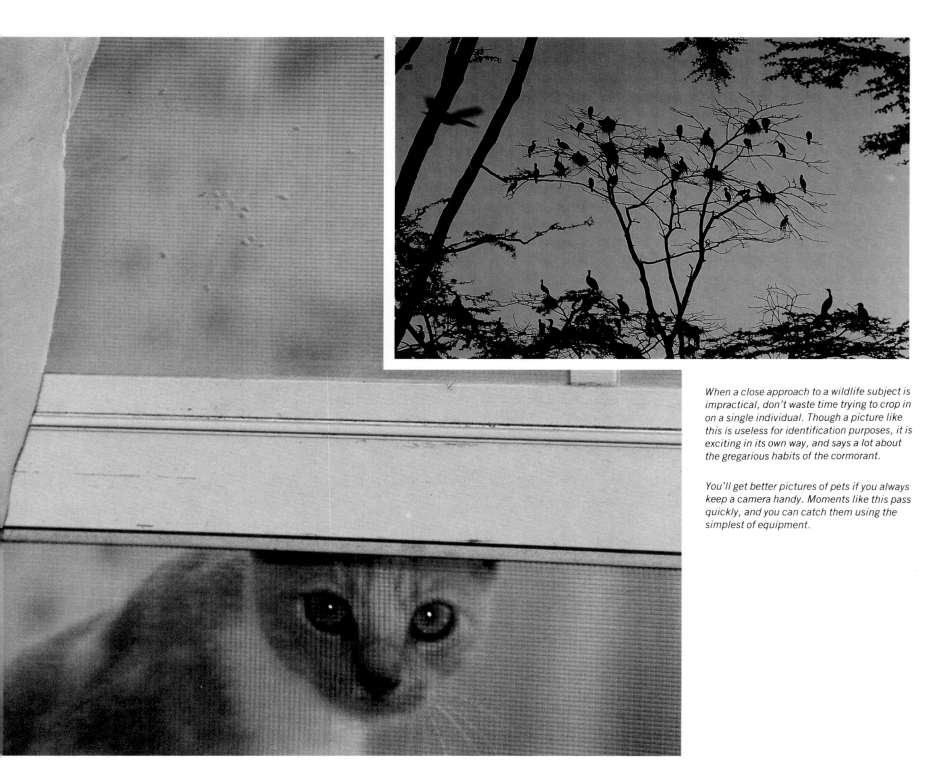

When a close approach to a wildlife subject is impractical, don't waste time trying to crop in on a single individual. Though a picture like this is useless for identification purposes, it is exciting in its own way, and says a lot about the gregarious habits of the cormorant.

You'll get better pictures of pets if you always keep a camera handy. Moments like this pass quickly, and you can catch them using the simplest of equipment.

NATURE IN CLOSE-UP

At some stages in their life cycle, timid creatures are much easier to photograph in close-up. If you move slowly, you can approach to within arm's length of an emerging dragonfly, and frame its drying wings with a macro lens and natural light.

In most aspects of photography it is people, their works and possessions that are the dominant theme. The one area where people are of little importance, or absent altogether, is nature. This field is so wide that no one photographer could ever explore and master all the necessary techniques and, if a high standard is to be achieved, it is wise to isolate areas of particular interest and concentrate on those. This speciality may be a geographical area, or perhaps a genus, but one possibility, fascinating but often overlooked by the amateur, is to go for close-ups.

Insects, for example, make extremely exciting subjects since they not only vary greatly in shape but many possess brilliantly coloured markings. Their diminutive size, however, presents the photographer with particular problems. One difficulty is that many of them move at great speed—the cicada-killer wasp, for example, propels itself by beating its wings an astonishing 682 times a second. In the open, insects seldom remain long in one place; and to make matters worse, there is often enough wind to create movement. The subject will not "pose" for long, nor is it likely to do so against a suitable

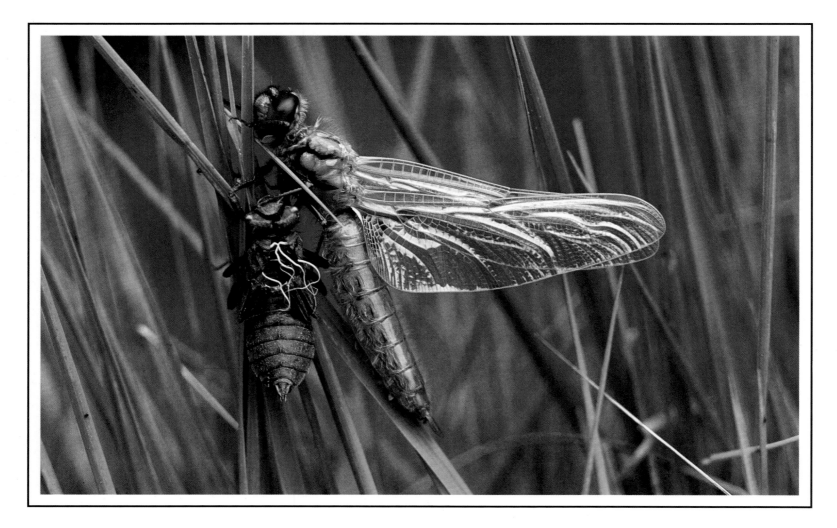

Modern cameras greatly simplify exposure for close-up: metering is automatic, even with flash. Both these pictures were made using the light of a small portable flash unit bounced from a cardboard reflector. Combining the lens with a bellows provided the necessary magnification—the common frog appeared twice life-size on film, and the baby cricket was just a couple of millimeters long.

background. The assistance of a naturalist is always helpful, particularly in locating the creatures, since many are camouflaged by their surroundings. For the same reason it is sometimes best to have a very small depth of field to isolate the insect from its background, while a long lens may reduce the risk of disturbing it. Unless the photographer enjoys "stalking" insects, however, it is usually easier to obtain good results by first capturing the subject and then bringing it indoors to photograph under controlled conditions.

Flowers, leaves and buds, on the other hand, are generally most easily and effectively photographed in their normal habitat. One problem is movement, but this can often be overcome by supporting a flower on a hidden wire or by shielding it with a three-sided box.

A cable release is virtually essential equipment for almost all types of close-up in nature work: not only does it prevent camera shake, but insects and small creatures will not be alarmed by the immediate proximity of the human hand.

Close-up in colour

Any camera will serve for close-up photography provided it has a detachable lens so that the distance between camera body and lens can be extended (see pages 96–7). A very shallow depth of field is inevitable, but in almost all cases this will enhance the photograph since the human brain is attuned to seeing small objects sharply defined but with the edges beginning to blur. The same effect in close-up will thus reinforce the viewer's impression.

The scope for close-up photography is limitless, both with animate and inanimate subjects, but fascinating subjects can be easily manufactured. If, for example, a nail is partly driven into a piece of reasonably hard wood and a close-up shot taken of its point of entry, a pattern emerges in the wood virtually identical to that made by a ship ploughing through the water. Such innovations can be experimented with at home, particularly by adding colour.

A ring-flash unit surrounds the lens with light, for shadowless close-ups.

SPORT

*B*ecause of its ability to freeze movement and capture brief moments of time, the camera is ideally suited to the specialized field of sports and action photography, compelling us to look afresh at a scene or incident that we know to be fact, often making us see it in a new way. Many of the photographs reproduced in the sports pages of newspapers and magazines illustrate the point perfectly, the camera having been used as a tool to isolate the decisive moment of a unique incident.

The camera can also be used as a visual instrument to study human and mechanical movements and, taken to its extreme development, record the precise finishing order at race-tracks and important sporting events.

Sports journalism, whether amateur or professional, relies essentially on four basic requirements: knowledge of the sport, fast reflexes and anticipation, reliable equipment that can be operated instinctively, and a little luck to be in the right place at the right time.

Camera and lens

Most cameras with a shutter capable of at least 1/500 second (preferably 1/1000 second) can be used for sport, but the most practical and widely used camera system is the SLR; its portability, ease of use and comprehensive range of lenses make it the most versatile for the various demands and range of sports that the photographer may meet. When used with a motor drive attachment the SLR becomes an unbeatable system.

The long-focus lens has obvious advantages, although it is generally safer to work with a normal lens close to the subject if possible. Whatever lens is used, it must have an aperture of f/4.5 or larger so that fast shutter speeds can be used, even in poor light. Filters are rarely used because they demand an increase in exposure—either a slower speed or wider aperture—and both are undesirable for action.

Film and speed

Sports and action photography rely heavily on fast shutter speeds and generally "slow" telephoto lenses, and these factors, coupled with the low levels of light often encountered, make the use of fast film standard practice. Although the normal range is the ISO 400 monochrome emulsions and ISO 400—1600 colour

reversal films, in many cases these basic ratings are "pushed" (up-rated beyond their stated speed) sometimes as much as 2½ stops, giving an increased exposure index of ISO 1000 for black and white and ISO 6400 for colour. While quality suffers in the increased grain, the results are acceptable.

Capturing movement

A moving person or subject can be recorded by the camera in two different ways. The first is by using either fast shutter speeds of ¹/₂₅₀ second upwards (see table on pages 92–3) or electronic flash. These literally freeze the action, generally resulting in pin-sharp images; but these can seem artificial, lacking any real feeling of action. A second group of techniques involves the use of slow shutter speeds (anything from 1/15 second upwards), panning, zooming and calculated degrees of blur; all these, used to varying extents, will help to convey the impression of speed.

Fast shutter speeds, the primary consideration for the sports photographer, are governed by the prevailing light, the choice of lens and the selective use of depth of field. Most professionals "pre-focus" or "follow-focus," allowing them to work at maximum aperture using the highest shutter speeds and to isolate their subject.

Some degree of panning is required, however, when the subject is moving quickly. Panning is best executed by "picking up" the subject early on as it moves across the angle of view and then releasing the shutter in one flowing action—but remembering to continue the pan after the release.

"Strobe" photography is an advanced studio technique where banks of electronic flash guns are synchronized into a control box that regulates the duration and frequency of the amount of light falling on the subject. It has obvious advantages in capturing the body's movements, but usually needs the controlled facilities of a studio.

Choosing the viewpoint

The successful sports or action photograph is often dependent on good camera positions, and the amateur photographer who is not afforded any special facilities at major sporting events may find it difficult from a limited spectator's position to produce anything more

exciting than a reasonable record of the event. Though some big sports events give the amateur fairly easy access to good camera positions—motor racing is a good example, where a telephoto lens from a well-known spot can produce "professional" results—it is usually difficult trying to operate from the spectator's conventional viewpoint.

Enthusiastic sports photographers may consider the advantages of local venues, where restrictions are far less and they are usually free to wander where they like. The atmosphere may not be quite the same and the "stars" may be missing, but it is likely that the opportunities for dramatic pictures will still present themselves.

This possibility will be heightened if you concentrate on close-ups and special techniques rather than on all-embracing pictures. Close-ups will capture the essence of the sport while eliminating what might be an "amateur" or distracting background; a slight blur or a zoom technique for an explosion shot can work as well at the local tennis club as at Wimbledon or Forest Hills.

Panning the camera

Moving the camera with the subject is usually essential if the subject is going faster than about 40kph (30 mph). In these three pictures the cars were all travelling at approximately the same speed (about 195kph/120 mph) and at the same angle to the camera (about 60°). For the top photograph a fast shutter speed (1/1000 second) and panning were necessary to "freeze" the car. This produces a rather artificial, if accurate shot—the car could almost be stationary. The middle picture goes to the other extreme, panning with a slow speed (⅟₃₀ second) to create blur. The last shot is a compromise: panning with a medium shutter speed produces sufficient definition to read the numbers on the cars but enough blur to give an impression of speed. To blur the static section of the image but retain sharpness in the moving element, the "pan" should be continued after the shutter is released.

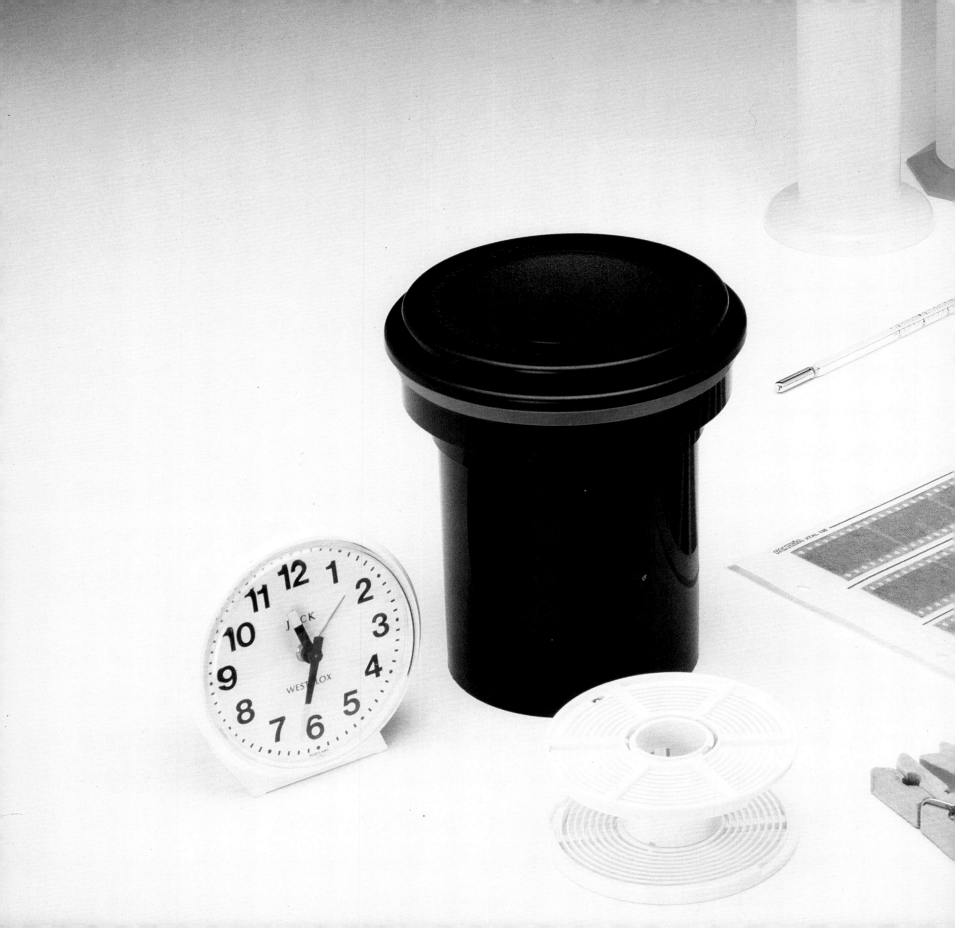

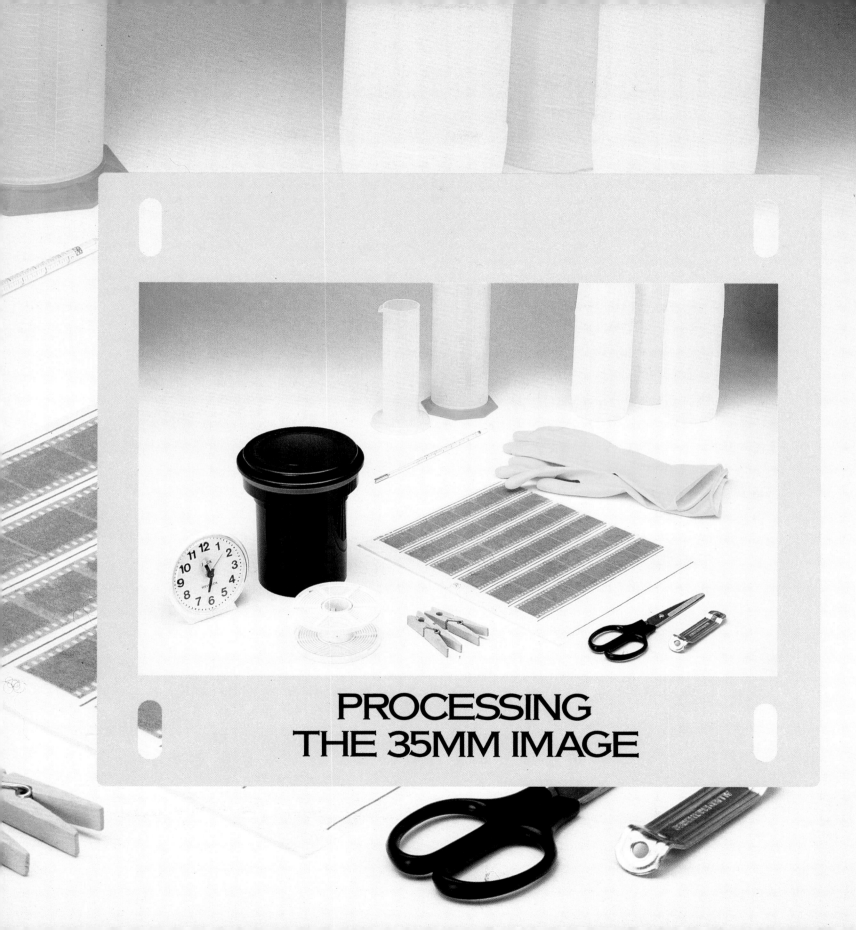

PROCESSING
THE 35MM IMAGE

*T*o the inexperienced amateur, setting up a darkroom can seem a daunting and expensive prospect. It need be neither. Most of the essential photographic processes can be carried out with few facilities and little difficulty, and while an elaborate darkroom may be more convenient there is no reason why top-quality results should not be produced with a simple, temporary arrangement such as a converted bathroom.

Ideally, of course, the darkroom should be permanent. If there is sufficient space for this—a spare room, attic or basement, or even a garage—it is advisable to spend some time planning a layout on paper. Photographers spend a good deal of time in their darkrooms and a comfortable, convenient layout will add to the pleasure of working in it.

Keeping out the light

The first task is to make sure that the room is made light-tight. Light-proofed blinds for the window areas can be bought in various sizes from photographic suppliers, but an alternative is to construct a softwood frame slightly smaller than the inside measurements of the window recess and cover it with hardboard. The edges of the frame should be covered with black felt or other thick fabric that will provide a tight fit and a light-trap around the edges of the shutter.

The door will probably be the only other source of a light leak. This can easily be overcome by hanging two rolls of thick curtain, overlapping and a few feet apart, or by constructing overlapping doors of hardboard.

To test the light-proofing you should sit in the room with the lights off for about ten minutes. It takes that amount of time for the eyes to become adjusted to the dark, and any other leakages of light will then be detectable.

Provided the room is adequately light-proofed, there is no advantage in having dark walls or a dark ceiling. The area behind the enlarger should be matt black, but if the safelight filter is correct for the materials being used (the manufacturers indicate this on their information leaflet) and the recommended wattage of the bulb is not exceeded, it is a positive advantage to have the walls and the ceiling matt white because the safelight will then cast an even light throughout the room.

The safelight enables you to see what you are doing without harming the materials in use—except, of course, during the process of loading exposed film and putting it in the developer tank, when total darkness is essential. In the temporary darkroom the normal bulb can simply be replaced by a special coloured bulb; the more established amateur will change the filter in the safelight to suit a particular process or stage. In a large darkroom (anything bigger than about 2.5 × 3m/8 × 10 feet) it is desirable to have more than one safelight, with one positioned near the middle of the ceiling and the other over the sink.

It is helpful if the white-light switch in the darkroom can be reached from both the enlarger position and the fix dish. This can easily be achieved by using a pull-cord switch to the light fitting and connecting this to a cord stretched across the darkroom about 30cm (12 inches) above head height.

Organization in the darkroom

One of the most important rules of darkroom procedure is to keep the wet and dry areas apart. The wet side should be reserved for chemical solutions, the dry side for the enlarger and its subsidiary items. This saves time and effort in the sequence of work and prevents contamination of materials.

In a purpose-built darkroom, it is best to keep wet and dry operations separate. Use the dry side (near right) for exposing paper with the enlarger, and for trimming and mounting prints. All film and paper processing takes place on the other side of the room, ensuring that chemicals and water do not splash prints or paper (far right).

In a custom-built darkroom it is helpful to have as a wet bench a rectangular sink, long and wide enough to accommodate three or four large dishes and deep enough to prevent splashing and spillage. These can be bought in various sizes from suppliers in moulded plastic or stainless steel.

Because you may need to find something urgently when the lights are off, you should be familiar with the location of all your materials and ensure that they are always kept neatly in the same place. Small strips of luminous tape on shelf edges, light switches and tank lids can prevent frustration. A pinboard is also useful to keep leaflets, manufacturers' information, development times and records of the number of films and papers put through the developer and fix.

There is virtually no limit to the comfort and convenience that can be introduced into a permanent darkroom, but many items are merely refinements. Excellent results can be obtained with simple, basic facilities.

Film-developing equipment

One of the most essential pieces of darkroom equipment is the developing tank. Where the budget allows, stainless steel should be chosen. Stainless-steel tanks and spirals will last a lifetime, and although the initial price may be as much as four times that of plastic alternatives, the eventual saving will be enormous.

In addition, two or three precision chemical measures in glass or hard plastic will be required for mixing and measuring the developers and the associated processing chemicals. One measure should be a finely graduated glass measure for up to 50ml (about 2 fluid ounces), and the largest should be of a suitable size to match the developing tank in use; there is little point in using a 250ml measure if your developing tank requires 500ml of solution. Essential for all processing procedures and mixing of chemicals is a good thermometer, preferably a mercury or digital one. Film hanging clips are also necessary, although clothes-pins can do the job quite efficiently. This equipment will enable you to produce your own negatives. Colour negatives are just as easy to process.

Printing equipment

To make the print an enlarger is the first requirement and you should pay special attention to the lens. Remember that the information contained in your negative can only be transmitted to the printing paper via a lens of similar or better quality than the lens on the camera that took the picture. There is little point in having a fine camera lens if a cheap lens is used on the enlarger. The final print is the sum of the quality of both optical systems.

The measures already purchased for film processing are suitable for mixing and measuring the print developers and the other chemicals. The same thermometer can also be used. The extra equipment needed includes at least three print-developing trays of suitable dimensions for the maximum print size, together with perhaps a set of dishes of each of the sensible smaller print sizes. For instance, if you intend to make prints up to 40 × 51cm (16 × 20 inches), you will need trays that are sufficiently large to enable the print to move in the tray to ensure sufficient agitation of chemicals over the paper's surface. A tray of approximately 50 × 60cm (20 × 24 inches) would be suitable. Obviously if this size of print-developing tray is required then the same size of tray is needed for the stop bath and for the fix bath. If small prints are to be made in large quantities the large tray is ideal, but a small tray will be more suitable for limited numbers. Stop bath and fixer chemicals are not used up to the same extent as developing chemicals and so the large trays could be used all the time for these. Developers are subject to surface oxidation and will deteriorate if they are lying in a large tray doing nothing.

A good easel, a safelight, a set of print tongs and a timer would complete the basic darkroom. If funds are available, an enlarging exposure meter and a colour analyzer for colour prints would make life easier, as would a print dryer and a negative-drying cabinet, although these are not essential.

A good negative filing system, such as the albums provided by Paterson, and a contact printer to enable a sheet of negatives to be printed at once and filed with the negatives for easy identification will both save a great deal of time when your negative collection reaches a reasonable size.

A BATHROOM DARKROOM
It is possible to print pictures in even the smallest of spaces, and for a makeshift darkroom the bathroom is ideal. There's a supply of running water, and most bathrooms have only small windows that are easy to black out. Run an extension under the door to power the enlarger and safelight, but take care that water and chemicals cannot splash the electricity supply. In a small bathroom, you can mount the enlarger and dishes on a board placed over the bath; raising the enlarger higher than the dishes reduces the risk of chemicals splashing on paper or equipment. Though you can wash prints in a small basin, it's better to use this as a plain water "holding area" for the prints: washing is always more efficient in a bigger sink, where there's a vigorous flow of water to remove fixer. If you're making colour prints, you can use the darkroom solely for exposing the paper. After a print is loaded into a drum, further processing takes place in daylight.

THE 35MM DARKROOM AND MATERIALS -2

Chemicals

Negative and print developers differ in subtle ways and are not really interchangeable. However, for black and white work the stop bath (a 2 per cent solution of glacial acetic acid) and the fixer bath are almost identical for both prints and negatives and the stop bath and fixer concentrates used for the one process may also be used for the other.

For straightforward black and white negative developing you will require a suitable developer—use the one recommended by the film manufacturer initially—a stop bath and a fixer. For the paper print you will require a special print developer. Once again, it is best to use the type suggested by the paper manufacturer.

Colour processing requires more chemicals and more processing stages. Additional chemical processes are bleaching of the silver image and stabilization of the dye image as well as an extra hardening of the gelatine bearer. For the reversal process, to produce transparencies, a fogging agent is also required. This is toxic and good ventilation is therefore required. Although colour processing involves more work it is really just as easy as black and white, and you should not be put off by the apparent complexity of the process.

Do it yourself?

With the vast choice of photochemicals now readily available, there is little sense in buying a vast array of chemicals. While there is an obvious schoolboy pleasure to be obtained by measuring, mixing and testing home-made brews, financially it is not viable. Raw chemicals have to be bought in fairly large quantities and the packaging of some of them is more expensive than the contents. It is far better to use the chemicals mixed by the manufacturer of the film of your choice. Then, when the need to experiment occurs, look out for specialist developers manufactured by such companies as Paterson, Phototechnology, May and Baker, and Tetenal, all of whom market first-class products. Manufacturers of the film stock, be it Kodak, Agfa or Fuji, certainly know what formulation will give the best results for their products. Another manufacturer will at best only match the quality, although most claim to give a different effect, such as finer grain, enhanced sharpness or better contrast control.

In addition, although formulas for alternative processes are available from such publications as the *British Journal of Photography, Leica Fotographie* and *Darkroom Photography* (US), the raw chemicals mentioned may prove to be a problem since most manufacturing chemists give different names to what is basically the same substance.

Developers

A fairly simple developer contains at least four constituents. The basic ingredient is a reducing chemical that will turn the colourless silver salts that have been affected by light into black metallic silver, thus changing the latent image on an exposed piece of film or printing paper into a visible image. The most common of these chemicals are Phenidone, Metol, Hydroquinone and Amidol, and they work by extracting the oxygen from water. Hydrogen remaining in the water combines with bromine in the emulsion and forms hydrobromic acid, which must be neutralized by an alkali in the developer before it halts the process. The alkalis used can be sodium carbonate, sodium or potassium hydroxide or sodium borate. Since the main constituent of the developer is a reducing agent, it would tend to absorb oxygen from the air and its potency would deteriorate. Consequently a chemical with a strong affinity for oxygen is added to prevent this. Sodium sulphite is the most usual chemical used. Finally, a chemical must be used to prevent the developer from reducing the unexposed silver salts as well as those that have been exposed. This chemical is known as a restrainer and is usually potassium bromide; without it the whole negative or print would fog.

These are the four basic ingredients of a black and white developer. They vary a great deal from manufacturer to manufacturer and to suit the purpose for which they were produced. A typical negative developer may, in a liter, have 0.75gm phenidone, 6.0gm hydroquinone (reducing agents), 2.5gm sodium borate (alkali), 75gm sodium sulphite (oxygen absorber) and 1gm potassium bromide (restrainer). A typical print developer may have 2.2gm metol, 17gm hydroquinone (reducing agents), 6.5gm sodium carbonate (alkali), 75gm sodium sulphite (oxygen absorber) and 2.8gm potassium bromide (restrainer). These have the same ingredients, but the proportions differ significantly.

With colour processing chemicals, the problems are increased by the need to keep to fairly tight pH factors. A change in the acidity has a marked effect on the colour balance of the resulting transparency or colour print. Repeatable quality is obtained only by exact formulation, and this requires strict quality control and monitoring. This can only really be obtained in factory production.

Printing materials

Printing paper consists of a sheet of paper with a light-sensitive emulsion coated on one side. The emulsion consists of silver salts that undergo chemical changes when exposed to light.

The basic printing papers are covered on page 200, but many specialized printing papers are available, including those with a colour base and those with fluorescent bases. Plastic is often used as a base, especially in certain modern colour processes such as Cibachrome.

Sometimes unusual bases are used. The emulsion can be spread on linen or wood to achieve various effects. One enterprising astronomer had a series of metal globes coated with photographic emulsion so that he could project on to them negatives of the moon as taken through a telescope. In this way he was able to smooth out the distortions of the surface features as seen from the earth and enable them to be observed in their true perspective.

The choice of papers for colour prints has improved recently, and a choice of contrast and surface is now available for amateurs. Individual papers are produced by the manufacturers of colour film so that both their products complement each other. Dye-destruction prints—those in which the dye already in the emulsion loses its colour in response to light leaving some of the colours behind to form the image—are available both on white plastic bases, to give prints, and transparent bases for slides. The images produced are rich and stable and are suitable for long-term display.

Holding the paper

The printing paper is usually held in position by an easel or a masking frame. This consists of a heavy flat base made of metal or plastic edged by two permanent abutments which make a right angle. Movable arms slide along the abutments to form the opposing sides of the rectangle that will be the picture area. Calibrations along the abutments help in this. Borderless easels hold paper in place either using magnetic corners, which grip the paper only at the extreme edge, or else using a vacuum pump, which sucks the paper onto a perforated board.

Larger sheets may be exposed by laying them on the floor and swinging the head of the enlarger around on its column so that the beam misses the base and the work bench. Some enlargers have heads that can be swivelled into a horizontal position so that an image can be projected on to a wall.

During enlarging, masks may be used to give different image shapes—for example, keyhole shapes and heart shapes for wedding photographs. Dodgers can be used to reduce tones locally and to ensure that some areas of the print have less exposure than the others. These dodgers consist of cardboard shapes on the ends of rods and they can be moved around over the area of the print where less exposure is required. Special screens can be bought to be placed over the paper during enlarging to give a simulated surface texture. These textures include canvas and oil-painting surfaces.

Finishing the print

Photo finishing is the final stage in making an exhibition print. In handling the negative, damage of a greater or lesser degree is inevitable. A minute and almost invisible scratch on a 35mm negative will be enlarged by the same degree as the image and on a large print will be objectionable. Dust and drying marks will also be enlarged. The dark lines of a scratch can be knifed out with the fine point of an X-acto knife, while the light spots caused by dust can be filled in with carefully matched watercolours or special print retouching dyes. For colour prints and enlarged display transparencies the same would apply, although the skills required for colour matching are harder to attain. A really good colour retoucher can, therefore, earn more than a good photographer. For retouching, a good desk is required together with good lighting (colour-matched for colour work) and a magnifying lens, a set of fine sable paintbrushes down to 00 size and a set of knives. Full details of retouching are given on pages 210–211).

DEVELOPING BLACK AND WHITE

REELS AND LOADING

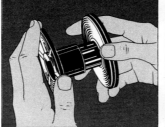

Plastic reels may, as a first step, need adjusting to fit the width of 35mm film.

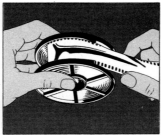

In total darkness feed the film into the spiralling flange until it is gripped by the ball-bearings.

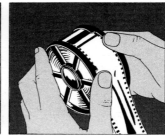

Rotating the two sides alternately back and forth draws the film progressively into the reel.

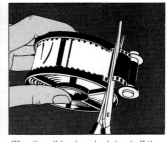

When the roll has been loaded, cut off the spool, put the reel into the tank and put on the lid.

When a film is exposed to light a latent image is formed. The process by which this image is made visible as a negative—developing—is one of the most exciting aspects of photography. It is also one of the simplest. Success is dependent on totally controllable factors, and with care, cleanliness and consistency of procedure there should be no problems.

The first chemical process is breaking down the exposed silver halides in the film to black metallic silver. The developer, a mixture of chemicals in solution, at first affects only those silver halides that have been exposed to light and does so in proportion to the extent to which they have been affected. In time, however, the developer would begin to convert the unexposed silver halides into metallic silver, causing an overall grey known as chemical fog, and it is vital that the time specified for the developer is not exceeded.

Most development times recommended for black and white film are calculated for a temperature of 20°C (68°F). Higher or lower temperatures may be used, but the development time must be adjusted accordingly, and the manufacturer's instructions will indicate these variations. Photographers can quite easily make up their own chemicals, but the manufactured products are inexpensive and save time.

The moment the developing time has been completed the development must be halted, either by a brief rinse in water or by use of a stop bath. The "stop," a mildly acidic solution, immediately checks the action of the alkaline developer and is thus more efficient than running water. It also helps to prevent the fixing solution, the third chemical, from being unnecessarily

DEVELOPMENT

Prepare for development by mixing developer, stop and fix according to the manufacturer's instructions. Warm the developer to 20°C (68°F), measure out enough to fill the tank, then quickly pour it in.

contaminated with developer.

The next chemical in the process is the fixer. This solution renders the unconverted light-sensitive chemicals in the emulsion soluble in water and enables them to be washed away in running water. Although it is quite safe to expose the film to light after a few minutes in the fixer solution, the negatives cannot be regarded as permanently safe until these remaining chemicals have been removed by the washing process. With water at 20°C (68°F) this stage, the last before drying the film, takes about 30 minutes.

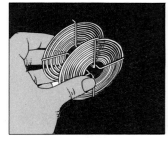

Stainless-steel reels need no adjustment, but loading needs more practice than with plastic reels.

Start by fixing the end of the film to the spring clip attached to the core of the reel.

Gently bow the film, and turn the reel so that film feeds into the spiral from the middle outwards.

Cut off the spool, place the reel in the tank and put on the lid. Now you can turn on the light.

Start the clock as soon as the tank is full, then put the lid on, and rap the tank a couple of times on the bench to knock any air bubbles off the film. This prevents "air bells" from forming.

Agitate the film every minute by inverting the tank a couple of times to ensure that developer flows evenly over the film. Some manufacturers recommend continuous agitation, so check instructions.

Shortly before the development time is up, take the lid off the tank and pour out the solution. Remember that the process of development continues until you pour the stop bath into the tank.

Stop bath arrests development and also extends the life of the fixer solution. If you run out of stop bath, you can replace this step with a half-minute rinse in water at 20°C (68°F).

Empty the tank into a measuring cylinder (you can reuse stop and fix) and fill up with fix. In rapid fix, film needs only about two minutes; agitate the tank continuously to make fixation even.

Drain the fix from the tank and wash the film in running water. When water is at 20°C (68°F), this step takes about twenty minutes. In colder water the process takes longer than this.

After washing, fill the tank with distilled or deionized water, then add a few drops of photographic wetting agent. This helps water drain evenly off the film and eliminates drying marks.

Hang the film to dry in a dust-free area. If you don't have access to a purpose-made drying cabinet, use a room without carpets or soft furnishings, such as a shower room, kitchen or bathroom.

Testing Exposure

*T*he best and safest way of determining the exposure time needed to produce a good-quality print is to make a test strip. This is basically a refinement of trial and error: instead of experimenting with different exposure times on several sheets of paper until one of them gives a good result, it is much more efficient to use one small strip of paper and give it several different exposures.

This is done by cutting off a strip of the photographic paper you are going to use and exposing it in sections so that each receives a slightly different exposure. Then, if the section at one end comes out too dark, and the section at the other end too light, there will obviously be one step somewhere between the two which is right. If necessary the accuracy can be narrowed even further by repeating the process with shorter intervals, but one experiment is usually enough after you have learned where to start.

Once the correct exposure has been established from the test strip, the final print can be made. It is important to remember that the degree of enlargement greatly affects the exposure time, so if the enlarger head is adjusted a new test strip will have to be made. The step-by-step sequence on the opposite page explains how to set about making a test strip in practice.

It may seem wasteful to cut up a whole sheet of paper, but in reality it is wasteful *not* to use test strips because more paper is wasted without them.

Make a test strip by first exposing the whole strip of paper for 2 seconds, then cover a fifth of the strip and expose for a further 2 seconds.

Subsequent sections of the strip are exposed in a doubling sequence: 4 seconds for the third section, 8 for the next, and finally 16 seconds.

Developing the strip reveals a range of exposures. If all are too dark, close the aperture two stops. If all are too light, open the aperture two stops.

PROCESSING PROBLEMS

*A*ll photographic materials have their own idiosyncrasies. Techniques which are perfectly satisfactory when used in conjunction with one combination of materials may produce unexpected and often unwanted effects when applied to a slightly different combination. Moreover, many of the chemicals are prone to deterioration, either in time or as a result of prolonged exposure to light, extremes of temperature, the atmosphere, or contamination with each other.

Another cause of faults is poor equipment, though it is often the case that results which appear to be due to a malfunction in your camera or damage to your film may actually be the result of your own techniques; this is particularly true if you are not familiar with the exact nature of the materials being used or with the hazards of the darkroom. The purpose of this fault-finding guide is to help you to identify the most common peculiarities in the process, and the faults they can give rise to, and to enable you to distinguish between a fault you can correct yourself by modifying your technique and a fault which requires processional repairs.

Exposure and development: too dark

Underexposure and underdevelopment both result in thin, pale negatives, which in turn result in dark prints. Their effects, however, are not identical, and it is important to be able to distinguish between them: an *underexposed negative* is lacking in detail, while an *underdeveloped negative* is lacking in contrast. Naturally, it is in the shadows that detail will suffer first if you are underexposing your pictures. Pictures showing neither shadow detail nor reasonable contrast are likely to be both underexposed and underdeveloped, in which case each fault must be corrected independently.

Underexposure Something may be wrong with your equipment—a faulty meter or a faulty shutter mechanism, for example—but there are a number of other simple possibilities that should be checked first. You may have forgotten to set the right film speed on your meter last time you changed film; you may have forgotten a filter factor (or that you were using a filter at

all); you may have been using stale film that has lost some of its original speed. Finally, under certain circumstances, underexposure can result from reciprocity failure.

Underdevelopment This may simply be caused by stale developer, but this is not the only possible reason. Film developer may cool a few degrees when it is poured into a cold developing tank, and it is likely to lose heat slightly during the development process itself. Check the temperature of the developer in the tank when you first pour it in by inserting a thermometer down into the middle of the spiral. The chemical manufacturers usually provide a graph of temperature against time, from which you can read off the exact development time needed at any given temperature. A negative showing either of these faults may be successfully improved by chemical or optical intensification (by making a contrasty duplicate).

Exposure and development: too light

Overexposure and overdevelopment produce dense negatives that result in light prints and loss of highlight detail. In the case of overexposure, the picture suffers from loss of contrast as well as blocked-up highlights, while an overdeveloped negative has excessive contrast, with good detail in the shadows but also blocked highlights. The border of the negative is often a useful guide: if it is dark or foggy, then overdevelopment is more likely to be the cause.

Overexposure A faulty light meter or a faulty shutter are possible causes of overexposure, just as they are of underexposure. Similarly, it is again worth checking the ISO setting on your meter before assuming it is damaged. Another mechanical failure which can cause overexposure is damage to the automatic diaphragm on the lens of an SLR. If the diaphragm does not close down quickly enough, or fails to close at all, the negative will be overexposed. Alternatively, you may be using some attachment that deprives you of the automatic system altogether (some extension tubes, for instance), or an unfamiliar lens that is not automatic.

Overdevelopment A faulty thermometer may be giving misleadingly low temperature readings, and this would cause you to develop at too high a temperature.

Alternatively, if you agitate the developing tank more than recommended you must take care to make compensations in the development time: some manufacturers give you alternative figures for continuous agitation.

An overexposed negative can be improved by subtractive reduction, an overdeveloped one by proportional reduction.

Fogging

A large area of increased density, sometimes covering all of the negative or print, in which the image is obscured, is known as fog. The most common cause is light reaching sensitized material where it is not wanted. If a negative is fogged but the borders are clear then the fogging could have been caused while the film was in the camera—by light entering through damaged bellows or a faulty shutter, for example. If most fogging is at the edge of the negative, it is probably due to a badly fitting camera back. The fogging of a negative over its whole area, including the borders, can be due to a large number of faults. These include excessive developing time; too high a developing temperature; developer exhausted or incorrectly mixed; unsafe darkroom light; light leaks in the camera, packing, darkroom or tank; stale film; and excessive exposure to air during processing. Developer that is too warm or exhausted may also give a dichroic fog that appears red by transmitted light and blue by reflected light.

This may also be caused by a fixing bath that is too warm or exhausted or contaminated by too much developer from previous prints, or by exposure of the negative to a strong light before completely fixed. The same faults also give rise to fogging on prints. Stray light from the enlarger during exposure may also fog prints, and in this case it can be diagnosed because the edges masked by the masking frame are left clear. Fogging along the edge of a print may be due to the paper having been stored in a damp or very warm room or close to a heater. Because film fog may also be caused by X-ray examination at airports, it is best to remove undeveloped film from luggage when travelling by air. Papers left lying near a safelight may be fogged overall and may show the outlines of those on top of them.

PROCESSING PROBLEMS

Spots

Spots on prints and negatives, whether dark or light, are usually caused by dust particles or other pieces of foreign matter.

White specks on the negative suggest the presence of dust on the film before the exposure. White specks on the final print are usually caused by dirt on the negative during enlarging or, sometimes, by dirt on the printing paper surface. Fuzzy white spots on the print may be caused by dust that has gathered on the top surface of the enlarger condenser system. The remedy is meticulous attention to cleanliness at all stages of the operation.

If the spots are fairly large and round they may be caused by air bubbles trapped against the film or the paper during developing. Such spots appear white on the negative and black on the print if this occurred during processing of the film, and white on the print only if during the developing of the print. Insufficient agitation is usually the cause, and it can be avoided by tapping the developing tank against the side of the bench as soon as it is filled. These faults can usually be rectified by retouching the print.

Fairly large areas of staining on the negative, sometimes with increased emulsion density round the edges, are drying marks caused by persistent drops of water that dry slowly. This can sometimes be rectified by washing again and drying.

Lines

The most common reason for lines on a picture is scratching. This may be caused by clumsy handling of the film, by grit in the entrance of a cassette or by the end of the film being pulled so that the roll tightens against itself. In less serious cases this may be rectified by retouching. Scratches on prints may also be caused by careless handling of papers—scraping sheets against each other or handling them with sharp tongs.

Uneven image density

A picture showing different image densities from one area to another means that either the negative or the print has had an uneven development. If it occurs on the negative it indicates that the developing tank has not had sufficient agitation or that there has not been enough developer in the tank. If it occurs only on the print then the tray has not been agitated enough or the print has not been completely covered by the developer during developing. A gradual increase in density towards one end of the negative may indicate an uneven drying.

Deposits on the negative

Hard water may give rise to a fine-grained coating of insoluble chalky residues on a processed negative. This can be cured by washing the negative first in a 2 per cent solution of acetic acid and then in clean water. A similar effect may be due to a precipitation of aluminium sulphite formed when the fixing bath loses its acidity. The remedy is to harden the negative in a 1 per cent solution of formalin, then wash it in a 5 per cent solution of sodium carbonate and then in water.

Discoloration

A yellowish-white negative is probably due to a deposit of sulphur from decomposing fixer and can be rectified by hardening in a 1 per cent formalin solution and washing in 10 per cent sodium sulphite solution at 38°C (100°F). Greenish-black tones on prints are due to underdevelopment of chloride and bromide prints, overdevelopment of chlorobromide prints, exhausted developer or excess potassium bromide in the developer. In these cases the print may be dyed.

Yellow or brown stains on the print may be due to insufficient agitation during fixing, exposure to white light before completion of fixing, insufficient rinsing between developing and fixing or exhausted fixer. Such a print may be bathed in the appropriate stain remover. Brown marks on hot-glazed prints are often formed by insufficient fixing or washing and can sometimes be remedied by bleaching in a potassium permanganate bleacher and then redeveloping.

Green image tones may occur when stale paper is used or when the developer is exhausted and can be avoided by using a developer improver. A red, blue or

green tinge on the negative support is the antihalation backing which should disappear during the processing. If it does not the negative can be soaked in 5 per cent sodium sulphite solution.

Reversal of negative image

Partial or total solarization may turn the negative image to a positive one after accidental exposure of the unprocessed negative during development. Care in handling the equipment is the only answer.

Light spreading from dense to less dense areas

Light may scatter within the emulsion of a negative to give a dark shadow surrounding a high-density area. Alternatively, light may be reflected from the negative backing to give haloes or rings around very high-density points in the picture. If this is not too great, the negative or the final print may be retouched.

Static marks

Electrical discharges that crop up when handling unexposed film can lead to dark marks on the negative. These can take the form of uneven diffused bands along the film where fingers have wiped it or branching, lightning-like patterns due to sudden movements in a hot, dry atmosphere.

Fingermarks

These are almost invariably caused by handling sensitized materials with dirty fingers. White marks on negatives may be caused by handling before developing with fingers contaminated by grease or fixer. Dark marks on negatives are usually caused by wet fingertips or fingertips covered with developer. Where the damage is slight the film or the print can be retouched.

Polygonal shapes on negatives

Dark shapes corresponding to the configuration of the diaphragm on the negative, often associated with dark streaks, are due to reflections of light between the lens elements. The only way to avoid these is to ensure that the lens is shielded from direct sunlight.

Reticulation

The network of fine cracks in the emulsion, known as reticulation, is due to washing the film at high temperatures or to using solutions of greatly differing temperatures.

Double exposure

When two totally different images appear on one negative, the film has not been wound on between exposures perhaps indicating that the winding mechanism is damaged. If a moving element of a single image is recorded twice in a slightly different position it may be due to shutter bounce, when the shutter opens again after exposure.

Image mispositioned on negative

If this is consistent over a number of negatives, the viewfinder of the camera may be wrongly aligned. This is most common on cheap snapshot cameras. If the viewfinder cannot be reset, the amount of deviation must be taken into account when sighting for subsequent photographs; if the image does not reach into the corners of the negative, it suggests that the wrong size of lens for the particular camera is being used; if these blocked-out corners are fairly sharp it may mean that the lens hood is of the wrong design. In all these cases the final picture may be saved by selective enlarging of part of the image.

PRINTING BLACK AND WHITE

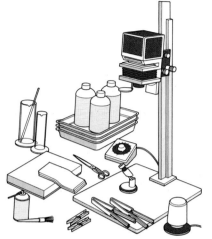

While developing negatives is essentially a routine process requiring care and accuracy but very little skill, it is at the printing stage that photography becomes a craft.

A good-quality print is one that faithfully reproduces the range of tones recorded on a good-quality negative. It will exhibit areas of deep black where the negative is clear as well as clean white where the negative is opaque, while at the same time showing all the detail that appears on the negative. This is the goal, but in the early stages the only guide is trial and error. The "perfect" print is achieved by the correct combination of paper, exposure time and development time.

Different grades of paper vary the contrast of the picture and can be used to compensate for variations that occur between negatives—a technique explained more fully on page 200. The other critical factor is exposure, and the test strip (explained on page 194) is the best method to select the ideal exposure time.

Making the print

To make a positive print from a negative transparency, light is projected through the negative on to special paper coated with a light-sensitive emulsion. The paper is then developed in the same way as film, using a slightly modified developer but the same stop bath and the same fixer. The paper is washed to remove all the unwanted chemicals and then dried. The resulting picture is the positive.

The emulsion on photographic paper is essentially the same as that on ordinary film, except that it is only sensitive to a small part of the colour spectrum, and this allows the use of a safelight. The paper is therefore processed in open dishes instead of the light-tight tank used for films, and the image can be watched as it appears when the paper is developed.

Contact printing

Although it is tempting to start making enlargements once the developed negatives are dry, it is better to produce a contact print first—a same-size print of all the negatives of a film side by side on a single sheet of photographic paper. This method (illustrated on these pages) makes it easier to select which pictures merit enlarging and saves you the expense and disappointment of enlarging inferior shots.

The normal printing process applies in making contact prints from negatives. First, light must shine through the negatives to expose the sensitized photographic paper; then the paper must be developed to reveal the positive prints. For the first stage 20 × 25cm (8 × 10 inch) printing paper is required and either a printing frame or a blemish-free sheet of glass a little larger than the paper. The negatives are sandwiched next to the paper in contact with the emulsion while the light from the enlarger shines through the negative on to the paper. The resulting positives are exactly the same size as the negatives.

MAKING A CONTACT SHEET

 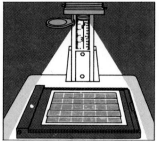

Mix developer, stop bath and fix according to the manufacturer's instructions, and fill the trays, taking care that chemicals don't splash from one tray to another.

Wind the enlarger head about half-way up the column, and adjust the aperture to f/8. Turn the focusing knob until the enlarger projects a sharp-edged rectangle of light.

Switch off the enlarger and white light, then place negative strips dull side down on the paper. Cover with a sheet of glass to keep the negatives and paper in contact.

Switch on the enlarger to expose the paper. How long you expose for depends on many factors—with experience you'll probably arrive at a standard time.

MAKING A PRINT

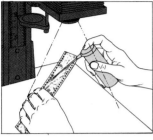

The enlarger magnifies dust so, before printing, clean the negative carefully using air from a can, or from a rubber bulb syringe.

Put the negative into the carrier, positioning the image you want to print above the rectangular cut-out, then close the carrier.

Slide the negative carrier and negative into the enlarger head, switch on the lamp and turn out the overhead white light.

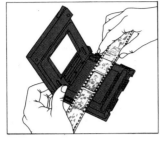

Adjust the enlarger lens to its widest aperture. This gives a bright image, and makes focusing more precise.

Move the arms of the enlarging easel to the size of the paper you're using. Remember to allow for the width of the borders.

Raise or lower the enlarger head until the image is about the right size—don't try to get it exactly right at this stage.

Now turn the focusing knob until the picture is sharp. This changes the size, and you may have to repeat the previous step.

Close the lens to the working aperture and expose the paper for the time determined using a test strip. Then process as shown below.

Slide the paper into the tray of developer, which should be at about 20°C (68°F). Rock the tray gently to cover the paper evenly with the solution.

After about 90 seconds (the time varies depending on which paper and developer you use) use tongs to transfer the paper to the stop bath for a 10–second rinse.

Fixing the paper removes its sensitivity to light. Transfer the sheet from stop to fix and rock gently for 2 or 3 minutes—time varies with brand and dilution.

Wash the contact sheet in running water to remove the fix. Resin-coated paper usually needs washing for only 2 minutes in water at about 20°C (68°F).

Finally, sponge off excess wash water from the surface of the paper and hang up to dry. With resin-coated paper, you can speed the process by using a hair dryer.

PRINTING CONTROL

*P*hotographic paper can vary in a number of ways. There are differences not only in the physical quality of the paper that supports the emulsion but, more important, also in the chemistry of the emulsion itself. The paper is described in terms of size, weight and surface, the emulsion in terms of grade, which refers to the degree of contrast it will give.

The difference in grades is a crucial factor in processing since paper, by correcting or modifying the contrast of an image as it appears on the negative, is the primary means of controlling print quality in the darkroom.

Grades of paper range from 1 to 5 (with occasionally 0 or 6 in addition), representing a scale of contrast from soft to hard in which grade 2 is normal contrast. Thus the most common grades are 1, 2 and 3, while grade 5 is usually used only for deliberately exaggerated effects or very thin negatives. Grade 4 is useful when grade 3 is insufficiently hard. The illustrations below show how the different grades of paper can be employed as a means of quality control.

Not all papers have separate and distinct grades. Variable-contrast paper, as its name suggests, offers a range of different contrast grades in a single emulsion. The paper is actually coated with not one emulsion, but two, each sensitive to a different colour of light. The green-sensitive emulsion is low in contrast, and the blue-sensitive emulsion creates high-contrast prints. Changing contrast is thus just a matter of altering the colour of the enlarger light source, and this is done by means of filters. Using variable-contrast paper greatly simplifies black and white printing: it is like having five grades of paper in one box.

The other variables are self-explanatory. Weight refers to "airmail," single-weight or double-weight, a thicker card useful for large prints which would be vulnerable to damage on single-weight paper. Surfaces other than the standard glossy include matt, luster, stipple, velvet, silk and high gloss.

In addition to these traditional variants, and papers with a tinted base, there is a choice between ordinary fiber paper and resin-coated paper. The latter is quicker to process because the paper itself does not soak up chemicals and so less time has to be spent washing and fixing prints. It also has less tendency to curl. Despite these advantages, the final quality of fiber-based paper is generally regarded as superior.

Print control

The information provided by a test strip is not, unfortunately, a complete solution to all exposure problems. A test strip should determine the best exposure time for the print as a whole, but in practice it

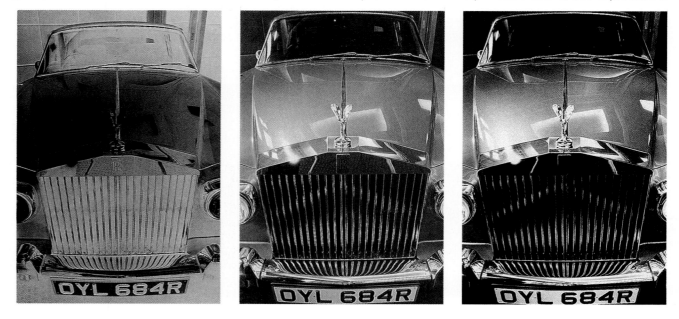

A negative exposed and processed correctly (right) should produce a good print on normal (grade 2) paper. Softer paper such as grade 1 produces a "flat" print—one with lower contrast (middle right). Harder paper, such as grade 3, produces higher contrast (far right).

will be found that some areas of the picture ideally require exposures considerably different from that given to the main subject.

A common example is the sky in landscape pictures, where the sky on the negative is so dense that it needs twice or three times the exposure given to the rest of the picture; without correction it appears an uninteresting area of white.

In cases such as this the solution is simply to extend the exposure time where it is needed while covering up the rest—a technique known as "burning-in"—which brings out detail in excessively bright highlights. "Dodging" (or shading, as it is often called) is the same process in reverse: holding back shadows so that they receive less than full exposure.

The only difficulty in applying the idea of controlled local exposures is avoiding sharp lines around the area that has been covered up. This is overcome first by holding the masking device away from the paper so that the shadow it casts is blurred, and also by keeping it moving continuously. A range of masking devices for shading can be made from pieces of cardboard taped to short lengths of black wire (shiny wire will give off reflections) and special shapes can be cut out when required. For burning-in, a hole is cut in a large sheet of cardboard instead. In most cases, however, it is perfectly acceptable to use your hands instead of cardboard, which is only really necessary for precise detailed work.

Burning-in and dodging can be applied to the same print if necessary. The vignette and reversed vignette are the creative extensions of the same kind of corrective techniques.

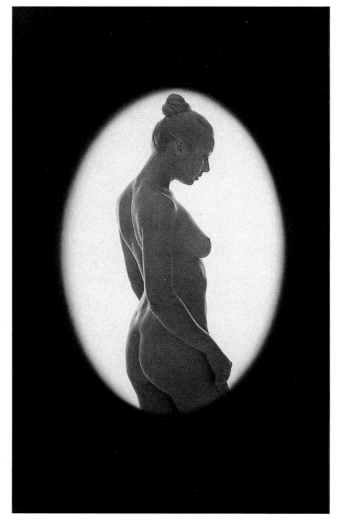

Burning in and shading a print (above) *is a rather inexact science: many photographers use their hands to cast the necessary moving shadows. Shapes cut from cardboard give more precise control. To produce a vignette* (left) *hold the cardboard mask with an oval aperture just above the paper and keep it still during the exposure; movement softens the edges.*

COLOUR PROCESSING

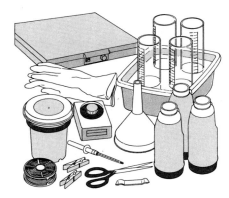

*P*rocessing colour film need be no more difficult than black and white. There is a wide range of colour films available, most of them suitable for home processing, but since each type of film has its own chemicals, it is essential that the chemicals should be compatible with the type of film used.

Colour-negative and transparency-film processing follows a general pattern common to all makes, although the particular formula, times, and the number of intermediary baths vary. The principal steps are development (including colour development in negative film); reversal bath; colour developer and conditioner (in transparency film only); bleach; fix and stabilizer. There may also be washes or rinses between some of these steps.

It is important to stress consistency and accuracy of time, temperature control and agitation. Provided these are carefully watched, processing colour at home will give the satisfaction that comes with a growing sense of craftsmanship—and it is much cheaper. Errors can be virtually eliminated by following manufacturers' recommendations.

Prints from transparencies

Prints can be made from slides as well as from

COLOUR NEGATIVE FILM

In total darkness, load the film into the reel as for black and white processing, put it in the tank and replace the lid. Then mix the chemicals according to the manufacturer's instructions.

Bring all the solutions up to temperature—37.8°C (100°F) for the Kodak Flexicolor process. Keep solutions warm in a water bath about 0.5°C (1°F) hotter than the process temperature.

Pour in the developer and immediately start timing. The colour negative process is more sensitive than black and white to inconsistency of temperature and time.

Agitate the tank at regular intervals, following the manufacturer's instructions. Again, try to be as consistent as possible, as variations in agitation affect density.

Drain developer out of the tank and immediately fill with bleach solution. The timing of the bleach step is not as critical as that of the developer.

When the bleach step is complete, drain the tank and wash in running water. The film is no longer sensitive to light, so you can open the tank at this stage.

Empty out the wash water and pour in the fix. After the correct time has elapsed, drain the fix, wash and add the stabilizer solution, timing the step as before.

There is no rinse after the stabilizer, you can just hang the film up to dry. Removing excess water with a squeegee makes the drying process faster.

negatives. Kodak Ektachrome reversal paper follows the same principle as the standard reversal film process. The Ilford Cibachrome system, described below, is unusual in that it involves a unique process of dye destruction which enhances print sharpness and guarantees long-lasting prints.

As alternative systems to the more common method of printing from negative described on the next page, both methods considerably simplify the problems of filtration assessment. They are, however, more expensive.

The Cibachrome system is different from others in that the dyes are not generated in the emulsion during development; they are already in the emulsion and are selectively bleached out during the processing.

COLOUR TRANSPARENCY FILM

To process transparencies you start with the same procedures as with other films: load the reel in total darkness and prepare the solutions at the correct temperature.

Put the solutions in a water bath to keep warm: for the E6 process, the developer solutions must be at 37.8°C (100°F) and the water bath a little warmer.

Pour in the developer, start timing and agitate the tank according to the manufacturer's directions. Put it back in the water bath to keep warm between inversions.

At the end of the development step, drain the tank and rinse the film in running water. Then pour in the reversal bath and start timing this second step.

Colour developer, conditioner, bleach and fix solutions follow. Drain the tank each time, then refill with the new solution. These steps can be carried out in daylight.

Wash the film briefly in running water, or, where tap water is very cold, with several changes of water at the process temperature, then drain the tank.

Fill with the stabilizer solution. The temperature at this stage is not critical—there is a margin of ± 3°C (5.4°F) for all stages except the two developers, which must be correct to within 0.3°C (1°F).

Finally use a squeegee or sponge to remove surplus water, and hang the film up to dry in a dust-free area.

CONTROLLING COLOUR PRINTS

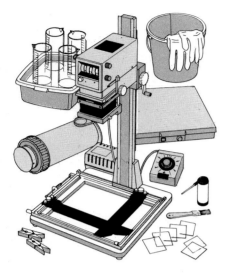

*D*espite increasing standardization, small variations still occur in the manufacturing of colour negative film emulsions and coatings. These are further compounded by the chemical process, disparities in the colour paper emulsion itself and in its own chemical activity. The goal in colour printing is to bring into balance these variations to re-create as faithfully as possible the original scene.

In order to compensate for the inability of manufacturers to provide colour emulsions and chemicals of absolute consistency, a methodical approach and routine discipline are required for reliable results. Using a small notepad to record filtration and exposure should become as habitual as systematic and consistent adherence to manufacturers' recommendations in processing.

All manufacturers "aim" their print material to give correct colour balance somewhere in the middle of the red range of filtration. This means that almost all colour printing will be produced with a final filtration using both yellow and magenta (Y + M = R) filters slightly above or below the middle of the range (i.e. a first test should be with 60Y and 60M filters).

Making a test strip

Test strips must be prepared, as in black and white printing, before a satisfactory print can be made. A range of exposures is necessary to establish the correct overall density of the final print. It is unlikely that the first test strip will be correct for colour balance. The main difficulty in viewing a colour print test strip for the first time will be to identify and evaluate the overall colour cast present, since wet colour prints look slightly darker than dry prints and they have a very slight bluish cast, particularly in the shadow areas.

The chart below is intended to assist in this evaluation. The six pictures all have an overall cast of 20 units of colour and are divided into overexposed, normal and underexposed sections. The picture with correct colour balance and correct exposure is also shown for easy comparison.

Filtration and exposure information is normally recorded in columns on a notepad. The sequence of columns shown—yellow, magenta, cyan, *f*-stop and exposure time—should be the same for every print. In this way a routine is quickly developed.

Yellow

Green

Red

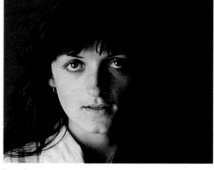

Normal

Tracking down colour casts is not always easy, and you'll find that printing a "ring-round" like this helps you identify colour imbalance. Each picture except the large one has 20 units too much filtration, and is divided into areas of correct exposure, then over- and underexposure.

Cyan

Magenta

Blue

The test strip should be from a part of the negative that is representative of the whole picture, and include both highlight and shadow. It should be matched as closely as possible to one of the reference pictures to determine the necessary correction. The first step is to establish the closest exposure density on the strip; the next is to determine the bias of colour in that density.

A slight red colour cast can look deceptively heavy in an overexposed area of the test strip. Conversely, a strong red cast may not look like much in an underexposed one. In practice, a test that seems too red is corrected by adding equal units of both yellow and magenta to the filters.

Corrections for colour are as follows.
If the colour is too:
blue—reduce yellow;
yellow—increase yellow;
magenta—increase magenta;
green—reduce magenta;
red—increase yellow and magenta;
cyan—reduce yellow and magenta.

A useful rule of thumb is to over-correct the colour on the test strips (if there seems to be a need for a correction of 20 units of a particular colour, for example, correct it with 30 units). Although colour discrimination and judgement will quickly develop with experience from the first few colour prints, this will need to be perfected after familiarity with the equipment and materials has been acquired by over-correcting on the early attempts.

Because all filters remove some light, increasing or reducing the filtration will affect the amount of light reaching the paper, and exposure compensation will be necessary. This will vary with the particular filter used, but these figures will act as a guide:
20Y will need a 5 per cent exposure compensation;
20M will need a 20 per cent compensation;
20C will need a 10 per cent compensation.

Knowing how much correction is "too much" means a third filtration and exposure test can then be assessed before the final print is made.

Although paper is sensitive to all but a very narrow part of the spectrum and must be handled only in complete darkness, an increasing familiarity with handling colour paper, methodical procedures with the enlarger and consistent processing habits following the manufacturer's recommendations all soon combine to eliminate any initial awkwardness.

Drum processors can be used for the development as in the Cibachrome process (see page 203) and once the final print is developed it is washed, dried and mounted.

The first test print is always a test strip to establish the correct time: it is much easier to judge colour when the print is the right density. The second test enables you to trim the colour within precise limits.

First test

Second test

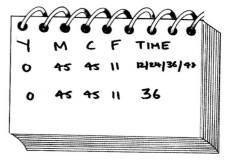

Final print

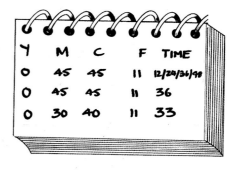

205

SPECIAL EFFECTS -1

The darkroom, in addition to serving as a laboratory, can provide its own kind of fascinating entertainment. In addition, in order to make the most of darkroom materials, you should know how they behave under unusual as well as normal conditions, and you can learn much about the nature of photographic materials from these effects.

All the special effects described on the following pages are well established and there is nothing experimental about them—although they can be combined in many new ways. In themselves they belong to the repertoire of familiar corrective techniques like dodging and burning-in (see page 201), and at various times in the history of photography it has been the opinion of some purists that all such "tampering" should be abandoned altogether. Nevertheless, exciting effects continue to be discovered by both professionals and amateurs.

In general, the more bizarre the result, the more limited the usefulness of a special process. The effects which tend to dominate the image are the ones which most quickly degenerate into clichés, while the more subtle variations continue to be used interestingly. The most sensible way to approach special effects is to learn the methods but to aim for different results: experimental photography should surpass old tricks.

The first techniques involve adjustments within the normal framework of the printing process, using such accessories as reducers, toners, texture screens and soft focus. The next degree of sophistication involves creating intermediate negatives and positives on film, paper or specially sensitized materials, so that the original negative comes to be regarded as merely the starting point in a series of steps which eventually result in a picture. Ultimately, you may set out to manufacture a preconceived image in the darkroom—the montage.

Photograms are the simplest of special techniques—you just lay object on photographic paper and expose the paper under the enlarger. The shadows form the image.
The Sabattier effect causes partial reversal of shadow areas: it is produced by exposing black and white negatives or prints to white light during development. Chemical reducer can be used to make the print lighter overall, or—as here—applied with a paintbrush to lighten just part of the image.

Colour pictures from black and white

*T*he various techniques described and represented
here all provide means of producing coloured pic-
tures from black and white material. Technically, they
belong to the realm of black and white and, just as a
coloured drawing is not the same thing as painting, they
should not be regarded as less sophisticated substitutes
for colour photography. If they are, the results are likely
to be disappointing. On the other hand, colours can be
used to pick out or to dramatize the essential or graphic
elements of a monochrome photograph.

Toning and hand tinting are relatively controllable
ways of introducing colour, and a little experimentation
should produce the required effect. Making colour
prints directly from black and white negatives, however,
is fairly unpredictable, although it is this random
element that often gives the technique its appeal.

*Toning a monochrome print (top) turns its
shades of black and white to a single colour—
sepia in this example. Tinting a black and
white image with dyes and paints (left)
requires more skill, but offers the creative
photographer tremendous potential.
Posterization (far left) turns selected parts of
a monochrome image to spectacular colour.
However, it is a complex technique which
involves making masks on line film so that
parts of the picture can be printed
sequentially on to colour paper.*

SPECIAL EFFECTS -2

In its most familiar form, black and white photography depends heavily on tones, the gradations of grey which separate pure black from pure white. It is these tones, as much as the accurate shapes of the objects, that are the cause of a photograph's illusion of reality: belief in a photograph is sustained by its tones even when the image is wildly improbable, like the montage picture below. Conversely, a straightforward image can lose its commonplace associations and acquire novelty and interest as its tones are eliminated.

You can exercise a limited amount of control over the tones of the print by using different grades of paper (page 200). But to exert complete control over tone, eliminating it so that all that remains is a semi-abstract image consisting of simple black and white areas, it is necessary to employ more radical techniques. This departure from realism is marked by an important step in procedure, namely the introduction of intermediate negative/positive stages that successively alter the original negative. Thus, instead of one negative you can have at your disposal any number of transparent images, all as different from each other as you like to make them, but all nevertheless made from the same original. The number of permutations in the way the picture can be printed is greatly increased, and the basic purpose of these two pages is to suggest how different combinations can be used to produce various effects.

Once the idea of intermediate stages has been grasped, however, photography begins to lose its completely distinct character, since techniques belonging to other methods of printing, such as silk-screen or lithography, can be introduced, leaving photography merely a part of an overall process. But the scope of this book is necessarily limited to "pure" photography.

Superimposing images (right) is a simple manual darkroom task, but creating a seamless finished print means working very methodically. These two images were combined by first preparing a tracing, showing where each image was to appear on the paper. First the landscape was printed, shading the area where the eye would appear. The eye negative then replaced the landscape, and the area around the eye was shaded during the exposure. To make high-contrast images (opposite page), simply copy a transparency on to lith film, which eliminates all detail except highlights and shadows. Printing the resulting negative on to hard paper makes a stark, graphic image. Sandwiching together a line negative and positive produces a bas-relief (far right).

Retouching

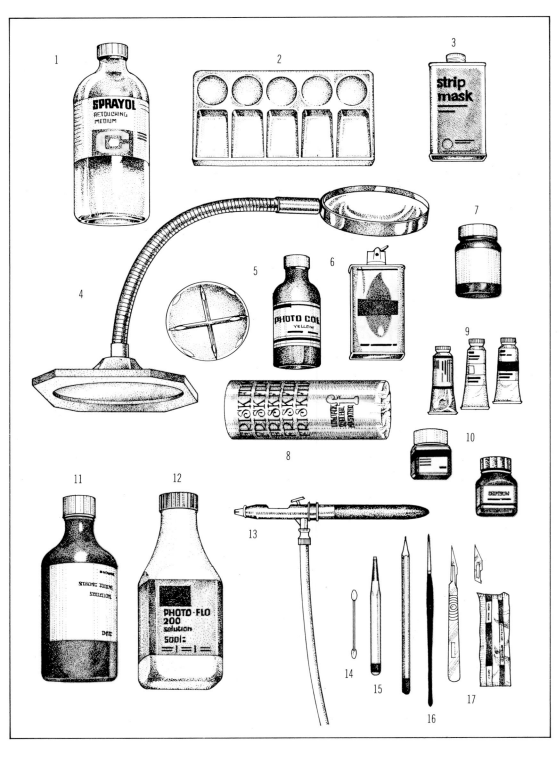

*N*o matter how much care is taken in the darkroom, blemishes, spots and scratches will still sometimes occur. These can almost always be corrected by retouching; obviously it is better to retouch the print since, unlike a spoiled negative, it can always be replaced. When working on a print the only requirement is a firm, solid surface, but to make retouching and bleaching easier, it is advisable to mount the print on card. Dry mounting (see page 212) is preferable, but a rubber-based solution is acceptable.

Retouching the original 35mm image is impractical because of its small size. However, retouching a transparency or negative is possible if the 35mm picture is optically enlarged to a bigger format. When working on enlarged negatives and transparencies it is essential that light shines through them towards the retoucher. Photographers' retouching desks are available, but they are expensive; a home-made device can be constructed by placing the negative on a raised sheet of ground glass with a light source beneath.

Equipment for retouching

Illustrated above are the basic items needed for retouching, all of which are available at most art supply shops.

1 Retouching medium fixative
2 China pallet
3 Strip mask
4 Magnifying glass
5 Photo-dye
6 Lighter fuel
7 Hypo-crystals
8 Clear adhesive low-tack film (Frisk film)
9 Designers' gouache (permanent white and lamp black) and sepia (watercolour)
10 Photographic dyes
11 Strong iodine solution
12 Wetting agent
13 Airbrush
14 Swab sticks
15 Fiberglass pencil
16 Sable spotting brush
17 Scalpel or X-acto knife and a variety of blades

Colour prints (above left and right) can be retouched to remove marks using designers' gouache and coloured dyes.

Working on black and white paper is easier: this example has been retouched using the techniques described to the right.

Retouching black and white
Dark spots can be removed with a craft knife. The print surface is lightly scratched without removing the emulsion (top left). White spots are touched out using water-colour paint in various strengths, applied using a very fine paintbrush (above left). To remove areas entirely, first mask off parts that are to be retained using low-tack film (above left), then spray unmasked areas with paint using an airbrush (above right).

Mounting and Storage

WET MOUNTING

Wet mount fibre-based prints by first soaking in water.

Remove excess water, then similarly soak and squeegee a waste print.

Apply photographic adhesive to one side of the mounting board.

Press the print firmly into position on the board.

Fix the waste print on the back in the same way and trim.

When dry the waste print prevents the finished mount from curling.

Resin-coated papers can be hung up to drip dry, but quality is improved if the paper is wet for the shortest possible time. A warm-air dryer yields more brilliant whites and prevents patchy shadows.

Mounting prints

Mounting a photograph for display is the last stage in the photographic process and, unfortunately, it is all too often given the least care and thought. This is a needless waste: a good picture will lose much of its impact if it is poorly or inappropriately mounted, while even the very best of photographs will be enhanced by suitable presentation.

Many photographs benefit from the use of a cut-out mount. This is simply a piece of card in which an aperture is cut, preferably with a bevel, to the size of the print area, then secured on top of the mounted print and trimmed flush. Consideration must also be given to a suitable type of frame.

DRY MOUNTING

Use an iron to tack shellac-coated dry-mounting tissue to back of print.

Trim the print to size using a craft knife and a steel ruler.

Use the iron to tack the corners of the tissue to the mounting board.

Finally cover the print with paper and iron it to melt the tissue.

Storage

There are two considerations when choosing a method for storing slides and negatives: they should be easy to locate when required, and they must remain in good condition. The first presents little difficulty, provided you decide on a method of classification and keep strictly to it. Transparencies, for example, can be fitted into numbered slots in special transparency boxes; an index card in the lid provides space for a short description of each slide. Coloured adhesive labels, usually in the form of small circles, or dabs with different colours of ink, are another method of indicating subject categories or distinguishing batches or years. The method is largely a matter of personal preference.

Several types of files, boxes and drawers for storage are now available from photographic suppliers—again it is a matter of function, size and personal preference—but consideration must be given to the storage site. In most rooms in a well-heated house there are no problems, but if an attic or a garage has to be used, where damp may be present, sealed containers are a wise precaution. Special containers are also available for very hot or tropical conditions.

UNCURLING A PRINT
Fibre-based paper has a tendency to curl as water evaporates, especially if you don't use a dryer. You can eliminate the curl by dampening the print slightly and sandwiching it between sheets of special photographic blotting paper. Leave it to dry under a heavy weight.

Storing prints
Ideally, store prints in steel cabinets to keep out light and moisture, which cause fading. Interleave piles of prints with acid-free paper.

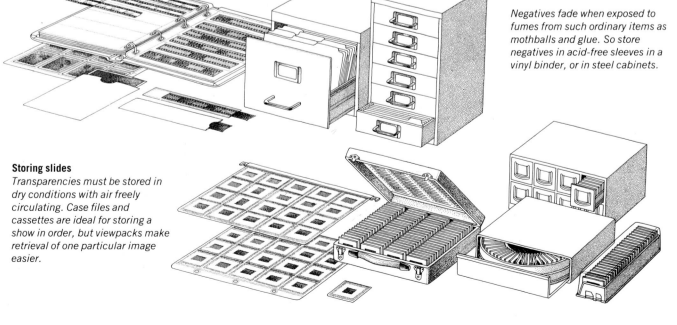

Negatives fade when exposed to fumes from such ordinary items as mothballs and glue. So store negatives in acid-free sleeves in a vinyl binder, or in steel cabinets.

MARKING SLIDES
Store slides in purpose-made holders—mark one corner to show which way up the slide should be held, and rule a line across a sequence to keep it in order.

Storing slides
Transparencies must be stored in dry conditions with air freely circulating. Case files and cassettes are ideal for storing a show in order, but viewpacks make retrieval of one particular image easier.

FILTRATION

The function of many photographic filters is self-explanatory: looking through a starburst filter, for example, it is easy to see what effect it will have on film. However, this is not true of light-balancing and colour-correction filters, some of which are so pale as to seem of insignificant value.

It is certainly true that if you use colour negative film, you will only ever need to use the deepest-coloured filters, because subtle colour corrections can be made at the printing stage. However, if you regularly use slide film, you do not have this safety net: the only chance you have to correct colour is when you are taking the picture.

So light-balancing filters are primarily for the benefit of slide film users. But which filter do you choose, and when is filtration necessary? The answer depends on the light source. Most film is manufactured to give best colour in noon summer sunlight: if you photograph a white subject in such conditions, it will appear white on film. In other conditions, however, the colour of the light source may be different, and your white subject will appear on film tinged with blue or yellow. On an overcast day, for example, daylight is too blue, and everyone is familiar with the warm colours of sunset.

Photographers usually refer to these different colours of light in terms of colour temperature. This is a hypothetical scale, corresponding to the temperature to which a pure black object must be heated to glow with light of the same colour. Thus reddish light sources have a low colour temperature, and bluish ones, a high colour temperature.

The scale is most often calibrated in units called kelvins, but you may also come across units called mireds (pronounced my-reds). The mired value is equal to a million divided by the colour temperature in kelvins.

From the colour temperature or the mired value, you can work out what filters will correct the colour of the light source to match the film's sensitivity.

Balanced for	Kelvins	Mireds
Daylight	5500	180
Tungsten light (Type B)	3200	310
(Type A)	3400	295

Virtually all film for use in tungsten light is now type B balanced.

Filter colours
The most widely available filters are Kodak's Wratten series. These consist of two ranges of filters: the darker-coloured filters are used to make gross changes in colour temperature, such as when using tungsten light-balanced film in daylight; light-balancing filters have paler colours and make smaller corrections. However, all are shades of blue and yellow, and for practical purposes, you can think of them as a single series of filters.

Yellowest **Bluest**
85B 85 85C 81EF 81D 81C 81B 81 neutral 82 82A 82B 82C 80D 80C 80B 80A

An alternative to the Kodak system are Mired filters which are calibrated with their mired shift values: those with positive values are yellowish, and those with negative values, bluish. Some manufacturers use deca-mired calibrations (1 decamired = 10 mireds) and simply mark the filters R and B for red and blue.

Which filter?
The chart (right) shows the filter required in a variety of different lighting conditions, and with daylight and tungsten (type B) film. If you are using type A film, fit an 82A filter in addition to the one shown in the chart.

All filters absorb light, and you have to give extra exposure to compensate for this. Filter manufacturers usually supply information about the necessary compensation, but if you use a camera with a built-in meter, no manual correction is necessary—the camera makes the adjustment automatically.

Filtering fluorescent light
Fluorescent tubes present the photographer with a special challenge. Unlike "hot" light sources, a strip lamp produces light that does not fit neatly on the colour temperature scale, so you cannot use the familiar blue and yellow 80, 81, 82 and 85 series filters. Instead, fluorescent tubes need colour correction filters—usually yellow and magenta—in a range of strengths.

Rule of thumb
If you are not sure which tubes you are dealing with, use 30 magenta filtration with daylight-balanced film, or 50 red with tungsten-balanced film (type B).

Matching tube and filter

If you can identify the tubes in use, you will be able to adjust filtration with more precision. Use these guidelines as a starting point—but carry out exposure tests, or use a three-cell colour temperature meter when colour rendering is critical.

Lamp type	Filtration Daylight-balanced film	Tungsten-balanced film
Daylight	50m + 50y	85b + 40m + 30y
White	40m	60m + 50y
Warm white	20c + 40m	50m + 40y
Warm white deluxe	60c + 30m	10m + 10y
Cool white	40m + 10y	10r + 50m + 50y
Cool white deluxe	20c + 10m	20m + 40y
Unidentified	30m	50r

Filtering light sources

If you are in total control of the location where you are shooting, you are not limited to the use of filters on the camera lens alone, and filtering the other light sources may be the best way to eliminate the colour cast that fluorescent tubes often create. Indeed, this may be the only option in circumstances where there is a mixture of light sources.

Filtering the fluorescents

Companies supplying filtration media to the film industry make amber and magenta sleeves that slide over fluorescent tubes, correcting their colours to match the sensitivity of tungsten- and daylight-balanced films. The same material is also available in sheet form.

These sleeves are matched to the phosphors of U.S. tubes—some small additional correction may be needed elsewhere.

Filtering other light sources

If a scene is lit by a mixture of fluorescent and other lights, a better approach may be to leave the tubes unfiltered and put gels over the other lamps. For example, you may wish to put green gel on windows to match the colour of daylight to that of the fluorescents; a magenta filter over the camera lens then corrects the hue of both fluorescents and windows.

If you are using flash, this technique is very econo-mical, because you can use very small pieces of filter gel over the flash unit.

Filter types

Fluorofilter—Corrects U.S. Cool White or daylight tubes for use with tungsten-balanced (type B) film
Minusgreen—Corrects same tubes for use with daylight-balanced film
Plusgreen—Corrects daylight-coloured sources to match fluorescent tubes
Plusgreen 50—Corrects tungsten (3200K) sources to match fluorescent tubes

"Impossible" corrections

All cool (i.e. non-incandescent) light sources produce a discontinuous spectrum, as shown below. Some sources are better than others, and electronic flash, for example, matches daylight perfectly. However, the worst light sources of this type totally lack certain wavelengths, and no amount of filtration will provide good colour rendition. The best approach is to light the scene with tungsten or flash, and briefly switch on those light sources that actually appear in the pictures, so that they appear illuminated on film. Where this is impossible, use the corrections below—but plan for a heavy colour cast.

Lamp type	Filtration Daylight-balanced film	Tungsten-balanced film
High-pressure sodium	70b + 50c	50m + 20c
Metal halide	40m + 20y	60r + 20y
Deluxe white mercury	60m + 20y	70r + 10y Clear
Mercury	50r + 20m + 20y	90r + 40y

215

ESTIMATING EXPOSURE

Chart 1

Subject matter	Film Speed (ISO) 64–100	125-200	250–400	400–800	1000–1600
Cityscape at night	1	2	3	4	5
Cityscape immediately after sunset	10	11	12	13	14
Cityscape at twilight	8	9	10	11	12
Moving vehicles on busy roads	3	4	5	6	7
Buildings lit up by floodlights	4	5	6	7	8
Festive illuminations outdoors	7	8	9	10	11
Neon advertising signs	9	10	11	12	13
Bright city streets—general view	7	8	9	10	11
figure lit by street lights	4	5	6	7	8
Illuminated shop window displays	8	9	10	11	12
Bonfires	8	9	10	11	12
subjects lit by them	5	6	7	8	9
Firework displays—ground pieces	8	9	10	11	12
air bursts	9	10	11	12	13
Fairgrounds	6	7	8	9	10
Landscape by moonlight	−3	−2	−1	0	1
the moon itself	14	15	16	17	18
Floodlit sports events at night	8	9	10	11	12
Circuses, theater performances	7	8	9	10	11
spotlit acts	9	10	11	12	13
School plays, amateur drama	5	6	7	8	9
Indoor sports—well lit	8	9	10	11	12
Swimming pools	6	7	8	9	10
Domestic interiors	5	6	7	8	9
close to bright lights	6	7	8	9	10
candle-light	5	6	7	8	9
festive lights & Christmas trees	4	5	6	7	8
Hospitals—wards and maternity units	7	8	9	10	11
Churches and chapels—indoors by day	5	6	7	8	9
Public buildings and offices	8	9	10	11	12
Museums and galleries	5	6	7	8	9

Exposure

Most modern cameras take care of exposure setting automatically, but there are times when it is useful to be able to estimate the correct exposure without help from a meter. At night, for example, your camera's meter may not respond to low levels of light, or may give a misleading reading. Even in normal, brightly lit conditions, an intuitive feeling for exposure, and the ability to guess the correct settings, ensure that you notice when your camera malfunctions.

You can estimate exposure using the "Sunny-16" rule. Bright sunlight is remarkably consistent in intensity, and if you set the camera's aperture to f/16, the correct shutter speed is roughly equal to the film speed. So if you are using ISO 400 film, you should set 1/400 second at f/16—on most cameras 1/500 second is the nearest equivalent.

In dimmer conditions, you will need to give extra exposure. In hazy sun, allow one extra stop; light cloud, two stops; and heavily overcast, three stops. In highly reflective surroundings, such as on light sand or snow, one stop less exposure is required.

Certain conditions can fool your camera's meter, and this chart should help you set exposure. In the left-hand column of the first table, you will find a range of different lighting conditions, and from these, you can read off the correct exposure value for the film you are using. On the second chart the diagonal rules indicate the same exposure values. From these you can read off the shutter speed and aperture combinations that will give the correct exposure on the horizontal and vertical axes.

For example, if you were photographing a floodlit sports event on ISO 800 film, the correct exposure value from the chart is 11. On chart 2 find number 11 and choose any point within the diagonal strip. Look up to find the shutter speed, and to the left for the aperture. Choosing a point at the bottom left of the strip gives a wide aperture and a fast shutter speed, such as 1/1000 second at f/1.4. Points further up the strip indicate all the other combinations of shutter speed and aperture that will give the correct exposure, right up to 2 seconds at f/11 at the top right. Obviously you would choose a fast shutter speed in this instance, but in other situations it is best to use a long exposure. For example, if you wanted to photograph headlight trails from moving vehicles, you need to set an exposure of 10 seconds or more.

CHART 2 – EXPOSURE VALUES AT ISO 100

Shutter speed (1/secs)

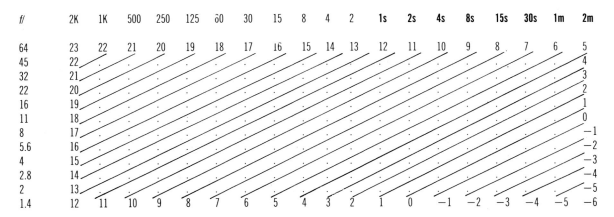

Condition	Colour temperature – Kelvins	Mireds	Required filtration with daylight-balanced film – Wratten	Required filtration with daylight-balanced film – Deca-mired	Required filtration with tungsten-balanced film – Wratten	Required filtration with tungsten-balanced film – Deca-mired
Blue sky	20,000	50	85B			
	18,000			12 R		
	16,000					
	14,000		85			
	13,000					
	12,000					
	11,000					
	10,000	100	85C			
	9,500					
	9,000					
Hazy sunlight	8,500			6 R		
	8,000					
Average shaded subject in summer	7,500		81EF			
	7,000		81D			
Overcast sky	6,500	150	81C			
	6,000		81B	3 R		
Light overcast sky			81A			
	5,800		81	1.5 R		
	5,600					
Summer sunlight	5,400		NO FILTER		85B	

218

Colour temperature and mireds

This chart shows the filtration that will yield optimum colour when the subject is lit by a variety of light sources. Filtration is listed for the Kodak Wratten series, and in decamireds. Tungsten-balanced film (right-hand column) refers to film balanced for exposure by light with a colour temperature of 3200K. Almost all tungsten-balanced films are of this type.

Light source	Colour temp (K)	Mireds	Daylight film (Wratten)	Daylight film (decamireds)	Tungsten film (Wratten)	Tungsten film (decamireds)
	5,200		82		85	12 R
	5,000	200	82A	1.5 B		
	4,800		82B	3 B		
Early morning and late afternoon sunlight	4,600					
	4,400		82C			
	4,200		80D	6 B	85C	
	4,000	250				
One hour after sunrise/before sunset	3,900					6 R
	3,800		80C		81EF	
	3,700				81D	
	3,600				81C	3 R
	3,500				81B	
Photoflood bulb	3,400		80B		81A	1.5 R
	3,300	300		12 B	81	
Tungsten halogen lamp	3,200		80A		NO FILTER	
	3,100				82	1.5 B
	3,000				82A	
100-watt light bulb	2,900	350			82B	3 B
	2,800				82C	
40-watt light bulb	2,700				80D	6 B

FILM TYPES -1

*T*hese charts show the most popular, general-purpose film that is available from the world's major manufacturers. They are not totally comprehensive, and exclude film in the following categories:

Own-brand film Many manufacturers produce film that is sold under the labels of other companies—notably major stores and "free-film" processors.

Obsolete emulsions These include many kinds of colour film produced in Warsaw Pact countries, which use processes long superseded in the West.

Limited availability Many kinds of film are sold only in one market. In Japan, for example, Fuji make and sell instant film, but this is not available elsewhere.

Professional film Much colour transparency film is available in so-called professional format. This film is to all intents and purposes the same as its amateur counterparts, but is manufactured to tighter tolerances, and batch-tested by the supplier for colour and speed. Often filtration and exposure details are packed with the

film, indicating the adjustment needed to fine-tune colour and density. Professional film is "ripe" when sold, and must be used immediately and processed promptly, or else refrigerated before and after exposure. Such film offers no improvement in quality unless treated with meticulous care.

1 Process in C-41 colour chemicals
2 Processing by manufacturer only

Black and white film

Most black and white film is processed using conventional chemistry, as shown on page 192. The exception is the dye-image film, Ilford XP1, which must be developed in the C-41 chemicals normally reserved for colour negative film. Only one film—Agfa Dia-Direct—provides monochrome transparencies, but other film can be reversal processed to give the same result. Before trying this, check that the film does not have a coloured base that would tint your projected slides.

Name	ISO Speed	Sizes generally available
AGFA-GEVAERT		
Agfapan 25	25	135–36, bulk lengths
Agfapan 100	100	135–36, bulk lengths
Agfapan 400	400	135–36, bulk lengths
ILFORD		
Pan F	50	135–20/36, bulk lengths
FP4	125	135–20/36, bulk lengths
HP5	400	135–20/36, bulk lengths
XP1 $_1$	400	135–20/36, bulk lengths
KODAK		
Panatomic-X	32	135–36, bulk lengths
T-Max 100	100	135–24/36, bulk lengths
Plus-X Pan	125	135–20/36, bulk lengths
Tri-X Pan	400	135–20/36, bulk lengths
T-Max 400	400	135–24/36, bulk lengths
High-speed infrared 2481	n/a	135–36
Technical Pan 2415	n/a	135–36, bulk lengths
Recording film 2475	1000–4000	135–36

Reversal film

Name	ISO Speed	Sizes generally available
AGFA-GEVAERT		
Dia-Direct $_2$	32	135–36

Colour negative film

All colour negative film is now processed in the industry-standard C-41 chemistry that was originated by Kodak. You can send any of the film listed below to a colour laboratory and expect consistent and reliable results. Note that the film speeds listed are fixed: processing of negative film continues to the theoretical limit, so you cannot "push" negative film to get an extra bit of speed.

Name	ISO Speed	Sizes generally available
AGFA-GEVAERT		
Agfacolor XRS100	100	135–15/27/36, bulk lengths
Agfacolor XRS200	200	135–15/27/36
Agfacolor XRS400	400	135–15/27/36
Agfacolor XRS1000	1000	135–24
ILFORD		
Ilfocolor HR100	100	135–12/24/36
Ilfocolor HR200	200	135–24/36
Ilfocolor HR400	400	135–24/36
FUJI		
Fujicolor Super HR100	100	135–24/36
Fujicolor Super HR200	200	135–24/36
Fujicolor Super HR400	400	135–24/36
Fujicolor Super HR1600	1600	135–24/36
KODAK		
Kodacolor Gold 100	100	135–12/24/36
Kodacolor Gold 200	200	135–12/24/36
Kodacolor VR 200	200	135–12/24/36
Kodacolor VR 400	400	135–12/24/36
Kodacolor VR 1000	1000	135–12/24/36
Konica		
Konica Color SR100	100	135–12/24/36
Konica Color SR200	200	135–12/24/36
Konica Color SR400	400	135–12/24/36, bulk lengths
Konica Color SR1600	1600	135–24
Konica Color SR-V3200	3200	135–24

FILM TYPES -2

Colour kits for home processing

E6 and C-41 chemistries are designed for high-speed machine processing at high temperatures. Process times are so short, and solutions so warm that consistency is difficult in home processing. Most of the kits listed here are therefore adaptations of the main processes, often with simpler chemistry, lower temperatures and longer process times.

For colour negative film (all C-41 compatible)

Agfa AP 70	500ml kit for 6 rolls 135–36
	3 bath, 24 mins at 30℃ (86°F)
Kodak	
Flexicolor	500ml kit for 12 rolls 135–36
	4 bath, 25 mins at 37.8℃ (100°F)
Paterson 2NA	150ml kit for 15 rolls 135–36
	2 bath, 12 mins at 38℃ (100.4°F)

For colour slide film (all E6 compatible)

Agfa AP 44	500ml kit for 4 rolls 135–36
	5 bath, 34 mins at 38℃ (100.4°F)
Kodak E6	600ml kit for 10 rolls 135–36
	7 bath, 37 mins at 38℃ (100.4°F)
Paterson 3E6	600ml kit for 6 rolls 135–36
	3 bath, 30 mins at 38℃ (100.4°F)

For prints from negatives (all Ektaprint compatible)

Agfa AP 92	1000ml kit for 20 sheets 25 × 20cm (10 × 8 inches)
	2 bath, 11 mins at 33℃ (91.4°F)
Kodak	
Ektaprint 2	1000ml kit for 14 sheets 25 × 20 cm (10 × 8 inches)
	2 bath, 8.5 mins at 33℃ (91.4°F)
Paterson 2RP	2000ml kit for 40 sheets 25 × 20 cm (10 × 8 inches)
	2 bath, 7.5 mins at 38℃ (100.4°F)

For prints from transparencies

Kodak	
Ektachrome	1000ml kit for 14 sheets 25 × 20cm (10 × 8 inches)
R-3000	3 bath, 10 mins at 38℃ (100.4°F)
Ilford	
Cibachrome A	1000ml kit for 16 sheets 25 × 20 cm (10 × 8 inches)
	3 bath, 9 mins at 24℃ (75.2°F)

Instant picture film

With the exception of Japan, instant film is now sold only by the Polaroid Corporation. Some Polaroid film is specifically designed for use in 35mm cameras, notably Polachrome CS. Unlike all other colour transparency film, this film uses the additive system, and makes colours using a series of filter strips that can be seen at high magnification. The transparencies look very dense to the eye, and need a powerful lamp for adequate projection or viewing. Other Polaroid film can be used only in specially equipped cameras—suitable camera adapter backs are made to fit most professional-grade cameras.

Colour transparency film

With the exception of Kodachrome, all colour transparency film is processed in Kodak's E6 chemistry, or in compatible baths from other manufacturers. The speeds listed are for normal first development, but by extending the time in this bath, the speed of any of the film can be increased. Some film, such as Kodak's Ektachrome P800/1600, is specially designed for pushing in this way.

2 Processing by manufacturer only
3 Balanced for exposure by tungsten light
4 For exposure by electronic flash
5 For exposure details see page 131
6 Process in E4 chemicals only
7 600 series films may only be used in 35mm cameras fitted with special adapter backs

Name	ISO Speed	Sizes generally available
AGFA-GEVAERT		
Agfachrome CT 100	100	135–27/36
Agfachrome 50 RS	50	135–36, bulk lengths
Agfachrome 100 RS	100	135–36
Agfachrome 200 RS	200	135–36
Agfachrome 1000 RS	1000	135–36
ILFORD		
Ilfochrome 50	50	135–20/36
Ilfochrome 100	100	135–20/36
Ilfochrome 200	200	135–20/36
FUJI		
Fujichrome 50 D	50	135–36
Fujichrome 100 D	100	135–36
Fujichrome 400 D	400	135–36
Fujichrome P1600 D	1600	135–36
Fujichrome 64 Tungsten $_3$	64	135–36, bulk lengths

Name	ISO Speed	Sizes generally available
KODAK		
Ektachrome 64	64	135–24/36, bulk lengths
Ektachrome 100	100	135–12/24/36
Ektachrome 200	200	135–20/36
Ektachrome 400	400	135–20/36
Ektachrome P800/1600	800–1600	135–36
Ektachrome 160 $_3$	160	135–20/36
Kodachrome 25 $_2$	25	135–20/36
Kodachrome 64 $_2$	64	135–20/36
Kodachrome 200 $_2$	200	135–20/36
KONICA		
Konica Chrome 100	100	135–20/36
SPECIALIST COLOUR FILM		
Kodak Ektachrome SE duplicating film $_4$	n/a	135–36
Kodak Ektachrome Infrared film $_5$	n/a	135–36
Kodak Photomicrography colour film $_6$	n/a	135–36

	ISO Speed	Image	Format
Type 668 Polacolor $_7$	80	Colour print 8 print pack	8.25 × 10.75cm (3¼ × 4¼ inches)
Type 667 High-Speed Print	3000	B & W print 8 print pack	8.25 × 10.75cm (3¼ × 4¼ inches)
Type 665 Positive/Negative	75	B & W print and negative 8 print pack	8.25 × 10cm (3¼ × 4¼ inches)
Polachrome CS	40	Colour transparency	135–12/36
Polapan CT	125	B & W transparency	135–36

GLOSSARY

Accessory shoe Standard-sized socket fitted to a camera to permit easy fitting and removal of an accessory — usually a flash unit — with a corresponding foot. See also HOT SHOE.

Additive synthesis The creation of coloured pictures by the mixing of light using the three primary colours, red, green and blue. See also SUBTRACTIVE SYNTHESIS.

Aerial perspective The tendency of distant objects to look lighter and bluer than nearby objects.

Aperture Variable-sized hole used to control EXPOSURE, formed by blades of the DIAPHRAGM in a camera lens.

Aperture priority System of exposure control in which the photographer sets the aperture, and the camera picks a shutter speed that will yield correct exposure. See also SHUTTER PRIORITY.

ASA Abbreviation for American Standards Association: system for measuring film speed that is numerically equal to, and now superseded by, ISO.

Aspherical lens Lens incorporating one or more surfaces that, unlike most lens surfaces, are not curved like a portion of a sphere. Aspherical surfaces are difficult to manufacture, but make possible higher quality images, lenses of wider aperture, or of lighter weight.

Autofocus Method of automatically focusing camera lens without manual intervention from the photographer.

B setting See BULB SETTING.

Backlighting Form of lighting in which principal light source shines directly towards the camera.

Back projection Projection of a photograph on to a special translucent backdrop placed between the projector and the subject, so that images shot in a studio appear to have been shot on location. See also FRONT PROJECTION.

Ball and socket head Tripod head that allows free movement of the camera in all planes when released; a single control locks the camera in position.

Barn-doors Movable metal flaps fitted to the front of a lamp in order to control where light falls on the subject.

Barrel distortion Lens fault causing straight lines in the subject to bow outwards on film, so that a square object takes on the appearance of a barrel. See also PINCUSHION DISTORTION.

Bellows Close-up accessory that fits between lens and camera to make possible MACROPHOTOGRAPHY over a wide and continuous range of subject distances.

Bracketing The process of taking additional "insurance" pictures at exposures above and below the optimum setting.

Bulb flash Form of flash photography utilizing disposable bulbs containing metal wire that burns to create a brilliant light.

Bulb setting Shutter setting, often marked as "B" on the shutter speed scale, that causes the shutter to stay open as long as the shutter release remains pressed.

Burning-in Form of local exposure control used during printing: a section of the print is selectively darkened by giving it more exposure than the rest of the image. See also DODGING.

Camera movements Relative movements of lens and film used to control shape and distribution of sharpness in the image. PERSPECTIVE CONTROL LENSES offer limited movements on 35mm cameras.

Chrome See REVERSAL FILM.

Chromogenic film See DYE-IMAGE FILM.

Clip test Method of checking correct exposure by processing short length of transparency film in advance of the rest of the roll. Density of the balance is adjusted if necessary by PUSHING or PULLING.

Close-up lens See SUPPLEMENTARY CLOSE-UP LENS.

Colour balance The colour of light that will yield natural-looking results when used to expose any given film. See also TUNGSTEN LIGHT BALANCED FILM and DAYLIGHT BALANCED FILM.

Colour cast An overall wash of unwanted colour usually covering the entire film area. Generally caused by exposure of film in incorrect lighting conditions.

Colour conversion filter Filter used on camera lens in order to expose film in lighting conditions for which it was not manufactured — e.g. DAYLIGHT BALANCED FILM in TUNGSTEN LIGHT.

Colour correction filter Filter used to make small corrections to colour rendition when using TRANSPARENCY FILM — e.g. to prevent a blue COLOUR CAST when taking photos in overcast weather.

Colour head Enlarger lamp housing incorporating movable coloured filters operated by dials, so that colour printing can take place without a separate set of filters in individual strengths and colours.

Colour temperature System of expressing the colour of the light falling on the subject, or the colour balance of the film. Bluish light sources such as blue sky have a high colour temperature; reddish light sources such as candles have a low colour temperature. Colour temperature is measured in KELVINS.

Contra-jour See BACKLIGHTING.

Contact sheet Print made by exposing sheet of photographic paper in contact with negative(s). With 35mm film, this is a useful way to produce a small reference print of every frame on the roll.

Contrast Difference in brightness between the lightest and darkest areas of the subject on negative, transparency or print.

Coupler Chemical that, while itself colourless, combines with developer by-products to create a coloured dye during processing, thus making a coloured image. See also SUBSTANTIVE EMULSION.

Databack Device for imprinting date, time, or number on the film at the moment of exposure.

Daylight (balanced) film Film with a COLOUR BALANCE suitable for taking pictures in daylight or with electronic flash. See also TUNGSTEN LIGHT BALANCED FILM.

Decamired Measure of COLOUR TEMPERATURE equal to ten MIREDS.

Dedicated flash "Intelligent" flash unit that exchanges information with the camera, perhaps to set the FLASH SYNCHRONIZATION SPEED or to measure exposure through the lens.

Definition Measure of how faithfully the camera has recorded fine details of the subject in a photographic image.

Density Measure of the darkness or paleness of a photographic image.

Depth of field The distance between the nearest and farthest parts of the subject that will appear acceptably sharp on film.

Diaphragm Circle of sliding blades inside a camera lens arranged to form a variable-sized APERTURE for the control of exposure.

Diapositive See TRANSPARENCY.

Dichroic filter Filter made by coating glass with an extremely thin layer of metal. The filter selectively absorbs one colour of light, just as oil on a puddle makes rainbows by absorbing different colours of light as the thickness of the film changes.

DIN Abbreviation for *Deutsche Industrie Norm,* a measure of film speed now superseded by ISO.

Diopter Measure of the magnifying power of a lens. In photography, generally used only to specify strength of SUPPLEMENTARY CLOSE-UP LENS or EYESIGHT CORRECTION LENS.

Dodging Form of local exposure control used in printing to selectively lighten part of the picture by casting a shadow on it for some of the exposure. See also BURNING-IN.

Dye-image film Black-and-white film such as Ilford XP1 that forms an image using coloured dyes rather than the metallic silver of conventional film.

Enlarger Arrangement of light source, negative carrier and lens used to project a magnified image of a photograph on to a piece of light-sensitive paper, thus making a print.

Emulsion The light sensitive coating that actually forms the photographic image on film.

Enprint Postcard-size print, usually made from a negative on a machine with semi-automatic control over print colour and density.

Exposure The amount of light that reaches the film in the camera. Exposure is controlled by the brightness of the image falling on the film (which is in turn controlled by the APERTURE; and by how long the shutter is open — the SHUTTER SPEED.

Exposure latitude The film's tolerance for exposure levels greater or less than the optimum.

Exposure modes Different ways of setting exposure, such as SHUTTER PRIORITY or APERTURE PRIORITY.

Eyesight correction lens Simple lens fitted over the camera eyepiece to make the viewfinder image clearer for photographers with imperfect vision.

f-number Measure of APERTURE: small apertures have a large *f*-number such as *f*/22. Large apertures have small *f*-numbers such as *f*/2.

f-stop See STOP.

False-colour infrared film Type of colour transparency film that records subjects reflecting INFRARED as red in colour, green subjects as blue, and red ones as yellow.

Fill-in flash Use of flash in daylight to illuminate shadows and reduce contrast.

Film speed The sensitivity of the film to light. Measured using the ISO scale.

Filter Glass, plastic or gelatin sheet fitted over the camera lens to control the colour or other qualities of light reaching the film.

Filter factor The amount of light absorbed by a filter.

Fisheye lens Extreme wide-angle lens that causes all lines which do not pass through the centre of the frame to bow outwards towards the frame edges.

Flare Unwanted pale areas on a picture caused by components within the camera or lens reflecting bright light sources.

Flash synchronization The firing of a flash unit at the exact instant when the shutter is fully open.

Flash synchronization speed The fastest speed at which a FOCAL PLANE SHUTTER simultaneously exposes the entire film area — and therefore the fastest speed at which flash can be used.

Fluorescent light Light formed by a continuous electric spark within a gas-filled enclosure. See also INCANDESCENT LIGHT.

Floodlight Any lamp that creates a broad beam of light.

Focal length A measure of the field of view of a lens. Lenses with short focal length take in a wide field of view, and vice versa.

Focal plane shutter Common form of shutter in which opaque blades or blinds are positioned just in front of the film. At faster speeds the blades form a slit that travels across the film, exposing portions of the image sequentially.

Focusing Movement of the lens toward or away from the film so that a selected part of the subject appears sharp.

Focusing screen Matt glass or plastic screen in the camera on which an image of the subject appears. Used to monitor focusing and composition.

Fog Overall unwanted exposure of the film to light.

Front projection Projection of a photograph along the lens axis via a half-silvered mirror and on to a reflective backdrop placed behind the subject, so that images shot in a studio appear to have been shot on location. See also BACK PROJECTION.

GN See GUIDE NUMBER.

Graduated filter A filter that consists of clear glass or plastic on one side, and a coloured or neutral tint on the other, with a gradual transition between the two areas.

Grain Granular, gritty texture of silver or dye particles that appears when pictures are greatly enlarged.

Grey card Piece of card that reflects exactly 18 percent of the light that falls on it, used as a reference tone when included in a picture, or to measure INCIDENT LIGHT with a REFLECTED LIGHT METER.

Guide number (GN) Measure of the power of a flash

unit, determined by multiplying the subject distance by the aperture, that will yield correct exposure. Powerful flash units thus have high guide numbers.

High key Type of image dominated by light tones. See also LOW KEY.

Highlight Brightest parts of a subject or picture.

Hot shoe ACCESSORY SHOE incorporating electrical contacts for FLASH SYNCHRONIZATION.

Hyperfocal distance Closest distance at which subjects are sharp when the lens is focused on infinity. Setting the lens to the hyperfocal distance produces the maximum possible DEPTH OF FIELD at any given aperture.

Incandescent light Light formed by heating a metal filament to a high temperature.

Incident light Light falling on the subject, as opposed to light reflected from it.

Incident light meter Meter held at the subject position to measure incident light, and thus determine the correct exposure irrespective of subject reflectance.

Infinity Lens setting for subjects a great distance away. Marked with a ∞ symbol on the camera lens.

Infrared Invisible radiation forming a continuation of the spectrum that we see as colour. Infrared radiation has a longer WAVELENGTH than visible light.

Infrared film Film that is capable of recording infrared as well as visible light. See also FALSE COLOUR INFRARED FILM.

Infrared focusing index Mark on the lens barrel, displaced from the main focusing index, to indicate where the focusing ring should be set when using infrared film.

Integral tripack Type of film in which three layers of EMULSION, sensitive to red, green and blue light, are permanently superimposed. All modern films are of this type.

Internegative Intermediate negative made from an image on REVERSAL FILM, and used to make a print.

Intervalometer Device used to repeatedly release the camera shutter automatically at a pre-set time interval.

IR Abbreviation for INFRARED.

Iris See DIAPHRAGM.

ISO Abbreviation for International Standards Association, and measure of film speed. Films that are very light-sensitive (fast films) have a high ISO rating, and vice-versa.

Kelvin Unit of COLOUR TEMPERATURE. Reddish light such as candlelight is rated low on the Kelvin scale.

Key reading Exposure meter reading from the most important area of the subject.

Latent image The invisible image formed on film by the action of light and revealed by subsequent processing.

Leaf shutter Type of shutter incorporated into the camera lens, comprising several blades which open to expose all areas of the film

simultaneously. See also FOCAL PLANE SHUTTER.

Lens Curved glass or plastic element that focuses an image of the subject on the film.

Lens hood Device used to shade the lens from light sources outside the field of view, thus preventing FLARE.

Lens shade See LENS HOOD.

Low key Description of image that is dominated by dark tones. See also HIGH KEY.

Macro See MACROPHOTOGRAPHY.

Macrophotography Generally, the photography of small objects.

Macro lens Lens designed to give optimum results at close subject distances.

Mid-tone Any part of the subject or image that has a brightness falling mid-way between the HIGHLIGHT and SHADOW areas.

Mired Measure of the colour of a light source or of the colour balance of film. Numerically equivalent to the COLOUR TEMPERATURE divided into a million.

Mirror lens Compact and lightweight type of TELEPHOTO lens that forms images using a combination of mirrors and conventional refracting lens elements.

Modes See EXPOSURE MODES.

Neutral density filter Grey filter used to cut down the amount of light reaching the film without affecting colour.

Normal lens See STANDARD LENS.

Pan and tilt head Tripod head with independent locks for camera movement in each of three planes, so that, for example, the camera can be tilted without the risk of unwanted rotation in a horizontal plane. See also BALL AND SOCKET HEAD.

Panchromatic film Black and white film that is equally sensitive to all colours of the spectrum. Virtually all modern camera films are panchromatic.

Parallax error Error in framing or composition caused when the viewfinder of a non-SLR camera is slightly displaced from the lens that takes the picture.

Perspective control lens Lens that can be moved at right angles to its axis, to change the field of view without turning the camera.

Photogram Picture made without a lens by resting a solid (usually transparent) object on photographic paper, and shining a light on it.

Photomontage The assembly of a picture using elements from several other pictures.

Pincushion distortion Lens fault causing straight lines in the subject to bend inwards on film, so that square objects take on the appearance of a waisted pincushion. See also BARREL DISTORTION.

Polarized light Form of light in which the waves vibrate in a strongly directional manner. Usually created by reflection from a surface. See also POLARIZER.

Polarizer/Polarizing filter Filter that cuts out POLARIZED LIGHT to eliminate reflections,

darken skies and enrich colours.

Posterization Partial elimination of tones in a picture when a gradual change from dark to light areas is replaced by two or more zones of flat tone or colour, with abrupt changes in between.

Pulling Deliberate underdevelopment of reversal film to increase DENSITY.

Pushing Deliberate overdevelopment of reversal film to reduce DENSITY.

Reciprocity failure Loss of FILM SPEED causing underexposure when exposure time exceeds about a second. On colour film reciprocity failure also creates COLOUR CASTS.

Reflected light meter Any meter that measures light reflected from the subject. Light meters integrated into cameras are all of this type. See also INCIDENT LIGHT METER.

Refraction Bending of a ray of light as it moves from one transparent medium into another in which light travels at a different speed.

Reversal film Film that creates a positive image directly, without an intermediate negative stage.

Sabattier effect Partial reversal of tones in a picture caused by a fogging exposure during processing.

Safelight Darkroom lamp that glows with a colour of light to which the paper in use is not sensitive.

Selective focusing Deliberate use of shallow DEPTH OF FIELD to restrict sharpness and thus direct the viewer's attention to one particular part of the picture.

Shading See DODGING.

Shadow In photographic terms, the darkest part of the image — even when this is not a shadow in the conventional sense.

Shadowgram See PHOTOGRAM.

Shift lens See PERSPECTIVE CONTROL LENS.

Shutter Device used first to prevent light from striking the film until the photographer presses the shutter release, and then to control the duration of the exposure.

Shutter priority Exposure control system in which the photographer sets the shutter speed, and the camera picks an aperture that will yield correct exposure. See also APERTURE PRIORITY.

Shutter speed Actually not a speed at all, but the time for whichh the shutter remains open, measured in seconds or fractions of a second.

Single-lens reflex Type of camera in which one lens is used both for viewing and composition, and for taking the picture.

Slave unit Compact electronic device that makes possible cordless SYNCHRONIZATION of several flash units.

Slide film See REVERSAL FILM.

SLR See SINGLE-LENS REFLEX.

Snoot Attachment shaped like a truncated cone, fitted to a lamp to narrow its beam.

Solarization Reversal of image tones caused by massive overexposure, but now used synonymously with SABATTIER EFFECT.

Speed See SHUTTER SPEED and FILM SPEED.

Spot meter Exposure meter that measures the light reflected from a very small portion of the subject.

Standard lens A lens that has a focal length roughly

equal to the length of the film diagonal.

Stop Generally, a comparative measure of exposure, one stop representing a halving or doubling of the light reaching the film.

Stop down To close the APERTURE to a smaller setting.

Substantive emulsion Any EMULSION that incorporates the COUPLERS necessary to make colour images. Most films have emulsions of this type. Hence non-substantive emulsions: these do not incorporate couplers, which are instead carried in the processing solutions.

Substitute reading Measurement of the light reflected from a convenient area that has the same tone as the subject, where this is itself inaccessible.

Subtractive synthesis The creation of coloured images by the removal of different wavelengths from white light using dyes in the subtractive primary colours, yellow, cyan and magenta. See also ADDITIVE SYNTHESIS.

Supplementary close-up lens Simple lens fitted over the main camera lens, in order to reduce the minimum focusing distance.

Synchronization See FLASH SYNCHRONIZATION.

Synchronization speed See FLASH SYNCHRONIZATION SPEED.

T setting See TIME SETTING.

Teleconverter Device fitted between the main lens and the body of an SLR to multiply the FOCAL LENGTH, usually by a factor of 1.4 or 2.

Telephoto In general terms, any lens that forms a bigger image on film than a STANDARD LENS.

Time setting Shutter setting that starts the exposure when the shutter release is pressed, and ends it when the release is pressed again, or the shutter speed dial is turned to a new speed. Usually marked with a "T".

Transparency film See REVERSAL FILM.

Tripack See INTEGRAL TRIPACK.

TTL Abbreviation for through-the-lens.

Tungsten light Form of incandescent light using a tungsten filament.

Tungsten (light-balanced) film Film manufactured to give natural colours when exposed to subjects lit by TUNGSTEN LIGHT.

Ultraviolet radiation Radiation that forms a continuation of the visible spectrum, but to which the human eye is insensitive. Ultraviolet radiation has a shorter WAVELENGTH than visible light and can cause FOG or COLOUR CASTS on film.

UV See ULTRAVIOLET.

Wavelength The distance between two successive peaks in intensity of a light wave. Wavelength is what gives light its colour.

Wide-angle lens Any lens that takes in a broader field of view than a STANDARD LENS.

X-setting Shutter speed setting marking the maximum FLASH SYNCHRONIZATION SPEED.

Zoom lens Any lens with a variable FOCAL LENGTH.

INDEX

INDEX

INDEX

Acknowledgements

ARORA Krishan, 8L, 8TR, 89L, 95R, 113, 127B, 143TL, 143R, 143B, 147BL, 147TR, 148R, 149B, 153R, 167L, 168B, 175T, 179R.

BROWN Duncan, 98—99.

BURNS AND SMITH, 65.

BUSSELLE Michael, 8R, 9L, 9R, 10, 14—15, 15R, 16—17, 16T (insert), 16B (insert), 17TL (insert), 17TR (insert), 52, 55TR, 59CB, 62TL, 63TL, 63TR, 69BL, 99CB, 101TL, 104—105, 112L, 114, 117T, 117BL, 118—119, 120TR, 121TL, 121TR, 128—129B, 129R, 131B, 136L, 136—137, 137R, 141R, 142L, 142R, 145CB, 150B, 152, 156L, 157L (insert), 157B, 159R, 160TR, 161TL, 164L, 164—165T, 165, 165BR, 166L, 168T, 170B, 172L, 207BL, 207CB.

CANON LTD, 11B, 57CB, 90TL, 90BL.

DEAL Shaun, 80T, 140.

DOHRN Martin, 6—7, 11T, 12L, 12—13, 12R (insert), 13R (insert), 14L, 54TL, 66R, 68L, 84L, 87, 88, 92TL, 96R, 97L, 97R, 119TR, 126R, 132—133, 135R, 138—139, 150—151T, 151B, 153CL, 170—171, 172—173, 178, 179L, 179CB, 181 (insert), 182, 183TL, 183R, 184BL, 185.

EASTMAN KODAK COMPANY, Courtesy of, 41BL/BR, 50TL, 51BC, 82/3, 154TR.

EASTMAN KODAK/ALDUS ARCHIVE, 24BR, 51CB, 82—83, 154TR.

HESELTINE John, 175BR.

HILLELSON John, AGENCY/Robert Capa, 28, Henri Cartier Bresson, 49, Erich Lessing, 34.

HOSKING Eric, 36BR, 36CB, 37B.

KING COLLECTION, The, 2L, 20—21, 25BL, 25C, 29, 30CB, 30TR, 35BL, 38.

KODAK LTD, 2C, 24BL, 32TC, 33TL, 33RB, 35TR, 36TL, 36TR, 36L, 37T, 50BR.

KODAK PATHE, 2R, 144, 155.

KOSHOFER Gert, 35BR.

LEITZ Ernst, WETZLAR, 26C, 26B, 27BL, 27TR, 27C, 27CB, 48TL, 48L, 48CB, 48BR.

MACKAY Tania, 180—181.

MILLER John, 119BR, 148L, 149T, 167R, 173B, 174, 184TL.

MINOLTA UK LTD, 40TL, 45CL, 47R, 51TR, 51BL, 63BR, 76CL, 77TR, 77CT, 78L, 78TR.

© **M.B.,** 32BL, 35CB, 42—43, 56 (9), 59BL, 59CB, Michael Busselle 71TL, 71BL, 72CT, (2) 72TR, 73TR, 73TL, 73CL, 73TCR, M.B., 75T, Michael Busselle 94TL, 94TC, 95TL (insert), M.B., 96C, 110TL, 110TC, 110TR, 110CL, 110CB, 110CR, Michael Busselle 110R, 111L, 111R, 116TL, 116CL, 116BL, 116TR, 126CL, 126BL, M.B., 128TR, 129TL, Michael Busselle 134—135, 140CB (2), 140TC, 145TC, 145TL, M.B., 162BL, 162CB, 162BR, 163BL, 163CB, 163BR, Michael Busselle 173TR, M.B., 186—187, Michael Busselle 200BL, 200CB, 200BR, 201B, M.B., 204BR, Michael Busselle 205C, (3) 206TR, M.B., 206CL, 206CB, 206BR, 207TR, Michael Busselle 208C, 208CR, 208CB, 208BR, 209, John Miller 220.

MORRIS Keith, 19.

NASA, 18TL.

NIKON UK LTD, 47TL, 58TL, 58BL, 61CR, 64R, 71BR, 74BL, 75CL (5) 76BR, 77BL, 79TR, 79CR, 79BR, 81CR.

NORMAN Ceri, 130—131.

O'DEA Robert, 175BL.

PAGE Tim, 30—31, 31TR.

PARKER Lucy, 100.

PENTAX UK LTD, 39T, 44.

PLATT Richard, 53TR, 53BR, 62CL, 62C, 62CR, 63BL, 63CR, 70CT, 70TR, 70CB, 70BR, 80—81B, 86C, 86R, 86BL, 86CB, 98L, 98C, 103TL, 103TC, 103TR, 103CR, 115TL, 115CL, 115CR, 115TR.

RAMSEY Colin, 89TR, 140L, 141TL, 150TL, 158—159B, 160L, 160R.

RONAN Ann, Picture Library, 23TR.

ROWLANDS Peter, 18B, 81TR.

SCIENCE MUSEUM, The, LONDON, 22CT, 22BL, 22BR, 23BL, 23CB.

SECOMBE David, 55TL, 70TL, 70BL, 72CL, 91, 93, 112BR, 130L, 162TL, 163TR, 169, 176, 177.

STARR John, 154TC, 154BR.

TRUSTEES OF THE WEDGWOOD MUSEUM, The, BARLASTON, 22CB.

VERKROOST Hans A., 64L, 66TL, 66BL, 92BL, 101BL, 106—107, 108CT, 108C, 108CB, 109L, 109TR, 109BR.

L = Left; C = Centre; R = Right; T = Top; B = Bottom.